FETISH

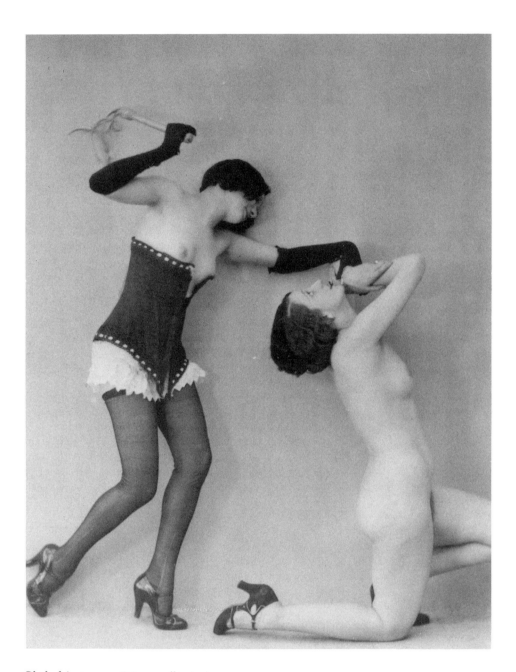

Clothed in power. (Private collection)

FETISH

Fashion,

Sex and

Power

Valerie Steele

NEW YORK OXFORD OXFORD UNIVERSITY PRESS

Oxford University Press

Oxford New York
Athens Auckland Bangkok Bogota Bombay Buenos Aires
Calcutta Cape Town Dar es Salaam Delhi Florence
Hong Kong Istanbul Karachi Kuala Lumpur Madras Madrid
Melbourne Mexico City Nairobi Paris Singapore Taipei
Tokyo Toronto

and associated companies in
Berlin Ibadan

Library of Congress Cataloging-in-Publication Data
Steele, Valerie.
Fetish : fashion, sex and power / Valerie Steele.
p. cm. Includes bibliographical references and index.
ISBN 0-19-509044-6
ISBN 0-19-511579-1 (Pbk.)
1. Costume—Europe—History. 2. Fashion—History. 3. Fashion—
Psychological aspects. 4. Fetishism (Sexual behavior)
5. Sex symbolism. 6. Erotica. I. Title.
GT511.S84 1996
306.77—dc20 95-17539

4 6 8 10 9 7 5

Printed in the United States of America
on acid-free paper

Acknowledgments

I am indebted to many institutions and individuals for visual material: Archive Photos (Michael Schulman); Peter Ashworth; Chris Bell; The Bettman Photo Archives (Joyceline Clapp); The Bodleian Library at Oxford University; Leigh Bowery and Fergus Greer; The British Library (Naresh S. Kaul); Peter Czernich of *O: Fashion, Fetish, Fantasies*; Kevin Davies; Peter Farrer; Films de Losange; The Human Sexuality Collection at Cornell University Library (Brenda J. Marston); Travis Hutchison; Impact Visuals and Robert Fox; The Kinsey Institute for Research in Sex, Gender and Reproduction (Jim Crump, Margaret Harter, and June Reinisch); Eric Kroll; Grace Lau; Jerry Lee of Centurian/Spartacus Publications (13331 Garden Grove Blvd., Suite G, Garden Grove, Calif. 92643); Andy Levin; Peter Lindburgh; Roxanne Lowit; *Movie Star News* and Paula Klaw; Angela Murray of Murray & Vern; Fakir Musafar of *Body Play* (P.O. Box 2575, Menlo Park, Calif. 94026-2575); Musée International de la Chaussure, Romans, France (Marie-Josèphe Bossan); Helmut Newton and French *Vogue*; Camille Norment; Patrice Stable; The Tom of Finland Foundation (P.O. Box 26658, Los Angeles, Calif. 90026) and Vince Gaither; Maria Chandoha Valentino; Trevor Watson; Vivienne Westwood; and Tim Woodward of *Skin Two* (23 Grand Union Centre, Kensal Road, London W10 5AX). Every effort has been made to obtain permission for use of all illustrations and photographs. If insufficient credit has been given, please contact the author via the publisher for credit in future editions.

Special thanks to Pearl, Bob and Cathie J., Lauren, Miss R. of the Torture Garden, The Baroness Varcra, Marie Constance of Dressing for Pleasure, Randall of the Caped Crusadist, the staff of Sin, Brandon of The Pleasure Elite, the Eulenspiegel Society, the London Life League, and Dianne Kendall. Thanks also to Halla Beloff, Katherine Betts, Anne Brogden, Marion DeBeaupré, Fred Dennis, Monica Elias, John Grant, Susan Kaiser, Robert Kaufmann, Dorothy Ko, Desirée Koslin, Nancy Lane, Thomas LeBien, Richard Martin, Lorraine Mead, Jimmy Newcomer, Isabelle Picard of Thierry Mugler, Ailene Ribiero, The Semi-

ACKNOWLEDGMENTS

nar on the History of Psychiatry and Behavioral Sciences at The New York Hospital/Cornell Medical Center, Dennita Sewell, Jody Shields, Joy Steele, June Swann, Efrat Tsëelon, Michel Voyski, and Rosemary Wellner. Many thanks to Peter Ferrar for giving me access to his excellent private research collection on corsetry and related subjects, and for sharing his expert knowledge with me. I am deeply grateful to Frank Liberto and Mark Micale for reading the manuscript. Most of all, thanks to my students and to my husband.

Contents

CONTENTS

FETISH

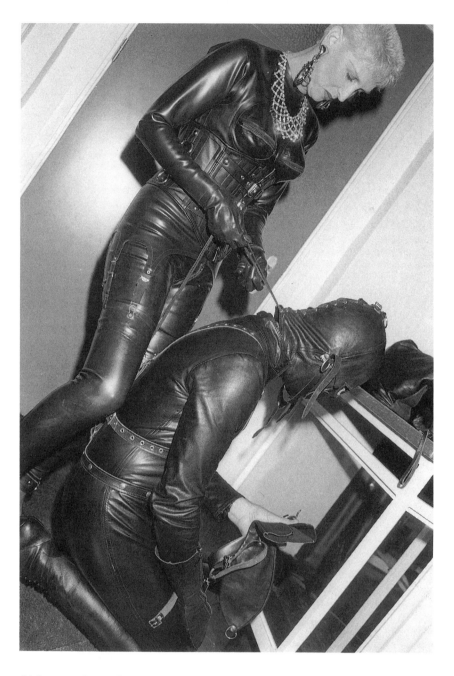

Club scene, Amsterdam, 1991. (Copyright © Grace Lau)

Introduction
In the Torture Garden

"How can you write about fetishism if you aren't into it?" asked the tight-laced dominatrix. It was fetish night at the Torture Garden, a London SM club, and several hundred enthusiasts roamed over four floors in a variety of fetish costumes, ranging from full-body rubber suits to black leather bustiers and high heels. One woman wore only a tiny plastic *cache-sexe* and a length of rope that wrapped around her body and snaked up to tie her hair like Pebbles Flintstone. A man strolled past, naked except for nipple and cock rings. Most people, however, were very much dressed.

Fashion was a big part of the London fetish scene, and I had to get special permission to attend the party in ordinary clothes. Earlier that day, I had telephoned Miss R., a hostess at the club, and explained that I was traveling with only a small suitcase but very much wanted to attend the party. She admitted that it would be a shame to have to spend a lot of money on a fetish costume. "You could borrow a corset from Pearl," she suggested hopefully, mentioning the famous male tight-lacer whom I had interviewed in New York. Miss R. called back a bit later with another concern: "Have you ever been to a place like this, dear? Are you sure it won't be too much for you? Maybe you ought to ask Pearl to come with you." In the end, Pearl did accompany me, and Miss R. left her own copy of my first book, *Fashion and Eroticism*, with the receptionist at the Torture Garden to let her know that I should be admitted despite my lack of appropriate attire. My literary ticket to enter the club was also the reason I was there in the first place.

I am a cultural historian specializing in fashion, and the book you are now reading is part of an ongoing project on the relationship between clothing and

sexuality. I am interested in exploring fashion as a symbolic system linked to the expression of sexuality—both sexual behavior (including erotic attraction) and gender identity. At the Torture Garden, in addition to the usual club fixtures, such as a bar and dance floor, were two rows of boutiques selling fetish shoes, piercing jewelry, and clothing items made of leather, rubber, and polyvinyl chloride (PVC). I chatted with habitués about the appeal of items like high heels and the sources for fetish fashion. Two American transvestites (one a former football player) gave me the addresses of important fetish fashion emporia in Europe and America that they frequented with their girlfriends.

I am not the only outsider interested in fetish fashions. Journalists have begun making forays, like my own, into the fetish underground. Alice Thomson of the *Times* squeezed into a corset to attend the 1993 Corset Ball at The Vox in London. In 1994, the *Guardian*'s Cynthia Rose covered an evening at Skin Two, where one person recalled that when the club first opened in 1983, "there were lots of old men hauling fat women by dog collars. Real hard-core fetishists. Not many girls like me, interested in the look as fashion."[1]

For fantastic as the costumes at the Torture Garden seemed, on closer inspection they bore a recognizable resemblance to contemporary fashion. Fashion quite often exhibits elements of fantasy, being "inspired" by such themes as ethnic dress, period costume, and military uniforms. Sexual themes, in particular, have become increasingly noticeable. Corsets, bizarre shoes and boots, leather and rubber, and underwear as outerwear (to say nothing of tattoos and body-piercing) have become almost as common on catwalks as in fetish clubs. The look probably appeals for different reasons to hard-core fetishists and dedicated followers of fashion. Nevertheless, fashion designers as diverse and important as Azzedine Alaïa, Dolce & Gabbana, John Galliano, Jean-Paul Gaultier, Thierry Mugler, John Richmond, Anna Sui, Gianni Versace, and Vivienne Westwood frequently copy "the style, if not the spirit, of fetishism."[2]

A word about terminology: After the publication of *Fashion and Eroticism*, in which I described certain nineteenth-century figures as corset and tight-lacing "fetishists," one man wrote to me to say, "We prefer to be called *enthusiasts*." This term, however, is rather vague, and euphemisms cannot gloss over the fact that the entire subject is controversial. Other enthusiasts, moreover, proudly use the term *fetishist*, which has the advantage of immediate recognition value. Nevertheless, words such as *fetishism* need to be placed within mental quotation marks, since this medicalizing language inevitably carries more or less pejorative conno-

tations. As a friend of mine put it, "I can't accept 'fetishism' because I would risk being called a fetishist myself—and I hate the imputation . . . of sexual perversity."

To understand contemporary fashion, it is crucial to explore fetishism. But this turned out to be more difficult than I had anticipated. There is an enormous literature on fetishism, comprising different discourses and genres, each with a complex history.

Fetishism as Cultural Discourse

The word *fetish* has a dual meaning, denoting a magic charm and also "a *fabrication*, an artifact, a labour of appearances and signs."[3] The original discourse on fetishism was religious and anthropological. Missionary tracts like *Fetichism and Fetich Worshippers* denounced the "barbarous" religions of people who worshipped "idols of wood or clay."[4] By the early nineteenth century, the term *fetish* had been extended to refer to anything that was irrationally worshipped. Then there evolved a second, Marxist interpretation. Karl Marx coined the phrase "commodity fetishism," analyzing the concept in terms of false consciousness and alienation that finds spurious gratification through the consumption of consumer objects. Lacking class consciousness, wrote Marx, the workers who produce objects attribute to them a "secret" value, which gives each consumer item the quality of a "social hieroglyphic" that needs to be decoded.[5]

Alfred Binet was the first to use the word *fetishism* in something like the modern, psychological sense in his essay "Le Fetichisme dans l'amour," published in the *Revue philosophique* in 1887. The concept of erotic fetishism was then adopted by others studying sexual deviations, such as Richard von Krafft-Ebing, who was himself coining terms such as *sadism* (named after the Marquis de Sade) and *masochism* (after Leopold von Sacher-Masoch, author of the classic fetishistic novel, *Venus in Furs*, who was very annoyed to find himself in a textbook on psychopathic sex).

As the word *fetishism* acquired an expanding repertoire of meanings, the separate discourses began to intersect. Fetishism is not only "about" sexuality; it is also very much about power and perception. The film scholar Linda Williams observes that in pornographic movies the "cum shot" (or money shot) is *fetishized*.[6] "The extreme anti-porn argument turns pornography into a fetish,

demonizing it as the primal cause of all male violence and all women's subjection," writes Anne McClintock of Columbia University. "Fetishizing pornography projects onto it a spurious power."[7]

The concept of fetishism has recently assumed a growing importance in critical thinking about the cultural construction of sexuality. Works such as *Fetishism as Cultural Discourse* and *Feminizing the Fetish* complement or critique the voluminous clinical literature on fetishism as a sexual "perversion." Neo-Marxists analyze "commodity fetishism," feminist scholars explore the contested issue of "female fetishism," and art theorists stress the subversive role of fetishism in contemporary art, arguing that a fetish can be "any article that shocks our sensibilities."[8]

It might seem presumptuous to propose another study of such a heavily theorized subject. ("How can you write about fetishism when it has already been studied so much?" one professor asked me.) Yet, to date, no scholar with an in-depth knowledge of fashion history has studied the actual clothing fetishes themselves. Enthusiasts lavish attention on the minute particulars of their chosen fetish object. But most scholars have lumped together the many "objects of special devotion," as though it made no difference whether an individual chose high-heeled pumps or combat boots, a silk petticoat or a leather jacket.

Nor has there been a serious exploration of the historical relationship between fashion and fetishism, an approach that promises to provide important insight into both the nature of fetishism and the erotic appeal of fashion. For just as the cultural interpretation of fetishism has evolved in conjunction with changing attitudes toward sexual expression and "deviance," so also has our understanding of "perverse" erotic styles. Moreover, there have been both changes and continuities in the choice of fetish fashions and fabrics. Corsets have long since disappeared from mainstream fashion, but they retain an important role in fetishism—and have reemerged in avant-garde fashion. Women's underwear and high-heeled shoes have long been among the most popular garments chosen as fetishes, but there is also evidence that uniforms, boots, and even Levis appeal to both male and female subjects. The materials that attract fetishists have also evolved over time, with silk and fur tending to be eclipsed by leather and rubber.

Because the subject itself is so full of interest, I have tried not to become overly entangled in theoretical debates. Instead, I have relied heavily on what fetishists themselves have written about their enthusiasms for items such as corsets, shoes, and underwear. Pornography has been a major source of information about the appeal of fetish objects. The non-erotic popular discourse on fetishism is also

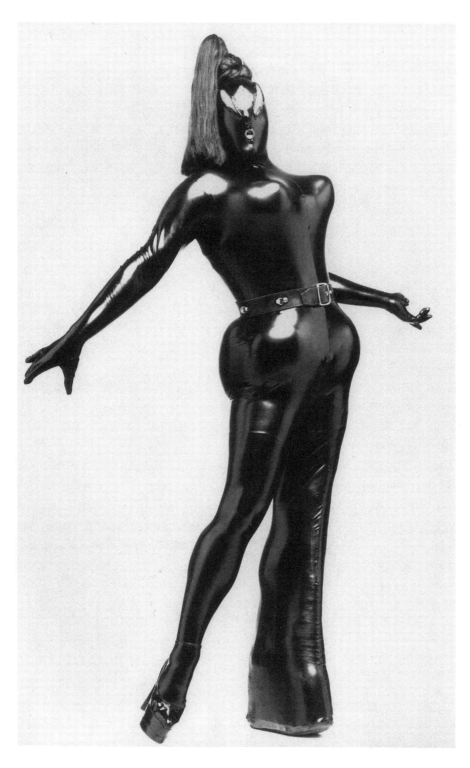

Performance artist Leigh Bowery, London, 1992. (Photograph by Fergus Greer; Leigh Bowery)

flourishing—and not only in fashion magazines. An article in *Self* warned female readers that "kinkiness may be more common than you think." The author characterized fetishism as "an avoidance of emotional intimacy" and a way that some men "channel frightening or destructive impulses."[9] An article in the *Ladies' Home Journal* quoted the unhappy wives of fetishists. "Outside the bedroom, David is the man every woman wants to marry," said one woman. "But he won't make love to me unless I wear my high heels to bed."[10]

In his memoir, *My Life in Court*, the famous trial lawyer Louis Nizer recounted how foot fetishism played a role in a divorce case. He represented the wife, who testified, weeping, how her husband would put his head under the covers and go on "what he called a treasure hunt," which meant kissing her feet, putting them in his mouth, and sucking on her toes.[11] More recently, Chuck Jones, the publicist for actress Marla Maples, was arrested for stealing about fifty pairs of her shoes. "As you can see, I have a problem," Jones allegedly told the police. The press treated the incident as a joke: "What a Heel! Sole suspect nabbed in Marla shoe thefts."[12] The Manhattan district attorney's office initially suggested that he plead guilty to a misdemeanor, with no jail time, but he was eventually indicted on burglary charges.[13] "It's not a perversion, not a foot fetish," Jones told a reporter for *Vanity Fair*.[14] But he admitted having a "sexual relationship" with Marla Maples's shoes.[15]

In studying fetishism, I found myself poised between discourses: the postmodern, the politicized, the psychiatric, the popular, and the pornographic. The different discourses often overlapped, of course. Some of the works that purported to be serious medical case histories or journalistic exposés read more like pornography. And some of the pornography read like advertising copy for a weird fashion magazine: A story in *High Heels* magazine, for example, purported to recount the "Diary of a High Heel Model":

> "This may startle you, at first," explained the photographer. "My client wants to issue a catalog of Fall clothes—namely wasp waist gowns, skin tight negligee, leather brassieres—you know, leather is the current rage and designers are outdoing themselves for ideas in new leather garments."[16]

The organization of this book is designed to focus on the relationship between fetishism and fashion. In the first chapter, I have juxtaposed the different voices emerging from the various discourses on fetishism. The second chapter explores why fashion has become increasingly fetishistic. In the next four chapters, I analyze individual clothing fetishes: the corset, shoes and boots, underwear, and ma-

terial fetishes such as leather. Finally, in the last and most important chapter, I examine the relationship among fashion, fetish, and fantasy through an exploration of the clothing "looks" that have been most important both within the fetishist subculture and in the world of fashion.

Fetishism evokes images of "kinky" sex, involving an abnormal attraction to items of clothing such as high-heeled shoes and tightly laced corsets, or body parts like feet and hair. Although obviously sensational, it would seem to be of marginal importance—except, of course, to individual fetishists. But the stereotype of fetishism as a "picturesque" sexual deviation is too simplistic. Leather, rubber, "cruel shoes," tattoos, and body-piercing—all the paraphernalia of fetishism have been increasingly incorporated into mainstream fashion. The popular interest in subcultural style is not new, but there has recently been a qualitative change in the reception of sartorial sexuality. Today sexual "perversity" sells everything from films and fashions to chocolates and leather briefcases. In answer to the dominatrix at the Torture Garden, I would say that anyone who wears clothes, listens to music, goes to the movies, or is on the Internet might want to know more about fetishism. Certainly, anyone who is "into" fashion has to address the issue.

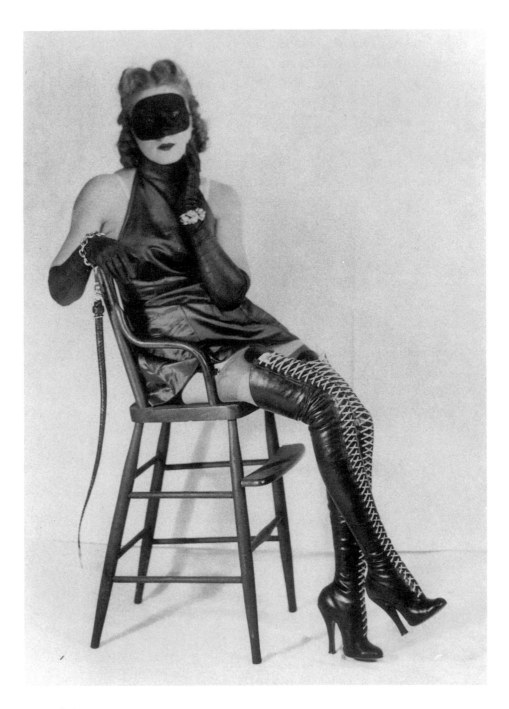

Fetish fashion, ca. 1944. (Kinsey Institute)

one

What Is Fetishism?

The nineteenth-century sexologist Richard von Krafft-Ebing defined fetishism as "The Association of Lust with the Idea of Certain Portions of the Female Person, or with Certain Articles of Female Attire."[1] Many men, of course, are sexually attracted to clothing items such as high-heeled shoes and silky panties, or prefer sexual partners with a particular physical characteristic, such as large breasts or long, red hair. Are they all fetishists? The early sexologists tended to think so.

"We are all more or less fetishists," declared Dr. Emile Laurent in 1905.[2] "Normal love," agreed Alfred Binet, is the result of a "complicated fetishism." Pathology begins only "at the moment where the love of a detail becomes preponderant."[3] According to Krafft-Ebing, in pathological erotic fetishism "the fetish itself (rather than the person associated with it) becomes the exclusive object of sexual desire," while "instead of coitus, strange manipulations of the fetish" become the sexual aim.[4]

"Is the pathological state merely a quantitative modification of the normal state?"[5] Yes and no. Fetishism probably needs to be conceptualized along a continuum of intensities:

Level 1: A slight preference exists for certain kinds of sex partners, sexual stimuli or sexual activity. The term "fetish" should not be used at this level.

Level 2: A strong preference exists. . . . (Lowest intensity of fetishism.)

Level 3: Specific stimuli are necessary for sexual arousal and sexual performance. (Moderate intensity of fetishism.)

Level 4: Specific stimuli *take the place* of a sex partner. (High level fetishism.)[6]

Fetishizing Is the Norm for Males

After studying erotic fantasies and sexual behavior for many years, the psychiatrist Robert Stoller concluded that *"fetishizing is the norm for males, not for females."*[7] This is not to say that women are uninterested in body parts or sexy clothes. But they do not seem to "lust" after them in the same way men do. (This is an important issue if we are to explore the appeal *for women* of clothes that men treat as fetishes.)

Men often fetishize body parts and garments, and might well describe themselves as "leg men," "breast men," or "ass men." A leg man is not a true fetishist, however, "unless he prefers to climax on his partner's legs rather than between them."[8] Although fetishism narrowly defined appears to be distinctly a minority practice, a *degree* of fetishism appears to be extremely common among men—normative, in other words, if not "normal." There exist a number of specialized sex magazines with titles like *High Heels*, *D-Cup*, and *Erotic Lingerie*. Yet only a small percentage of pornography is "specifically written for any of the various fetishes."[9] Only "an extremely small audience depends on these specific images for sexual arousal." But images of "women wearing high heels and lingerie [are] as prevalent as images of vaginal intercourse, suggesting that they have become normative sexual imagery."[10]

In the course of researching this book, I have looked at a lot of pornography and have come to the conclusion that it is amazing what turns people on: everything from *Amputee Times* to *Wanda Whips Wall Street*. Body parts are more likely to be fetishized than clothing items per se. Typical pornographic titles include *Big Bazooms*, *Ten-Inch Tools*, *Up Her Ass*, *Up My Ass*, *and This Butt's for You*. Body types and races are also fetishized: *Fat Fucks*, *Black and White Fetish Exchange*, and *Oriental Fetishes*. But breast fetishism has its counterpart in a fetishism devoted to *Huge Bras*, and an emphasis on the genitals with *Panty Passions*.

Most pornography deals with genital intercourse (straight or gay), like *A Cock Between Friends* and *A Date with Pussy*. Clothing references occur occasionally with titles like *Tight Rubber*, *Lisa's Rubber Seduction*, *Hard Leather*, *Lust for Leather*, *Leather Licking Slut*, *High-Heeled Sluts*, *Flesh and Lace*, and *Skirts Up, Pants Down*. There are noticeably more references to clothing fetishism when the pornography involves transvestism and/or sadomasochism, indicating that fetishism frequently overlaps with these sexual variants. Transvestite pornography is fairly common and includes such titles as *Macho Man in Heels*, *Pretty Panty Marine*, and *Barry's New Bra*.

Clothing fetishes are frequently combined to form costumes, which are clearly associated with particular sexual fantasies. Uniforms are very important: *Our Boys in Uniform*, *Sluts in Uniform*, and *Naughty Nurses* are representative titles that reveal how fetishism involves erotic scenarios. *Black Leather Biker* and *Boots and Saddles* are typical of an enormous genre devoted to leathersex. *Domina in Leather*, *Leather Master*, and *Leather Mistress* indicate how leather is associated with power. By contrast, *Harem Girls in Bondage* and *Maid to Be Spanked* focus on submissive dressing.[11]

Readers may feel that some material in this book is so grotesque and bizarre as to defy comprehension, except by reference to extreme psychopathology. Yet bizarre elements exist in the erotic imagination of many people. In his brilliant study *Observing the Erotic Imagination*, Robert Stoller compared one of the most extreme cases discussed by Krafft-Ebing with dozens of advertisements from pornographic magazines:

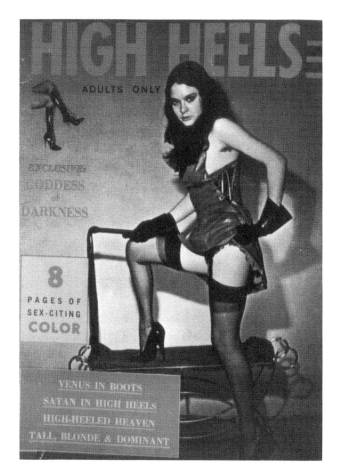

Fetishizing is the norm for males.

SHITEATING! CATFIGHTS! TORTURE! AMPUTATION! DISFIGURED GIRLS! PIERCED PENISES AND PANTY LOVERS.[12]

My own research into clothing fetishism supports Stoller's idea that there exists "a whole race of erotic minifetishists: most males of most cultures."[13]

Neither "pathological" fetishism nor "normal" fetishizing is typical of women. As Louise Kaplan notes, "Except for sexual masochism where the ratio of cases is approximately twenty males to one female, *less than one percent of the cases cited as sexual perversions have been of females.*" People often deny that this is true; they can think of exceptions. Or they insist that as women become more sexually "liberated," they will achieve parity with men. Sometimes, women congratulate themselves that only men are "perverts." There is a certain naïveté in all three responses. "A more carefully considered response . . . is that males are androgen–testosterone driven . . . whereas females . . . are less inclined toward perverse acting out," writes Kaplan, although she believes that this explanation gives too much weight to biological factors.[14] Meanwhile, psychiatrists "cast about for female fetishists, transvestites, sadomasochists, [and] exhibitionists," ignoring the possibility that women have perversions of their own. "The male perversions use some manifest form of kinky sex . . . to keep the devils at bay." By contrast, Kaplan argues, "sexual behaviors per se, kinky or otherwise, are not the key to female perversions."[15]

Certainly, I found that all the men (straight and gay, old and young) to whom I mentioned the subject of my book responded with enthusiasm. In contrast, many of the women to whom I spoke felt that the subject was somewhat "disgusting" or "depressing." The exceptions were mostly younger women, often in the arts, with an interest in pornography.

The Phallic Woman

Freud argued that "the fetish is a substitute for the woman's (the mother's) penis that the little boy once believed in and . . . does not want to give up. . . . [F]or if a woman has been castrated, then his own possession of a penis was in danger."[16] This theory seems "bizarre and unconvincing" to many people and requires some explanation.[17] There is ample evidence, however, that little boys and girls frequently go through a phase of believing that at least some females (such as their mothers) have a penis. Kaplan describes fetishism more vividly, and prob-

ably to many modern readers more convincingly, than Freud, but she follows his basic outline:

> The little boy whose childhood curiosity, fantasies, anxieties, and wishes lead him to endow his mother with a substitute penis is constructing only a temporary, elusive fantasy . . . that the adult fetishist will concretize into a shoe or fur piece. . . . As Freud was the first to insist, the extravagant sexual theories of little boys may be outgrown and forgotten but they are never entirely given up. They are repressed . . . but persist as unconscious fantasies that are ready to return . . . whenever there is a serious threat, imagined or actual, to a man's hard-earned masculinity.[18]

Some of my students asked why someone did not just tell the fetishist that women have no penis; of course, he knows that, yet he may, unconsciously, wish to endow his sexual partner with a substitute penis.

According to Freud, the only way the adult fetishist can surmount his "aversion . . . to the real female genitals" is by "endowing women with the characteristic which makes them tolerable sexual objects."[19] The fetish object thus functions as "a token of triumph over the threat of castration and a protection against it."[20] Kaplan again describes the classic scenario: "The adult fetishist cannot introduce his penis into that temple of doom called a vagina without a fetish to ease the way."[21] To become sexually aroused, he needs an inanimate object, such as a leather boot or a black corset, as a phallic substitute. His sexual partner may wear it, or he may wear the fetish himself. Alternatively, Kaplan adds:

> The fetish may be a part of the sexual partner's body . . . [or even] the sexual partner herself. For example, just as a high-heeled leather boot may represent a female with a penis—the so-called phallic woman—so a woman, with or without boots, may be endowed with phallic properties by her fetishistic lover and thus become, for him at least, a fetish. Some fetishists are able to be sexually aroused only by policewomen or nuns or nurses, or women they command to dress up as these personalities.[22]

Fetishism involves phallic symbolism, but what is that? "Is the Washington Monument supposed to be a phallic symbol?" asked one of my students. Sexual symbolism works differently from most symbolism, which is consciously agreed on (a red light means "stop!"). Not everyone believes that a gun or a high heel can symbolize the penis. But although phallic symbolism may seem absurd on the level of common sense, it has some psychic reality. One day, the four-year-old son of an acquaintance of mine ran into the living room with an erection and proudly announced, "Look, Mommy! I'm the Washington Monument!"

The phallic woman. A slightly different version of this photograph appeared on the cover of Demonia. (Copyright © Eric Kroll, 1994)

Castration anxiety is real, too, as indicated by the furor over the Bobbitt case (when a woman severed her husband's penis with a knife). Heinrich Hoffmann's nursery rhyme evokes a deep-rooted fear:

> The great tall tailor always comes
> To little boys who suck their thumbs,
> And ere they dream what he's about,
> He takes his great sharp scissors out
> And cuts their thumbs clean off—and then,
> You know, they never grow again.[23]

According to the French psychoanalyst Jacques Lacan, the phallus is not the same as the penis, although we tend to use the words interchangeably. Whereas the penis is a part of the male body that may or may not be especially impressive, the phallus is the eternally erect and massive symbol of power and potency. "If the penis were a phallic symbol, men would not need . . . neckties or medals."[24] Neither men nor women "have" the phallus, but they both want what it signifies. I don't ask readers to take it on faith that the phallic woman is "the ubiquitous fantasy in perversions,"[25] but after we have looked at a number of fetishes, I think they will be inclined to agree that such is often the case, although it is not the entire picture.

There are, however, problems and lacunae with classic Freudian theory. Fetish objects are not randomly chosen, and Freud wondered, legitimately, why certain objects (such as shoes, fur, and underwear) were so often chosen as "substitutes for the absent female phallus." He suggested that they were, perhaps, related to "the last moment in which the woman could be regarded as phallic." Thus, "pieces of underclothing, which are so often chosen as a fetish, crystallize the moment of undressing." Fur is associated with the pubic hair, which should have revealed a penis. Shoes evoke the moment when the little boy glanced up his mother's skirt. Recent research, however, has stressed the overdetermined character of fetish choice.

Freud's idea that the fetish keeps the fetishist from becoming homosexual (by compensating for the otherwise terrifying sight of the female genitals) has been clinically proven to be incorrect: "If the fetish were none other than a substitute for the mother's penis, the subject being unable to bear the sight of the 'castrated' female genitals which arouse in him the fear of castration, this fear should be non-existent for a man whose sexual partner is another man."[26] But there are

homosexual as well as heterosexual fetishists. Some men also wear the fetish themselves while engaged in auto-erotic activities.

Not Just the Mother's Penis

The fetish may well be a substitute for the mother's penis, but that is not *all* it is. The classical Freudian theory is insufficient because it interprets the castration complex "in a narrow sense, as bearing on the perception of the female genitals." But "the very idea of castration has to be enlarged" to include "what precedes it: separation anxiety."[27]

Castration is a problem of physical and emotional vulnerability not limited to fears about the genitals.[28]

As early as 1953, the child psychologist Phyllis Greenacre observed:

> If we . . . substitute for "threat of castration" "sight of mutilated and bleeding body," I think we may envision what happens in a certain number of children. . . . The traumas which are most significant are those which consist of the witnessing of some particularly mutilating event: a mutilating death or accident, operation, abortion, or birth at home.[29]

There is evidence that this is especially true if the child personally is injured.

The psychiatrist Robert Stoller has reported on the case of Mac, "a child fetishist" who, at the age of two and a half, became sexually obsessed with his mother's stockings and pantyhose. Freud's theory that fetishism results when the child sees the female genitals around the same time that he is threatened with castration for masturbating does not apply in Mac's case.[30] But Greenacre's theory about mutilating trauma does apply: Mac had been severely traumatized by a delayed and extremely painful circumcision. His relationship with his adoptive mother was also disturbed.

"We cannot get into Mac's mind," writes Stoller. "Still, we can imagine how her silky smooth, skin-like pantyhose . . . fit his needs to have her with him, part of him, . . . comforting him more reliably than she, a full person did." It oversimplifies, Stoller argues, to make "the fetish equal mother's phallus," or even "the good breast," because theorizing prevents us from seeing how "other parts of mother" like the skin "are also incorporated into the fetish."[31]

In a revision of Freudian theory, the French psychoanalyst Janine Chasseguet-

Smirgel identifies the fetish with a fantasied "anal penis."[32] Describing a patient whose fetish was the prosthesis of a one-legged male friend, she writes:

> If the fetish was nothing but the mother's phallus, then the case of the one-legged man and of his prosthesis would be an actual riddle, for we are confronted here with a two-fold paradox: the fetish is linked to a man, and this man is a castrated one!
>
> As a matter of fact, . . . in times past, any thriving brothel featured a "wooden-legged woman." While the anal penis is a prefiguration of the genital one, *a posteriori* it is an imitation of it.[33]

By maintaining the illusion that he has no need to envy his father's penis, the fetishist asserts that no rivalry exists between them and therefore no threat of castration. The mother–child unity is maintained.

Another of Chasseguet-Smirgel's patients felt compelled to put his wife's boot in his mouth whenever she was away. "The fetish is the deposit of all the part objects lost during the subject's development." In fetishes that involve constriction (such as corsetry and shoe fetishism), "the fetish is both content and container," putting the nipple back in the mouth, so to speak, and symbolically revising the primal scene.[34] The psychological discourse on fetishism has increasingly been challenged, however.

The Invention of Fetishism

Michel Foucault called sex "the explanation for everything, our master key." He also described "fetishism" (in quotation marks) as "the model perversion," which "served as the guiding thread for analyzing all the other deviations." But he rejected the psychoanalytic view of sexuality as the core of an individual's identity and the motive force of human action, arguing that the "psychiatrization of perverse pleasure" was the modern equivalent of the confessional and the latest form of knowledge-power.[35]

Inspired by Foucault's ideas, many scholars have questioned the traditional view of sexuality as a fixed "essence" and rejected both biological and psychological determinisms. Although the essentialism/constructivism debate has focused on "homosexuality," it also throws into question the validity of other modern sexual categories like "fetishism." Foucault's work on "the repressive hypothesis" and the rise of *scientia sexualis* also encouraged inquiry into the historicity of sexual

Anti-corset caricature, 1874. (From *Madre natura versus the Moloch of Fashion*)

practices and categories, while his emphasis on "bodies and pleasures" and his view of the body as the site for the deployment of discourses has resulted in virtually a new field of study—"bodyology."[36]

An analogy with pornography may be useful. Explicit depictions and descriptions of sex organs and activities have existed in most, probably all, times and places, ranging from obscene graffiti scratched on rocks to elaborate philosophical and artistic productions like the *Kama Sutra*. But some scholars argue that "pornography as a legal and artistic category seems to be an especially Western idea with a specific chronology and geography." It was in early modern Europe that pornography first became "an end in itself."[37]

Fetishism, like pornography, has a history. Although almost every "kinky" activity we know of today already existed at the time of the Roman Empire, this does not necessarily mean that fetishism has always existed.[38] There are two theories about this. The first basically says that yes, fetishism is a universal—or, at

Fetishism, like pornography, seems to be a relatively modern invention. "La grande épidémie pornographique . . ." (From *La Caricature*, 1882)

least, it has existed for thousands of years in many cultures. The second theory argues, on the contrary, that fetishism developed only in modern Western society. There is evidence for both sides.

Body modification and cross-dressing are common ritual practices in many cultures. Body parts and clothes have also been widely fetishized. The Roman poet Ovid was devoted to the charms of female feet, and Chinese foot-binding exibits many of the characteristics associated with fetishism. The Sambia of New Guinea (who engage in ritual fellatio) fetishize boys' mouths.[39] But although fetishizing may characterize most males in most cultures, fetishism, as we understand it to-

day, seems to have first appeared in Europe in the eighteenth century and then *crystallized* as a distinct sexual phenomenon in the second half of the nineteenth century.

"Why were there so many perverts in the nineteenth century?" asks Colin Wilson in *The Misfits.* "It seems strange that none of the 'sexologists' recognized the obvious and simple fact that most of the perversions they were writing about dated from their own century."[40] In Wilson's opinion, "imagination and sexual frustration had combined together" to breed fetishes. There are serious problems with this theory, not least with respect to the popular idea of the sexually "frustrated" (and therefore "perverted") Victorians. Yet something seems to have happened in the nineteenth century that forever changed the meaning of sexuality.

The eighteenth century was a transitional period, during which traditional sexual attitudes and behaviors began to evolve toward the modern pattern. There was an increasing preoccupation with explicit eroticism, as associations were drawn between free thought and sexual "libertinage." Gradually, people stopped thinking in terms of sexual acts and began thinking of sexual identities. The development of capitalism and urbanization in Europe apparently provided an environment within which "fetishists" could begin to become aware of themselves and contact others with like interests. Yet biology also plays a role in fetishism.

The Evolution of Fetishism

Sexuality is a product of both history and nature. Human sexual behavior (including sexual anomalies like fetishism) is almost certainly determined in part by biological factors. Neither history nor psychoanalysis satisfactorily explains why fetishism, like all the "perversions," is so much more common among men than women. Sociobiology appeals as an explanatory paradigm because it seems to address this type of issue in terms of material evidence with respect to evolution, genetics, and hormones. Although many people resist accepting it because of what they perceive as its iniquitous political implications, there seems little doubt that not only our bodies and genitals but also our minds are sexed.[41] Men and women have different attitudes toward love and sex.

In one of Woody Allen's films, Diane Keaton says, "Sex without love is an

empty experience," to which Allen replies, "Yes, but as empty experiences go it's one of the best." This attitudinal difference is not absolute, but then neither are physical differences; yet no one would deny that, on average, most men are taller than most women. Exceptions do not disprove generalizations. Nor does social learning theory adequately explain gender differences. If men are much more inclined than women to fetishize body parts and clothes, this may not only be because they inadequately separated from their mothers or grew up in a patriarchal society.

The principles of sociobiology (or evolutionary psychology) imply that much of our sexual behavior evolved through the normal process of Darwinian natural selection because it served adaptive purposes over the long run. Most relevant here is the observation that the secondary sexual characteristics evolved as they did because they convey information about reproductive fitness. (The information conveyed might or might not be true in individual cases, but if it is true more often than not, it becomes an evolutionary force.) Thus, if heterosexual men are attracted to women with large breasts, slim waists, and smooth skin, this is because these characteristics are associated with young adult females of maximum reproductive capacity. Ancestral males who preferred prepubescent or older females lost out in the competition to perpetuate their genes. This is potentially relevant to fashion, because in the animal world secondary sexual characteristics (antlers, vivid plummage, etc.) might be considered biological fashions in the sense that variations in those characteristics can enhance or inhibit one sex's attractiveness to the other. The process is circular: Over the generations, characteristics that are attractive because they denote reproductive fitness are selected for and thus gradually become phylogenetically dominant.

Throughout the animal kingdom, males and females tend to have different evolutionary strategies. Male mammals, being free from the burdens of childbearing and lactation, can maximize their genetic legacy by mating with as many fertile females as possible. Human males, therefore, seem to have evolved highly visually oriented patterns of sexual arousal as a result of being continually alert to the possibility of mating with any "attractive" (i.e., apparently reproductively fit) female who might happen by. The human male tendency to become sexually aroused by visual cues suggests, in turn, that human fetishes might have biological roots. A corset, for example, exaggerates the hourglass shape that attracts many heterosexual men; that exaggeration might exert a powerful psychological attraction on a subset of males.

As the psychologist Glenn Wilson writes, "It is probably no accident that the brain area responsible for assertive male sexuality is a part of the hypothalamus that is close to the visual imput system (the preoptic nucleus)." If male sexuality evolved to be "target-seeking," this may be one reason "why men are particularly prone to the distortions of sexual inclination we call paraphilias."[42] Wilson's research into sexual fantasies reveals striking gender differences, including a much greater emphasis in men's fantasies on visual, voyeuristic, and fetishistic themes. Male fantasies often include references to clothing items, "such as black stockings and [garterbelts], sexy underwear, leather, or nurses' uniforms; for example, 'A sixteen-year-old virgin dressed in a short-skirted school uniform.' "[43] Men apparently have this type of fantasy two and a half times more often than women. One might speculate that such articles of clothing act (at least for some men) as, in effect, artificial secondary sexual characteristics that serve as indicators of the sexual desirability and availability of the female.

Dominance and rank-related aggression seem to be characteristic of human males, not only because men compete for access to women (and other resources), but because women who preferred to pair with high-status males would on the whole be more successful in raising and protecting children. Dominance and aggression as evolved sex-linked characteristics may also be related to the much greater prevalence of paraphilias among men. A "dominance-failure" interpretation of fetishism has received some empirical support: Male students who were told that women found them unattractive showed temporarily diminished interest in women and a greater response to objects such as shoes and underwear.[44]

The experiment involved only a temporary and artificially induced fetishizing, of course. Yet the links between fetishism and sadomasochism may imply the devaluation of a human love object. That sounds moralistic (like much of the writing on fetishism), but sociobiology implies that male "hard-wired" characteristics make men inclined to be lustful and indiscriminate in their sexual couplings. Nature may also have constructed sex variants, either by chance or for reasons that are still unclear. At the very least, one can conclude that evolved psychological characteristics will be expressed to a greater or lesser degree across a range of possibilities, and that some percentage of individuals therefore will exhibit extreme behaviors.

The increasingly convincing demonstration by evolutionary psychologists that human sexual behavior has evolved through natural selection does not rule

out the possibility that individual behaviors might have diverse and complex causes, including specific organic lesions. By the middle of the twentieth century, medical researchers had begun to explore the relationship between altered brain states (organic brain disease) and "sexual psychopathology." Arthur Epstein, for example, studied "thirteen cases of fetishism or fetishism-transvestism, of which nine [of the patients had] abnormal electroencephalograms, two frank seizures, and five clinical evidence of brain disease." He also surveyed the literature on fetishism, finding a number of cases in which epilepsy was also present.

One case from the 1950s of a safety-pin fetishist was particularly striking. The subject became " 'glassy eyed' after staring at the pin" and would make a "humming noise." Sometimes the sight (or thought) of a safety pin would trigger actual seizures, and sometimes, after a period of immobility, he would dress himself in his wife's clothes. The patient underwent a left-anterior temporal lobectomy, which cured both fetishism and transvestism. Dissection of the brain segment revealed a gliotal process (i.e., a type of brain tumor).[45]

Epstein also suggested that the characteristics associated with fetish objects might be related to factors that were significant in shaping the sexual behavior and psychosexual characteristics of the human species. For example, the shininess, smell, and/or shape of certain objects or materials might be connected with the evolution of sexual-arousal patterns in primates. In support of this theory, he reported how two nonhuman primates in a zoo became sexually aroused by a boot. There is no conflict between his two theories—the evolutionary and the brain-disease theories—since in the human fetishist also, "the relationship to the fetish object may be understood as a release of an approach automatism toward a specific object."[46]

There are problems with organic (biological) explanations, which focus exclusively on the physical organ of the brain while ignoring the mind that the brain produces. Physiological brain malfunctions (particularly in the temporal lobe) may be factors in some cases of fetishism, as in other kinds of compulsive behaviors. But the evidence indicates that there are at least "two possible etiologies: one that is set off inside a scarred brain and one that, of course using the brain, is a response primarily to psychological experience."[47]

Many psychologists today believe that Freudian theories have little scientific validity, and they place more credence in neurological factors, arguing that the preponderance of paraphilias among males can be at least partially

explained by genetic, hormonal, and evolutionary causes.[48] "Research has shown that there may be some genetic predisposition to SM and TV traits, though a liking for rubber and leather appears totally learned," writes research psychologist Chris Gosselin. "It also seems that some are biologically more prone to this conditioning than others—it's the way their minds are built." Whether or not an individual plays this genetic "card" may depend on life experiences.[49] Fetishism is widely believed to be "a kind of compulsion, a combination of unusual 'brain wiring' and aberrant conditioning," including "a restrictive sexual upbringing."[50] In many instances, fetishism appears to involve an exaggeration, or perversion, of characteristics shared by most human males. Specific manifestations of fetishism are almost certainly overdetermined (caused by more than one thing).

Neosexualities and Normopaths

The *Diagnostic and Statistical Manual* of the American Psychiatric Association defines fetishism as "recurrent, intense sexually arousing fantasies, sexual urges or behaviors involving the use of nonliving objects (e.g. female undergarments)."[51] In practice, however, it is often impossible to draw a clear line between, say, foot and shoe fetishism.

The inanimate fetish object is often, but not necessarily, a piece of clothing: aprons, boots, dresses, eyeglasses, gloves, handkerchiefs, raincoats, shoes, stockings, underwear, and uniforms. Often quite specific requirements exist: The dress might have to be wet or slashed; the shoes, shiny or creaking. The fetish can also be a type of material, such as fur, leather, silk, or rubber, which may or may not be made up into a particular kind of clothing. The material fetishes have been divided into two types: "hard" and "soft." Hard fetish items (made of materials such as leather and rubber) tend to be smooth, shiny, and black, and are "often tight constricting garments or shoes." Soft fetishes are fluffy, frilly, or fuzzy. Examples include lingerie and fur.[52]

Many objects have been used as fetishes, however, not only clothes: hairbrushes, prostheses (artificial limbs), safety pins, snails and cockroaches (the fetishist may put them on his body while he masturbates, or imagine them crushed under high-heeled shoes), whips, roses, and the handlebars of an Italian racing

Sexual symbolism? Nineteenth-century trade card.

bike. There are also the so-called negative fetishes, which involve the absence of something normally there: Some men are sexually attracted to amputees or cripples. Nevertheless, clothes are particularly important, both because of their close association with the body and because they are artificial objects that can be replaced, hoarded, and handed from one person to another.[53]

The *Diagnostic and Statistical Manual* lists fetishism under "Sexual and Gender Identity Disorders" (formerly "Psychosexual Disorders"), along with exhibitionism, pedophilia, sexual sadism and masochism, transvestism, voyeurism, zoophilia, and atypical paraphilias, such as coprophilia, klismophilia, urophilia, telephone scatalogia, and necrophilia. This framework is understandably unpopular with many enthusiasts, who prefer to regard fetishism as an unorthodox but legitimate sexual variant, perhaps even a more liberated sexuality.

David Kunzle, in *Fashion and Fetishism*, argues that psychiatric interpretations

of fetishism are "useless, if not actually harmful."[54] A critical approach to pathological case histories is certainly warranted, but Kunzle makes no distinction between century-old texts like Krafft-Ebing's *Psychopathia Sexualis* and contemporary medical research into human sexuality. He rejects any attempt to analyze the possible unconscious significance of fetish fashion on the grounds that all psychological accounts of fetishism are necessarily reductionist and repressive because they interpret the phenomenon in "pathological" terms. Apparently in response to such protests, the most recent edition of the *DSM* has changed the diagnostic criteria for fetishism from "act[ing] on these urges" to "caus[ing] clinically significant distress or impairment in social, occupational, or other important activities of functioning."[55]

Kunzle prefers to rely exclusively on the "feelings, experiences, and judgements" of "dedicated fetishists."[56] This type of "field work" is crucially important, yet informants do not always tell the whole truth because as insiders their perspective is inevitably one-sided and may entail a degree of denial. The psychiatrist Joyce McDougall has described

Constriction fetishes may symbolize both container and contents, argue psychoanalysts. Trade card.

a fetishist patient who paid prostitutes to whip him and stamp on his genitals. In one session he reported meeting another client of the same brothel who suggested that they had much in common since he too paid to be whipped on the genitals—but by boys. My patient became highly anxious and said, " . . . but that man's crazy. We have absolutely nothing in common. Why he's a homosexual!"[57]

How do fetishists explain why some people find it sexy to be corseted and whipped or put into rubber panties for "watersports"? "I'm not going to answer that question by constructing a theory about infantile trauma caused by soggy Pampers and mommy's cold hands," writes Pat Califa, a leading figure in America's lesbian SM/fetish community. "Psychoanalytic theories about the origins of sexual preferences never give you testable hypotheses that can be operationally defined and proved or refuted. Instead what you get are moral statements about the inferiority of 'the other,' or a recycled version of your own sexual prejudices. A sociological or anthropological approach is more interesting."[58]

Califa is one of the most articulate exponents of what might be called the fetishist point of view, with both the strengths and the weaknesses of that perspective: the intimate knowledge and the lack of critical distance. As she says of an English acquaintance, she is "good at rationalising sexual deviation." By a "sociological or anthropological approach," she really means, I believe, a purely descriptive approach to fetishism, one that either avoids analyzing what it means or assimilates modern fetishism to ritual practices in other cultures. Her approach is not entirely satisfactory, yet Califa is surely correct in arguing that "the more we know about what people do, the more we can understand how that behavior functions in their lives—what the rewards, stresses and penalties are."[59] As Freud observed, "[Fetishists] are usually quite satisfied with [their fetish], or even praise the way it eases their erotic life."[60]

Is fetishism "normal"?[61] The very term has become problematic, except as a synonym for *normative*. Many sexual practices that were regarded as abnormal in the past (such as oral–genital sex) have become increasingly accepted. Most doctors today do not ask " 'Is this behavior normal?' but rather 'What does this behavior signify for this client? Is it reinforcing or handicapping?' and, of course, 'Is the behavior socially tolerable?' "[62] A study of 100 rubber fetishists indicated that "fetishism may exist as one isolated preference and is no more associated with pathology than a hobby such as stamp collecting."[63] But it is undeniably true

that some violent criminals are severely disturbed sexually.[64] William Heirens, for example, murdered three women by the age of seventeen and had long been obsessed with "the feeling and color" of women's panties.[65]

> Some deviations, such as the tendency to get excited by high-heeled shoes . . . might seem trivial or even laughable. But others, such as the ritual slashing of women in the stomach so as to create a wound reminiscent of the vagina . . . are among the most horrific crimes known to human society. It is impossible to escape the impression that there is some kind of continuum between minor fetishistic and sadomasochistic "kinks" and some of the ghastly serial crimes that culminate from an escalating chain of sexual fantasy and acting out. That is why the understanding of these phenomena is so important to clinical and forensic practitioners. Although many forms of sexual behavior previously regarded as perverted have been legitimised in recent decades, there is bound to be a limit to the process.[66]

Human sexuality is never just a matter of doing what comes naturally; it is always a psychological construction in which fantasy plays an important role. This is why fetishism is so interesting.[67] Precisely *because* it seems so bizarre—why would someone be sexually excited by shoes?—fetishism shows how "the sexual instinct and the sexual object are merely soldered together."[68] The psychoanalyst Joyce McDougall uses the term "the neosexualities" to describe variants like fetishism that involve the creation of a new sexual scenario.[69] She asks: When analysts declare a behavior or fantasy to be *perverse*, "upon what grounds do they make these pronouncements?" "Adaptation to reality" sounds good, but whose definition of reality will be the standard? What hidden value judgments lie behind the criticism of perverse fantasy? We may insist that "the pervert is always someone else!" But at least some of those who "flee imaginative life" (McDougall calls them "normopaths") act in a way that is harmful and dehumanizing. If "the normopath does everything in the missionary position," is that not also perverse?[70]

"It used to be that a pervert was simply a guy who made love to old shoes, say," writes "layman" George Stade, "but no longer, not if you read the people with clinical experience." For "the experts agree . . . that a pervert is not a pervert by virtue of what he does, sexually speaking, . . . but by virtue of the frame of mind in which he does it"—with "fantasies of degradation and revenge," for example, or the "desire . . . to reinstate the primitive mother–child unity." But Stade asks, "Would humans bother with sex at all if you were to take away their fantasies of degration and revenge?" (What would a "normal" fantasy be like?) As

Stade observes, many men "fall in love with stand-ins for their mothers and . . . if they don't want to merge with them, I'm damned if I know what they want to do." It is easier to identify "straights." "They are us." We just need to ignore all the polymorphous perverse behavior we engage in under the name of "fore-play."[71]

But what if "straights" and "perverts" begin to dress alike?

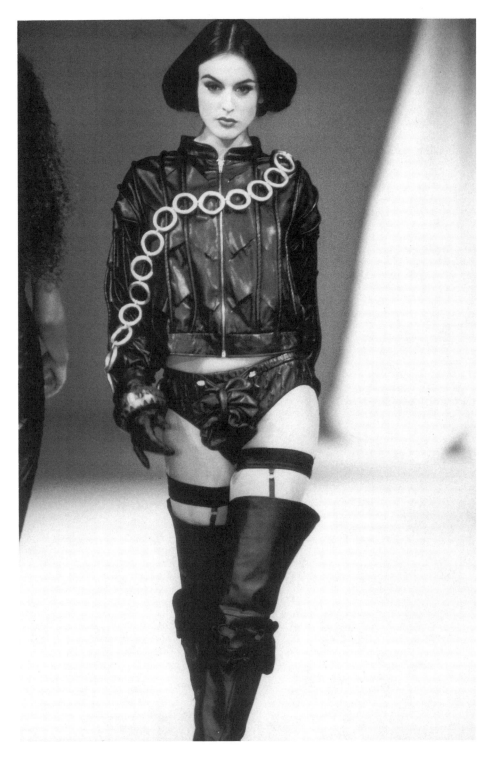

Everything from a fetishist's dream is on the fashion runways. (Vivienne Westwood)

two

Fashion and Fetishism

"Today bondage, leather, rubber, 'second skins,' long, tight skirts, split dresses, zipped *bottines* —everything from a fetishist's dream—is available directly from Alaïa, Gaultier, Montana, Versace."[1] As *Vogue* reported in 1992, many of the world's most important fashion designers were inspired by sexual perversity. A year later, however, some observers dismissed fetish fashions as a passing fad: "Gone are the styles glorifying bondage and S/M."[2] But this was manifestly inaccurate.

For the past *thirty years*, the "playful" use of fetishistic themes has been increasingly assimilated into fashion. Whatever the ebb and flow of seasonal collections, fashion has repeatedly and increasingly emphasized fetishistic styles. Fetishism is especially significant at this time in history because it is no longer associated primarily with individual sexual "perversions" or sexual subcultures. Hitherto secret practices have become increasingly visible throughout popular culture. Prior to about 1965, fetishistic imagery was mostly hidden away in sex magazines like *High Heels*, and fetish fashions were hard to obtain. But then the objects and images associated with fetishism began to come out of the closet.

Kinky Boots and Catsuits

The "sexual liberation" movement of the 1960s and 1970s led to a reassessment of sexual deviations. "Prudery" was increasingly dismissed as an unfortunate historical product of "the Judeo-Christian religious tradition" and the rise of the capitalist bourgeoisie. The "body taboo" was said to be "crumbling under a reaf-

firmation of human sexuality and a denial of sexual guilt."[3] As rebellion and pleasure were increasingly privileged and the restrictions imposed by civilization correspondingly criticized, "perverse" sexuality was openly acknowledged to be seductive.

The first fetish fashion to achieve popular acceptance was the so-called kinky boot, previously associated primarily with prostitutes, especially dominatrixes. "Fashion or Fetish?" asked the editors of *High Heels*.[4] The high-heeled leather boots could be knee-high or thigh-high, and they were often buttoned or laced. A reader of *Bizarre Life* submitted two photographs of English fashion model Jean Shrimpton, along with a note: "I thought your readers might get a thrill out of seeing [these]. The 'Kinky' boots send shivers up my spine whenever I look at them, and I must admit that Jean's long, luxurious hair is thrilling, too."[5]

The television show *The Avengers* was particularly influential in popularizing fetish fashion. Diana Rigg played Emma Peel, a powerful, sexy woman whose leather catsuit was directly inspired by the "couture" fetish costumes created by John Sutcliffe of Atomage. The first version of Mrs. Peel's costume was even more closely modeled on the Atomage prototype, but the television producers thought it was too overtly fetishistic, so the full-face mask and hood were lopped off.

In 1990, there was a revival of interest in Emma Peel's style, concurrent with a fashion for Sixties Retro—especially catsuits. This time around, she was heralded in the fashion press as a feminist heroine and compared with Catwoman, another fierce female. The image of a woman who is both strong and sexy obviously appeals to many women (as well as men). Whatever the style means, it is not just something being foisted on women by male designers.

It is important to emphasize how *common* fetish fashion has been for a very long time. "The 1960s were wonderful years for those of us interested in exotic-erotic wear," recalled one rubber enthusiast.[6] In 1971, fetish-inspired fashions (such as kinky boots, leather, and corset-style lacing) were even being sold at low-budget department stores like Montgomery Ward. Men's clothing also became conspicuously more erotic during this period, when rock and roll provided a new type of male role model. As one anonymous leatherite asserted,

> Permissiveness always brings with it new insights. . . . We have become more blasé. . . . We say that "It's his hangup," or even more casually "He's doing his thing!" . . . No longer is the leather lover looked upon as a "freak." . . . The cavorting rock and roll singer wearing the skin-tight leather suit is the masculine sex symbol to

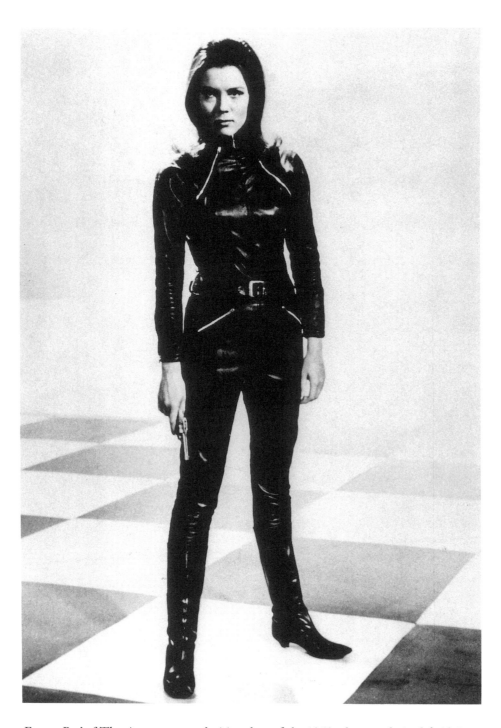

Emma Peel of The Avengers, *a television show of the 1960s that popularized fetish items like the leather catsuit.* (Archive Photos)

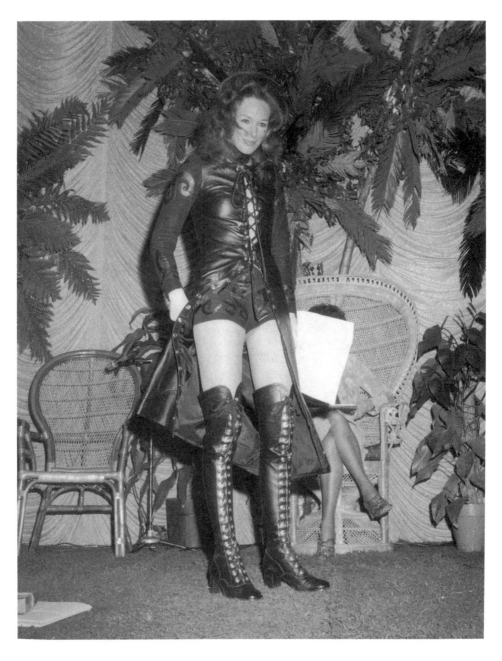

All in leather at a Montgomery Ward fashion show, 1971. (Copyright © UPI/Bettmann Archive)

our nation's youth. . . . There's no doubting that leather represents masculinity and that's what our girls want (regardless of their sex).[7]

Long before Madonna "spearheaded the mass reception of S/M imagery," many performers used fetish clothing.[8]

The punks, a youth subculture associated with bands like the Sex Pistols, were especially instrumental in bringing fetishism into fashion. The punk "style in revolt" was a deliberately "revolting style" that incorporated into fashion various offensive or threatening objects like dog collars and chains that were designed to horrify straight observers:

> Safety pins were . . . worn as gruesome ornaments through the cheek, ear, or lip. "Cheap" trashy fabrics (plastic, lurex, etc.) in vulgar designs (e.g., mock leopard skin) and "nasty" colors, long discarded by the quality end of the fashion industry as obsolete kitsch, were salvaged by the punks and turned into garments . . . which offered self-conscious commentaries on the notions of modernity and taste. . . . *In particular, the illicit iconography of sexual fetishism was . . . exhumed from the boudoir, closet, and the pornographic film and placed on the street.*[9]

Punk women "appropriated this forbidden discourse and redirected or undermined its meanings."[10] They manipulated sexual clichés such as fishnet stockings, stiletto heels, visible brassieres, and rubber mackintoshes. The female singer Siouxsie Sioux wore black underpants in wet-look vinyl, a harness bra, one thigh-high black boot, and one high-heeled shoe with an ankle strap that said "Bondage." Also a Nazi armband.

The fashion designer most closely associated with the punks was Vivienne Westwood. In 1974, she transformed her store into the notorious SM, bondage, and fetish boutique Sex, which sold rubberwear, bondage leather, and bizarre shoes. The store was decorated with whips, chains, masks, "tit clamps," and even a hospital bed covered with a rubber sheet. The clients were about half fetishists (who had expensive rubber suits custom made) and half young people who wanted clothes that were "about breaking taboos" and making "a statement about how BAD you are."[11] "The bondage clothes were ostensibly restrictive," says Westwood, "but when you put them on they gave you a feeling of freedom."[12]

Westwood herself wore "total S&M as fashion" in the very early 1970s. She wore "rubber stockings and negligees with stilettos, and later full bondage at a time when everyone was in flares and platforms." It was a way of challenging

"orthodoxy in dress."[13] Westwood's former partner Malcolm McClaren recently argued that because rubber and leather "symbolize a radical attitude . . . fetish fashion is the embodiment of youthfulness!"[14]

Terrorist Chic

The sinister undercurrent of sex and violence was not limited to subculture styles. Seventies fashion, in general, was characterized by such a strong undertone of perverse eroticism and sadomasochistic violence that one scholar described it grimly as "Terrorist Chic."[15] The "fantasy clothes" of the 1960s had been replaced by a "new brutalism."[16] Even department-store windows featured mannequins that were blindfolded, tied up, and shot, and fashion magazines emphasized perversity and decadence.

"Cabaret freaks and perverse sex find echoes in today's decadence," wrote Barbara Rose in an essay for American *Vogue*. The article was illustrated by Helmut Newton, whose "photographs of beautiful women trapped or constricted accentuate the interface between liberation and bondage. . . . [A]n anonymous hotel room evokes fantasies of potential erotic adventure. . . . Glittering surfaces catch and reflect light in images that couple elegance with pain, fin-de-siècle opulence with contemporary alienation." Yet because there were usually "no visible oppressors" in these sadomasochistic "mini-dramas," Rose suggested that the photographs implied that the "bondage was of woman's own making."[17]

Helmut Newton is said to have "made fetishism chic." Back in the 1970s, fashion stylists who were looking for the right accessories for Newton's photographs had to ransack shops that catered to prostitutes and fetishists. But by the 1990s, high fashion had come around to his view of the modern woman.[18] Although Newton cannot be credited with single-handedly bringing fetishism into fashion, his photographs have been extremely influential because of their focus on the relationship between sex and power. His dramatis personae—sexual personae—included the voyeur, the exhibitionist, the prostitute, the fetishist, the sadomasochist, the transvestite, and the dominatrix.[19]

Consider, for example, one of a series of photographs by Newton published in French *Vogue* in 1977 under the title "Woman or Super-Woman." A woman stands before a mirror, wearing a helmet and riding boots; her legs planted firmly apart, she pulls open a black leather trenchcoat by Claude Montana, a designer

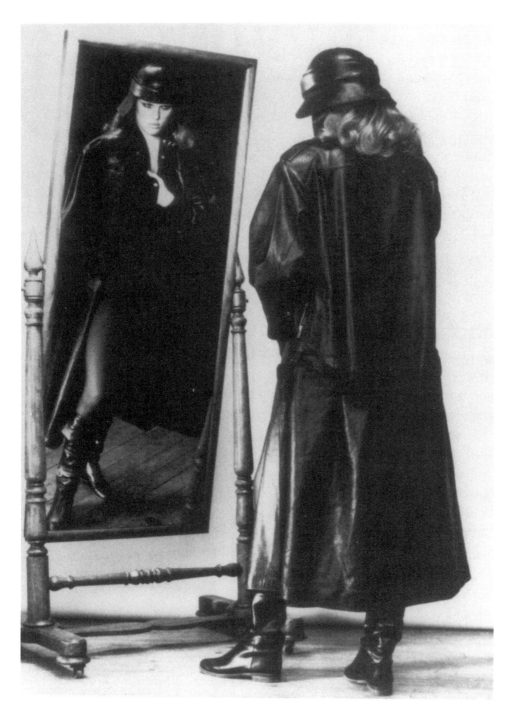

Woman or Superwoman? Leather trenchcoat by Claude Montana photographed by Helmut Newton for [Paris] Vogue, *1977.* (Helmut Newton and [Paris] *Vogue*)

known for his sexy leather. Although the mirror usually functions in art as an icon of female "vanity," here it recalls the mirror-play of the fetishistic masturbator. The horsewoman or amazon may be considered a subcategory of the dominatrix, and, indeed, the photograph on the next page of *Vogue* showed a well-known model wearing swollen jodphurs (by Thierry Mugler) and riding on a man's back. According to the text, garments like the trenchcoat and jodphurs are part of the wardrobe of "femmes conquérantes."

The fetishistic appeal of "hard tack" has long played a role within fetishist and SM pornography, where the idea of woman as rider sometimes merges with its opposite. (In 1994, American *Vogue* reproduced Newton's photograph "Saddle," which depicts a woman on a bed wearing jodphurs and boots—and with a heavy leather saddle on her back, ready to be mounted.) It is one thing, however, for prostitute cards to advertise "Horse Riding Fantasies" and quite another for the "Riding Mistress" of pornographic fantasy to appear in the world's most prestigious fashion magazines.

The 1970s were not a period of calm after the uproar of the 1960s. Although the political radicalism of the student left faded after the end of the Vietnam War, in almost all other respects the cultural radicalism of the 1960s not only did not vanish, but diffused throughout the wider society. In particular, the sexual revolution became a mass phenomenon. Legal restrictions on censorship weakened, and the commercialization and commodification of sex accelerated.

"Dig Black Stockings and Boots?" asked a 1975 article in the popular journal *Sexology*, adding reassuringly, "There's a Bit of Fetishist in Everyone." "Surprise! All the embellishments of sex are more healthy than not—so enjoy them." The author, Roger Madison, admitted that extreme cases might present a problem. "But not that bad a problem." The man with a lust for shoes might wish to be "rehabilitated," but if not, well, he had "a very simple and inexpensive sex life." After all, the fetish wasn't really "hurting anybody." Ultimately, it seemed more important to avoid "the trap of neurotic guilt feelings."[20]

It still mattered what the fetish was, however. According to the author of a paperback that combined pop psychology and soft-core pornography, "If the desire is directed at an old pair of Army boots—to pick an absurd item—we would have to begin therapeutic exorcision of this particular fetish. But the more usually seen attachment to the female high-heeled boot is another matter." After all, the boot is related to the leg and the leg to the vagina, so the fetishist is relating to the female that way! And "men *do* like high heels for the constricting effect they

give to the female walk."[21] In retrospect, we can see the biases in this analysis. The "old pair of Army boots" seemed "absurd" and sick because they implied a homoerotic attachment. The fetishizing of the *female* body and clothes, on the contrary, and even the interest in bondage, seemed normal and healthy.

Shifting from sleazy paperbacks to college textbooks, we find that fetishism was increasingly described as a problem for only "an older generation," since with "increased public body exposure such fetishes may begin to disappear."[22] But as long as fetishes lasted, they were to be tolerated. As medical experts adopted an increasingly permissive tone toward male fetishists, they were correspondingly censorious toward the men's wives. Asked about a man who wanted his wife to be partly clothed during coitus ("Does this obsessive behavior require psychiatric help?"), the columnist for *Medical Aspects of Human Sexuality* responded sharply: "What really requires being examined more fully is the wife's need to make an issue of this request. . . . One would want to know her attitudes toward sex." Marital counseling was suggested, "if they continue to experience this situation as a problem."[23] The book *Sex and the Liberated Man* encouraged spouses to "give in, at least to some extent."[24]

> This doesn't mean if your partner insists on going to bed with you and a boa constrictor, you have to agree! Fetishes and fetishistic acts vary widely, and you may find some of them rather disagreeable . . . however, you can try to discover whether your mate has some innocuous fetishes that you can go along with. If you do, you will probably find her most grateful. By the same token, if you can get her to agree to let you indulge yourself in some of your own harmless fetishes, you will feel closer to her—and you probably will feel considerably more stimulated than you otherwise would. Particularly if either of you has certain sex problems . . . the use of fetishistic enjoyments may prove desirable for the achievement of maximum adequacy.[25]

(Notice how the gender of the fetishist spouse keeps shifting.)

By the late 1970s and the 1980s, however, there was something of a reversal in both popular and psychiatric attitudes. Sexual liberation was not all happy and healthy. One could criticize the "Victorian" attitude toward masturbation and still reject the man who masturbated to pictures of women's bound and mutilated bodies. Robert Stoller's book *Perversion* was particularly influential among psychiatrists. The women's movement also called attention to the ways in which male sexual behavior exploited or dehumanized women. The reassessment of fetishism, like the new critique of pornography and "sexist" imagery in general, would eventually lead to serious disagreements between pro-censorship feminists and sex radicals.

More S Than M

Fashion, especially fashion photography, has played an important part in the so-called sex wars or the sex/porn debates, which began in the 1970s and continue to rage today. The orthodox feminist view emphasized the aggressive aspects of the "male gaze" and the way fashion objectified women. The most overtly erotic fashions and fashion photographs came in for the most criticism. But by the 1980s, some feminist scholars questioned whether fashion imagery could be decoded so simply.[26] Do women necessarily respond to fashion images with a passive narcissism? Might not some viewers (such as lesbians) consume fashion images in a defiant or subversive way? According to Rosetta Brooks, photographers like Helmut Newton used the conventions of the pornographic photograph in such a way as to call into question existing stereotypes, "mak[ing] straightforward accusations of sexism problematic."[27]

"Fashion coverage that shows women as primarily sexual, even masturbatory fantasy figures has had an effect upon how *all* women are viewed—an effect no less powerful because it is insidious; an effect no less dangerous because its medium is fashion," insisted fashion writer Colin McDowell.[28] But the English fashion designer Helen Storey argued that since all clothes carry gender messages, "a Laura Ashley smock which [signifies] the subservient woman locked prettily in her place is far more frightening than black plastic boots."[29]

In 1991 when journalist Sarah Mower asked Storey about the symbolism of her own sexy "bondage" collection, the designer insisted that it was "more liberating than restricting" and that it was about women's "anger." Mower mused, "From the woman's point of view, it seems that the new way of looking at bondage is much more S than M." It was important to remember, Mower added, that "the link between fashion and fetishism has a long history . . . [and] what shocks at first becomes commonplace in time . . . we all know what happened to 'kinky' boots."[30]

Many fetish-inspired fashions have found their way "onto the style pages, into the stores, and onto the streets." In December 1987, for example, British *Elle* published a cover featuring clothes in shiny PVC, Lycra, and rubber. In January 1988, *Elle* showed a black satin corset and leather micro skirt. February's *Elle* teamed a rubber jacket by Ectomorph with a corset-bondage belt, and so on. Of course, "words like 'fetish' tend to be too direct, too threatening, for mass-market purposes—so other terms have to be found . . . like 'body conscious,' 'slick chic,' or just plain 'sexy.' "[31] Today, as in the 1980s, "kinky" fashion is frequently interpreted simply as "sexy" fashion.

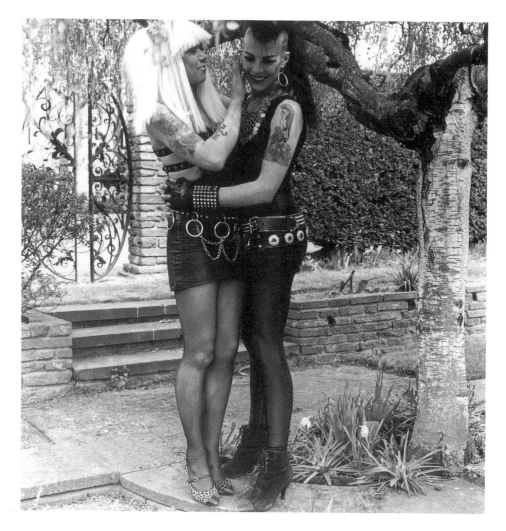

Punk girls, 1987. (Copyright © Grace Lau)

Because fetish fashion often resembles dominatrix gear, it can also be read as a subcategory of "power dressing," which was the major fashion trend of the 1980s. "Helmut Newton's photographs from the 70s and 80s are a strong influence," said designer Liza Bruce in 1994. "The idea of the woman being very strong."[32]

The image of the "bad girl" also appeals to many women. The American designer Betsey Johnson did a fashion show in the 1980s at the Mudd Club, featuring bad girls behind bars. More recently, the feminist organizers of an art exhibi-

tion used the title "Bad Girls" (rather than, say, "Angry Women") to characterize the artists being shown. Many women wear clothing with fetishistic associations. Whether they do this to please men or because they themselves find erotic gratification in items like high-heeled shoes and lingerie may be left as an open question for the moment.

It is likely, however, that the sex-and-power "bad girl" image is part of the appeal of fetish fashion for women. This brings us back to the issue of female fetishists. Some feminists seem almost to feel that there is a stigma associated with the rarity of female "perverts," who take on the heroic proportions of valorized "bad girls," compared with mousy and repressed neurotics. Under the circumstances, their avid search for female fetishists begins to look like a strange form of "perversion-theft" or, as Naomi Schor wonders, perhaps even "the latest and most subtle form of penis envy."[33]

Because Freud interpreted fetishism in terms of phallic symbolism, he is often accused of "phallocentrism."[34] For many feminist theorists, the fetish is interpreted as "a symptom both of capitalism and patriarchy, in its double aspect of glorifying objects and objectifying women: a perspective which means, yet again, that the fetishist is always male, while the woman becomes the fetish itself, the perfect object." Other feminists, however, have observed that this analysis "can end up leaving women's desire out of the picture." Therefore, the newer theory states that

> while emerging within the framework of a phallic order, the fetish disrupts that order by fixing sexuality away from its "proper" . . . focus of attraction—that is, the genitals of the opposite sex—and ultimately away from the gendered body altogether. It moves sexuality towards a preoccupation with the fragment, the inanimate, . . . and since the fetish is an object out of place, its power erupts outside a hierarchy of "normality." . . . Fetishism is classified as a perversion in that it pushes to the limits and disrupts a phallocentric, or penis-focused, sexual order.[35]

This type of feminist critique is frustrating because of the way it combines trenchant analysis with ideological postering. Yes, women *are* frequently objectified, treated as "tits and ass." And yes, it *is* inadequate to regard women solely as victimized objects, since they are also sexually desiring subjects. But it is naive to imagine that sexuality could be moved "away from the gendered body altogether." Are we hermaphrodites? Nor is it apparent that women's lives would be improved by moving sexuality "towards . . . the fragment, the inanimate." The concept of disrupting the "phallocentric . . . sexual order" is much beloved by certain aca-

"Bad girls" from Betsey Johnson fashion show at the Mudd Club. (Roxanne Lowit)

demics, but the fact remains that fetishists themselves tend to be intensely "penis-focused."

Although fewer women than men are sexually aroused to the point of orgasm by clothing items, some are. Juliet Hopkins published a case study of foot and shoe fetishism in a six-year-old girl. Yet, as Hopkins herself admits, "the girl was psychotic and believed herself to be a boy."[36] In a recent and important book, *Female Fetishism*, Lorraine Gamman and Merja Makinen cite a number of cases of female fetishists, including a seventeen-year-old mackintosh fetishist and a white-stocking fetishist who was also a bulimic. The authors also make the provocative (but not entirely convincing) argument that eating disorders like bulimia could be considered a type of food fetishism.[37]

The psychiatrist Robert Stoller has reported on several fetishistic transvestites who are female. One woman said that "simply putting on men's clothing" could "provoke an orgasm," which gave her "far greater pleasure" than intercourse. In early adolescence she experienced her first orgasm while wearing her brother's suit, "and when I looked at myself in the mirror, I found that I resembled my father enormously."[38] Another women said that she had been "sexually excited" by wearing Levis ever since she was about eleven years old: "When I put on a pair of blue denim Levis—and not any other male clothing has this effect—I feel much more than just masculine. The excitement begins immediately—as I begin to pull them . . . up, towards my thighs." The orgasmic feeling was accentuated when she wore boots.[39]

Women often wear men's clothes, of course, but usually for practical, political, or fashionable reasons, *not* because they obtain direct erotic satisfaction from the clothes. (Among women, transsexuals are more common than transvestites.) The argument that men are unfairly stigmatized as "perverts" while women are socially permitted to cross-dress misses the point. It is not behavior that is significant, but the meaning that the behavior indicates. A woman in a low-cut dress may be exhibitionistic, but she is not an exhibitionist in the same way that a flasher is—because her feelings and motivations are different.

Trickle-Down Perversion

Fetishism is not the same as clothing eroticism. Consider the seventeenth-century poet Robert Herrick, whom the fashion historian James Laver described as the "first fetishist." In one poem, Herrick writes:

Whenas in silks my Julia goes
Then, then, methinks, how sweetly flows
The liquifaction of her clothes.

But it was not the silks per se that attracted Herrick; rather, he refers to them in order to allude to Julia's silky soft body and to the creamy ecstasy of sexual orgasm. Similarly, when he writes, "A sweet disorder in the dress / kindles in clothes a wantonness," the lover's disordered clothes imply a state of erotic dishabille, of undress as a prelude to love-making. It was not the "tempestuous petticoat" that he wished to embrace, but Julia herself. Herrick may have fetishized, but he was not a fetishist; he was merely susceptible to some of the many other erotic aspects of fashion—its tactile sensuality, for example, its role in amorous foreplay, and its ambiguous status with regard to the body that it simultaneously conceals and displays—all of which may appeal to women as well as men. There were a few "real" fetishists in the eighteenth century, but they seem to have been much more common after 1850.

The historical interpretation of nineteenth-century sexuality has undergone dramatic changes in the past twenty years. Back in 1966, when Steven Marcus published *The Other Victorians*, most scholars accepted his picture of Victorian sexual life as hypocritical prudishness overlaying pornography and perversion. But gradually, scholars began to wonder whether this interpretation did not rely too unquestioningly on the axe-grinding of twentieth-century sexual reformers—and on our own prejudices. The British historian Michael Mason has unearthed a wealth of evidence to indicate that sexual hypocrisy among the Victorians was rare and that many Victorian women had orgasms and practiced birth control. There was also a self-consciously hedonistic subculture, "living by the creed that 'fucking is the great humanizer.' "[40]

Approaching the subject from a very different perspective, Michel Foucault also questioned the "repressive hypothesis," suggesting that nineteenth-century society may actually have placed a new emphasis on sexuality, creating a "veritable discursive explosion" of attention to sex.[41] Far from sex being an unspeakable topic in the nineteenth century, it was talked about (in modern jargon, "problematized") as never before. Nor were people simply talking about sex.

The French historian Alain Corbin has, in fact, uncovered evidence that attitudes toward sexuality evolved considerably between 1850 and the First World War—particularly with respect to the growth of demands for "elaborate eroticism." He goes so far as to compare the sexual culture of the later nineteenth

century with that of the 1970s: "[J]ust as the 1970s saw the proliferation through-out society of erotic images, . . . magazines, and gadgets, so the final decades of the nineteenth century, despite all the efforts of legislation . . . saw the spread . . . of tastes, fantasies, and techniques that had formerly been the pre-serve of aristocratic eroticism."[42]

Perversions, he argues, began to "trickle down" through bourgeois and even working-class society. No longer satisfied with the quick satisfaction of genital needs, the clients at brothels began to demand hitherto exotic practices like fella-tio, which not long before had been regarded with such abhorrence that any prostitute practicing oral sex was shunned by the other brothel inmates and made to "eat by herself." But by the end of the century, brothels hired specialists to teach the fine points of oral sex.

Prostitutes increasingly adopted specialized fantasy costumes: Brides and nuns were especially popular, as were schoolgirls and maids. Other sex workers wore

Cross-dressing courtesan by Numa, Paris, ca. 1850.

luxurious and fashionable negligees. Nudity was also popular, and prostitutes engaged in lesbian tableaux, displayed against a "black velvet carpet or in rooms hung with black satin to bring out the whiteness of their bodies."[43] (Richard von Krafft-Ebing also reported that some "men at brothels demand that the women . . . put on certain costumes, such as that of a ballet dancer or nun, etc.; and . . . these homes are furnished with a complete wardrobe for such purposes."[44]) Sadomasochistic scenarios, group sex, and voyeurism became features in many brothels, writes Corbin. All such practices made of sexuality a theatrical production and a visual spectacle—which would be conducive to the rise of specialized sexual fetishes that rely heavily on visual stimuli and role-playing.

Why this sexual revolution happened when it did was the result of a multiplicity of social and cultural factors. Corbin cites an increase in wealth extending farther down the social ladder, which led to changed patterns of consumption—of "illicit" sex, as well as the more documented cases of food (the spread of gastronomy) and clothing (the democratization of fashion). Progress in feminism (and particularly the minority discourse on women's sexual emancipation) also played a role in the increasing visibility of sexuality in the last quarter of the nineteenth century. The spread of *scientia sexualis* and the dissemination to adults of this new information about sexuality were particularly important.[45]

Was sex research descriptive behavioral science? Or did psychiatry function repressively to stigmatize "perverse" sexuality? Early sexologists like Krafft-Ebing have been criticized for regarding people with unusual sexual interests as a bunch of "blood drinking, shit eating, corpse mutilating perverts."[46] Certainly, Krafft-Ebing frequently focused on the "criminal" and "pathological" aspects of fetishism. A methodological bias may be at work: Since few fetishists voluntarily came in for treatment, many of those who entered psychiatric history had been arrested, usually for the theft of fetish objects, sometimes also for assault or what we would call sexual molestation: slashing women's silk dresses or cutting their hair, for example. Havelock Ellis, who interviewed acquaintances, took a more romantic or sex-positive approach, arguing that "erotic fetishism" had "normal foundations" and expressed the human ability to construct symbols and read "meaning" into objects.[47] But whatever their biases, the sexologists provided information about a wide range of sexual variations.

The Beat poet Allen Ginsberg told the *New York Times* that Krafft-Ebing's was the first "forbidden book" he had ever read and that he "discovered with joy case histories like mine."[48] It seems, then, that fetishism emerged as part of the nineteenth-century sexual "revolution." It was not an entirely new phenomenon

(the "perversions" of eighteenth-century aristocrats were "trickling down"), but it was also not one that merely received a pathologizing label at this time. The "labeling" process associated with the development of modern sexual psychology marked an important, if ambivalent, stage in the fetishists' growing awareness of themselves.

The Sex Appeal of the Commodity

"Fashion prescribed the ritual by which the fetish commodity wishes to be worshipped," declared the Marxist literary theorist Walter Benjamin. The use of words like *ritual* and *worship* brings us back to the anthropological discourse on fetishism. But Benjamin also employed an erotic trope, when he associated fetishism with "the sex-appeal of the commodity."[49] As we have seen, Freudians argue that erotic fetishists "worship" the power that they irrationally attribute to particular objects, such as shoes, while Marxists emphasize how alienated workers have a "superstitious" adoration of "idols" that they themselves constructed. Economists have also used a metaphor from the family romance: Fashion is "capitalism's favorite child."[50]

Contemporary intellectuals who write about fetishism tend to utilize both psychoanalytic and Marxist interpretations, albeit selectively, avoiding any reference to the recent clinical literature and juxtaposing, say, a Lacanian analysis of phallic signifiers with a neo-Marxist reading of commodity fetishism. The self-proclaimed fetishist Pat Califa is dismissive of academic leftist theories, praising instead the capitalist entrepreneurs who have braved a puritanical society to supply fetish fashions and equipment to eager "perv" consumers (although she does criticize outsiders who profit from the "kinky" community without pumping capital back into it). The subject of the production, sale, and cultural significance of fetishist commodities is too large to address adequately, but a few words may be appropriate.

The idea of commodity fetishism has been considerably elaborated since the publication of Marx's *Capital*. While Marx focused on the production of commodities, others such as the sociologist Thorstein Veblen emphasized the "conspicuous consumption" of commodities such as clothing that conferred prestige on their owners. The Hungarian Marxist intellectual Georg Lukás carried the analysis of commodity fetishism a step further through the concept of "reification," which described how capitalism turns both things and people into abstractions.

More recently, cultural critics such as Judith Williamson, author of *Decoding Advertisements*, have used semiotics to explore how advertising fetishizes commodities through the use of language and imagery: A diamond is made to symbolize love, for example. Jean Baudrillard's writing on commodity fetishism has further stressed the autonomy of the sign, undermining the traditional Marxist interpretation.[51]

Meanwhile, a number of feminists have analyzed the "fetishized" images of women that are so ubiquitous in capitalist society. Certainly, "codes of the sexual erotic have been commodified in the twentieth century, and . . . this 'consumer fetishism of the erotic' has permeated representation." Yet as Lorraine Gamman and Merja Makinen argue in *Female Fetishism*, feminist critics may be mistaken in reading this as "sexual fetishism" that inevitably positions women as objects and victims. As they point out, "images are often ironic and may be read differently," depending on many variables, including the (constantly changing) cultural context.[52] They use the same example that I do: Emma Peel from the television series *The Avengers*, whom many women have perceived as both sexy and powerful. Let us leave images, however, and return to tangible commodities.

Prior to the commercial production of fetishist garments and paraphernalia, individuals made their own fetish objects, just as they made their own pornography. By the turn of the century, some people had gone into the business of producing and selling fetish objects, especially those like corsets and shoes, which are difficult to make at home. The famous "Bottier" of London is still remembered fondly by enthusiasts. By the 1940s and 1950s, Maniatis of Paris and Cover Girl of London were also producing fetish shoes with exaggerated heels and platforms. Through the 1970s, however, many fetish shoes were anonymously produced. They bore no labels and may have been specially ordered by individual clients from ordinary (but tolerant) shoemakers.

The producers and distributors of fetish garments and paraphernalia have sometimes faced legal sanctions, just as pornographers have. (Several English companies that made rubber and/or leather clothes were prosecuted in the 1960s.) In some respects, the situation was easier in the early twentieth century, when the authorities apparently saw nothing "sexual" in fetishist material, since it focused on objects and rituals, rather than nudity and genital intercourse.

From 1923 to 1940, *London Life* (probably the most important fetishistic periodical of the twentieth century) published an extensive and notorious correspondence on corsets and high-heeled shoes (for both men and women), body-piercing, cross-dressing, corporal punishment, and related topics. This was at a

The sex appeal of the commodity. Erotica catalogue illustrated by Carlos, ca. 1930–1940. (Kinsey Institute)

time when the publication of "scientific" literature on sex (such as the work of Havelock Ellis) was officially banned in Great Britain. *London Life* printed advertisements for shoes ("7-inch heels") and corsets ("tightlacing our specialty"). Laurence Lenton of 27a, Crookham Road, London advertised: "Gentlemen's Corsets Made to Specification."[53] The commercialization of fetishistic sexuality may have popularized neosexualities, but it did not create them. Birth-control devices, aphrodisiacs, abortions, and risqué French postcards also existed prior to being advertised in *London Life*. Clothing manufacturers seem, in fact, to have been surprisingly slow to respond to the desires of fetishists, who often complained that they found it hard to obtain the garments they wanted.

Some of the corsetiers, shoemakers, and rubberites who catered to the fetishist market may have been enthusiasts themselves. Madame Kayne, for example, is said to have been a tight-lacer. (She argued that the fashionable waist in the later

Kidskin corset by Laurence Lenton, as seen in London Life. (Peter Farrer Collection)

nineteenth century measured 14 to 18 inches, "and many young ladies boasted even smaller than that.") In the 1930s, she specialized in "old fashioned slender waisted stays" for "gents" as well as for ladies. "All corsets are well-boned," her advertisements promised. She also sold "silk or satin undies" as well as rubber knickers, pyjamas, and even rubber breasts.[54]

"Admirers of the Tiny Waist, the High Heel, the Ear-Ring, and any number of other imaterial [*sic*] objects, are fetishists—and each and every one belongs to a high intellectual order," declared Cosmopolite in a 1911 article entitled "The Fascination of the Fetish."[55] The corseted waist, the high heel, and the practice of body-piercing were (and remain) three of the most popular fetishes. These enthusiasms did *not* usually reflect the fashions of the period—certainly not the men's fashions. But enthusiasts were apparently able to acquire the clothing they wanted.

After the Second World War, a climate of conservatism seems increasingly to have forced individual fetishists "underground." Yet the mainstream fashions of the 1950s contain a number of fetishistic elements. In particular, Christian Dior's New Look of 1947 brought modified corsetry back into fashion. In addition to foundation garments, such as the "waspy" and "merry widow," fashions such as the stiletto heel, the petticoat, and the pointed brassiere also flourished. Indeed, later generations of fetishists tend to look back on the 1950s as a sort of "silver age" of fetishism, inferior only to the golden age of the Victorians.

But "the feminine mystique" (not an upsurge in fetishism) was responsible for the new ultra-feminine fashions. Also relevant were structural changes within the fashion system (especially the development of fashion for the masses) and political events such as the Cold War, which contributed to widespread nostalgia for the past, including traditional gender roles and symbols. Psychiatric interest in fetishism reached a new peak in the 1950s, but no conceptual progress was made. The homophobia characteristic of the era infected the psychiatric interpretation of fetishism, and behavior modification was often recommended.

Meanwhile, no matter how dramatically fashion changed—from the androgynous styles of the 1920s to the sex-role stereotyping of the 1950s—enthusiasts remained loyal to classic clothing fetishes. The Biz-zarre Club circulated a mimeographed correspondence column in the 1950s that recalled the pre-war *London Life*. One man wrote, "I love tight corsets [and] ultra high heels . . . and my face heavily made up." Another correspondent liked "beautiful lingerie especially of the period 1900-1920"; he was also "very interested in tight-lacing."[56]

The situation was very different in the 1980s, when English journalists an-

nounced that "it was cool to be kinky—fetishism was back in fashion." Even during the 1970s, hard-core enthusiasts of "restrictive" and "protective" clothing had hesitated to appear in public wearing the fetish garb they bought from firms such as Sealwear (specialists in rubber) and John Sutcliffe of Atomage (creator of custom-made leather). This changed in 1983, when fetish fashion clubs opened and were patronized by a mixture of older enthusiasts and trendy young people.[57]

Contemporary street style is made up of various "style tribes." In the 1980s, new tribes proliferated: "The Goths continued the Punks' interest in fetishism and translated it into a more dressy, extravagant style," recalls Ted Polhemus. Then came the Pervs, who had a pronounced influence both on later style tribes (like the CyberPunks) and on fashion in general. The Pervs were usually not "real" fetishists, although they dressed in fetish materials like rubber and adopted items like the corset and bizarre shoes. They comprised a contingent of pop musicians, alternative fashion designers (like Pam Hogg and Krystina Kitsis), and trend-setting club kids.[58] Today, the "fetish scene" or "pervy world" is an international phenomenon. Consumers have access to garments designed and manufactured by a wide variety of companies, such as Axford (corsets), Ectomorph (rubber and wet-look), and Ritual (stilettos). There are fetish stores in Australia, Denmark, France, Germany, Holland, Japan, Switzerland, and throughout the United States. (Seattle is a center of SM, for example, as Atlanta is for cross-dressing.)

Capitalism has certainly played a part in the rise of fetish-inspired fashions, both because fashion itself developed concurrently with the rise of capitalism and because the fashion industry has recently stolen a great many items from the fetishist's wardrobe. But this is part of a more general process whereby subculture styles are assimilated into mainstream fashion, after having been pioneered by small producers catering to "kinky people." Once fetish fashions achieve a certain "style factor" among trendsetters, they are picked up by internationally famous fashion designers whose work is then "knocked off" by mass-market clothing manufacturers.

"Fashion is the comparative of which fetishism is the superlative," suggested the clothing historian James Laver.[59] Like many of his "Great Thoughts," this is an oversimplification that contains a grain of truth. Fetish shoes with 7-inch heels are certainly an exaggeration of ordinary high heels, but that is not all they are. Even when fashion designers more or less consciously reproduce the look of fetishism, the resulting clothes have a different meaning depending on the context and players.

Black leather fetish corset, as seen in Skin Two. (Trevor Watson)

three

The Corset

A s Michel Foucault reminds us, the body has been subject to various kinds of "disciplinary power." The relations of power "invest it, mark it, train it, torture it, force it . . . to emit signs."[1] Many feminist scholars have argued that the female body, especially, has been the site of disciplinary regimes, such as dieting and feminine dress, that are designed to make women docile and "feminine." In this context, the corset, in particular, has been interpreted as an instrument of physical oppression and sexual commodification. But the corset has also been praised for its erotic appeal, and the art historian David Kunzle has even argued that far from being oppressed by their corsets, nineteenth-century tight-lacers were sexually liberated female fetishists who found physical pleasure in the embrace of the corset.[2]

"Bound for pleasure?" asked the *New York Times*. "The debate on whether corsets embrace or imprison may stir again as newfangled corsets, seen at the recent resort collections, are appearing on the streets."[3] "Take a deep breath," warned *Vogue*.[4] The reappearance of the fashionable corset (as both underwear and outerwear) reveals how the meaning of clothing is constantly redefined. In this chapter, we will look at corsetry, past and present, as fashion, fetish, and fantasy. If I may interject a personal note: Some members of the London Life League, an organization of corset enthusiasts, believe that I am "anti-corset," in part because I have interrogated the corset literature. I also use the word *fetishism*, which, according to the league, causes "many innocent people [to] risk being branded with a wholly undeserved stigma."[5] Conversely, some academics believe that I am "pro-corset" (virtually an apologist for corset torture) because I have pointed out that corsetry has erotic associations and that its dangers have been

much exaggerated. I would like to stress, however, that I am neither for nor against any particular item of clothing—and I am cognizant of the fact that sartorial enthusiasm can have a variety of meanings.

The Votaries of Tight-Lacing

The corset, like the shoe, was one of the first items of clothing to be treated as a fetish, and it remains one of the most important fetish fashions.[6] But it is crucial to distinguish between ordinary *fashionable* corsetry, as practiced by most nineteenth-century women, and the very different minority practice of *fetishistic* tight-lacing, which sometimes overlaps with sadomasochism and transvestism. Although most Victorian women wore corsets, they were not usually tight-lacers with 16-inch waists any more than most women today wear fetish shoes with 7-inch heels.

The journalist Susan Faludi confuses fashion and fetishism when she writes: "Victorian apparel merchants were the first to mass-market . . . lingerie, turning corsets into a 'tight-lacing' fetish."[7] But there was never mass-market corset fetishism. Only a handful of corset manufacturers catered to the fetishist market, producing unusually small corsets for women—*and men.*

The corset has aroused more controversy than any other item of clothing. There are two basic reasons: one medical, the other textual—and sexual. It is beyond the scope of this book to analyze the medical literature on corsetry, but a medical doctor, Lynn Kutsche, and I have found that most claims of corset-induced disease are either completely invalid or greatly exaggerated. There is also no evidence for the popular idea that Victorian women had their ribs removed. The use of textual sources has also been extremely naive. Faludi, for example, writes:

> In every backlash, the fashion industry has produced punitively restrictive clothing and the fashion press has demanded that women wear them. "If you want a girl to grow up gentle and womanly in her ways and feelings, lace her tight," advised one of the many male testimonials to the corset in the late Victorian press.[8]

The notorious advice to "lace her tight" has often been quoted as "proof" that Victorian girls and women were forced to undergo painful, "rib-crushing" tight-lacing as part of a deliberate policy of female oppression. Yet this quotation

comes from one of the most suspect sources imaginable: the infamous "corset correspondence" published in the *Englishwoman's Domestic Magazine*.

Between 1867 and 1874, *EDM* printed hundreds of letters on corsetry and tight-lacing, often with a pronounced sadomasochistic tone. There were also related letters on topics such as whipping girls and spurs for lady riders. Many historians have uncritically accepted the bizarre accounts of tight-lacing in *EDM* as being evidence of widespread corset torture during the Victorian era. Faludi, however, apparently did not actually even read the *EDM* correspondence. Instead, her main source for information on corsetry was my book *Fashion and Eroticism*, from which she selectively drew the quotation from MORALIST's letter.[9] I was therefore annoyed, although not particularly surprised, to see how she either misunderstood or willfully misinterpreted the evidence I presented.

To characterize MORALIST's letter as among "the many male testimonials to the corset in the late Victorian press" is extremely misleading, since tight-lacing was almost universally anathematized in the nineteenth century. The *EDM* letters and their successors are highly unusual in defending the practice. Presented out of context, the letter apparently links corsetry with women's oppression. But if the letter is read in conjunction with others of the same genre, MORALIST's enthusiasm takes on a very different significance.[10]

Certainly, the *EDM* correspondents had priorities very different from those of the average Victorian woman. Their preoccupations fall into three categories: (1) extreme body modification, which involved wearing tight corsets day and night; (2) a sadomasochistic delight in pain and an emphasis on erotic scenarios involving dominance and submission; and (3) corsetry as an element in cross-dressing. Fakir Musafar, also known as "the Ol' Corsetier," is probably the most famous corset enthusiast alive today. He says that he learned about tight-lacing in part by reading sources like *EDM*, which "had a pretty fetish-y concept going."[11]

The self-proclaimed "votaries of tight-lacing" described undergoing tight-lacing to extreme tenuity. Other "fetishist" periodicals also claimed that young women were having their waists reduced by as much as 10 inches. Nelly G., age fifteen, was allegedly reducing her waist from 20 to 16 inches by wearing a tight corset day and night.[12] Even more extreme was "Bertha G., Waist 11 Inches, Age 15," who was sanctimoniously described as "A Child Martyr."[13] If you mention these figures to modern audiences, they gasp with horror. Already conditioned to believe in Scarlett O'Hara's (fictional) 16-inch waist, they seldom question even the most extreme claims. Yet the tight-lacing letters are not necessarily true.

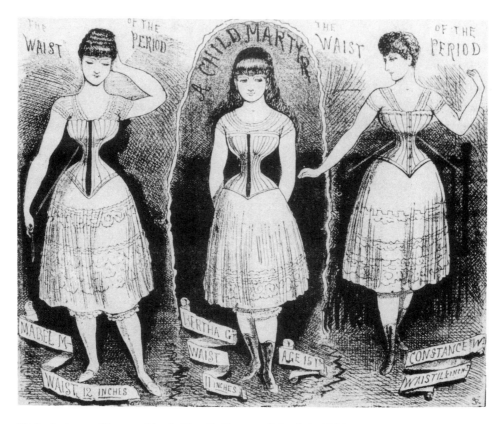

Tight-lacing, as illustrated in the Family Doctor, *March 3, 1888.* (Peter Farrer Collection)

When I brought the male tight-lacer Pearl to the Costume Institute of the Metropolitan Museum of Art, he was disappointed to find that few of the corsets we saw were as small as his own 19-inch stays.[14]

Corsets were usually advertised as 18 to 30 inches. Larger corsets of 31 to 36 inches were also widely available, and some advertisements mention sizes of 37 inches and above. Of the hundreds of corset advertisements I have examined, fewer than half a dozen mention corsets of less than 18 inches. One advertisement for "very small-waisted corsets" gives figures of 15 to 26 inches, and may have been targeted at a tight-lacing clientele. The tiny waists mentioned in sources like *EDM* were not at all typical of Victorian women. Yet so notorious is the correspondence that an exhibition on Victorian fashion at the Costume Institute of the Metropolitan Museum of Art captioned a display of corsets with a quotation from the *EDM* letters!

Given the extremes of human behavior, I cannot say that there was never any such thing as a 16-inch waist. Indeed, I know from contemporary evidence that waists smaller than that can and do exist—as we will see. But the historical evidence shows that in the past, as today, such waists were rare. It is, therefore, time to discard the myth of the 16-inch waist as a touchstone for thinking about the nineteenth-century woman.

In 1994, the magazine *Verbal Abuse* published an interview with Pearl conducted by the dominatrix Mistress Angel Stern, who saw "corsetry as a fetish for number and for measurement." Pearl replied that "the waist-size magic-number is eighteen. Any number below eighteen becomes extremely potent—yes I would say magical."[15]

Pearl's idol, Fakir Musafar, a key figure in the world of body modification,[16]

Pearl in a black corset, 1994.
(Travis Hutchison)

Fakir Musafar as The Perfect Gentleman. (Fakir Musafar and *Body Play*)

has identified "three basic types of people" who wear corsets today. First, there are what he calls the "corset nonconformists," who want to "change the shape of the body . . . and realize some kind of aesthetic ideal." (This is, presumably, the category in which he would place himself.) Second, there are the "corset identificationists," who associate corsets with "femininity and feminine undergarments." They are not necessarily particularly interested in "sculpting the body" (i.e., tight-lacing), "but by wearing the corset they seemed to have a kind of gender transformation." (He does not say so specifically, but many transvestites fall into this category.) Third are the "corset masochists," who tight-lace "to create erotic discomfort."[17] Considerable overlap exists among these categories, and some people do not fit neatly into any one category. There are also, of course, the followers of fashion—fewer today than in the nineteenth century, but not to be discounted.

Discipline and Punish

"One might imagine that in the world of SM roleplay, the corset wearer is always the submissive, the slave," writes Stephanie Jones. But this is not true; the symbolism of the corset is more complex. Some sadomasochists believe that leather corsets are only for dominants and rubber corsets are only for submissives, but others insist that corsets have no such "predetermined sexual 'colour.'" The meaning of the corset is contexual and constructed: "The dominatrix wears her corset as armour, its extreme and rigid curvature the ultimate sexual taunt at the slave who may look but not touch. . . . The slave, on the other hand, is corsetted as punishment."[18] The corseted dominatrix looks and feels "inpenetrable." By contrast, the corset for the slave both signifies and enforces a sense of "discipline" and "bondage." Because of this, the corset is often used in "the transformation of male into she-male." It simultaneously gratifies his wish to look like a woman, while punishing him and thus assuaging his sense of guilt.[19]

The erotic appeal of the corset may be related to "the mystery of woman," suggests sex worker Alexis DeVille. "All I know is if I wear a corset in a scene, it gets better results with a slave than if I'm not wearing it."[20] For "masochists," though, "even a moderately laced corset has a marvellously negative effect on the mobility, balance, and physical stability of its wearer." An article by Fakir Musafar on safe corseting techniques for sadomasochists emphasizes, however, that "a corset is a piece of equipment, with safety and quality requirements, just like many

other pieces of SM equipment. . . . There are a few cautions to observe when doing SM scenes with tight corsets."[21]

Neither the word *slave* nor *sadomasochist* occurs in the nineteenth-century fetish literature, but many of the *EDM* letters contain references to "discipline," "confinement," "compulsion," "suffering," "pain," "torture," "agony," "submission," and "the victim." A small waist size alone was not enough for some correspondents, who argued that "half the charm of a small waist comes, not in spite of, but on account of its being tight-laced"—"the tighter the better." "Well-applied restraint is in itself attractive."[22] (This was *extremely* unusual within the wider

"S. M. with about a 15-inch waist." (Peter Farrer Collection)

Victorian culture, where the "naturally" small waist was greatly preferred to its corseted facsimile.)

Some votaries, like ALFRED, sadistically imagined female victims:

> There is something to me extraordinarily fascinating in the thought that a young girl has for many years been subjected to the strictest discipline of the corset. If she has suffered, as I have no doubt she has, great pain . . . from their extreme pressure, it must be quite made up to her by the admiration her figure excites.[23]

But it was also common for correspondents to imagine men and boys who were forced to tight-lace at the hands of dominant women. Others were inspired to torture and victimize themselves. One man wrote to *Modern Society* in 1909, "I was persuaded . . . to get a pair of corsets by a 'Tortured Victim' with a waist of seventeen inches."[24]

Krafft-Ebing described one man who enjoyed the "pain of tight-lacing, experienced by himself or induced in women."[25] Wilhelm Stekel, another major sexologist writing in the early twentieth century, described several such cases, including a "respectable" married man who tight-laced, cross-dressed, and wore women's high-heeled shoes that were so tight he limped: "It actually appeared as if physical pain were an integral part of his bliss and he gloated in it as long as it were caused by some feminine article of apparel." He had also

> collected all the literature that had been written for and against [tight-lacing]. He often tried to lace himself so tightly that he would faint but in this he was unsuccessful. He even succeeded in persuading his wife to lace herself closely and tied her corset tighter every day himself until her waistline had been reduced about six inches. This also gratified him sexually.[26]

A thirty-six-year-old policeman who consulted Stekel also wore corsets and "masturbate[d] before a mirror with the fantasy that he is the woman he saw." The policeman had filled a scrapbook with pictures of corsets clipped from newspapers and overlaid with obscene sketches and marginal notes: "Ha! what a thrill to disrobe such an insanely corseted woman and then rape her (first her corset would split in the struggle)." Stekel referred to this volume as the fetishist's "Bible," and drew attention to the contrast between the man's Christian and celibate life and his "hellish" fantasies.[27]

Pain and compression were frequently juxtaposed in the *EDM* letters with references to the "fascinating," "delightful," "delicious," "superb," "exquisite," and "pleasurable" sensations supposedly afforded by tight-lacing. Pain and pleasure

were not the only issues, however. Dominance and submission were at least as important. Hence the many stories about forced tight-lacing.

The French Mistress

Some of the earliest and most influential corset letters placed the site of tight-lacing at boarding school. NORA, for example, wrote:

> I was placed at the age of fifteen in a fashionable school in London, and there it was the custom for the waists of the pupils to be reduced one inch per month until they were what the lady principal considered small enough. When I left school at seventeen, my waist measured only thirteen inches, it having been formerly twenty-three inches in circumference. Every morning one of the maids used to come to assist us to dress, and a governess superintended to see that our corsets were drawn as tight as possible.[28]

In order to assess the significance of such accounts, it is necessary to look at a number of the letters side by side and analyze the language used.

As I wrote in my first book, the scenarios are often similar: Girls are undisciplined or uncorseted for years, perhaps because their "relatives" are "abroad." But the situation changes suddenly, and they are forced to submit to a cruel corset discipline. A dream-like vagueness of narrative is interrupted at key points by a minutely detailed focus on the specifics of corsetry. As FANNY wrote,

> Up to the age of fifteen, I was . . . suffered to run . . . wild. . . . Family circumstances and change of fortune . . . led my relatives to the conclusion that my education required a continental finish. . . . I was packed off to a highly genteel and fashionable establishment for ladies, situated in the suburbs of Paris . . . [where] I was subjected to the strict and rigid system of lacing.[29]

Sometimes the girls rebel or beg for mercy, but they are forced to submit.[30] The stories became increasingly salacious as the nineteenth century wore on, and should really be considered in conjunction with the related correspondence on corporal punishment. Just as the best methods of tight-lacing are debated at length (are handcuffs or locked corsets useful?), so do correspondents argue whether it is best to strap a girl across the "horse" or chain her to the ceiling, to leave her underwear on or strip her naked. Many of the tight-lacing letters recount scenarios that could easily have been part of a pornographic novel, and any

"*A fashionable young lady being 'drawn-in' . . . by a buxom maid, superintended by her mistress . . .*" *Illustration by Annette Laring from* London Life, *March 30, 1929.* (Shelfmark: Cup 701a5, British Library)

temptation to feel indignant about historical tight-lacing at real schools gives way to the belief that these letters need to be analyzed as sexual fantasies.

One letter described what happened to WASP-WAIST when she rebelled against being laced smaller than 18 inches:

> The French mistress, on hearing this, became very angry, for it was her special business to see that all the girls should have wasp waists. I then received a punishment which thoroughly subdued me, and it most certainly did me a lot of good. The weight of my body was suspended from my wrists, which were fastened above my head, while my feet, which were encased in tight, high-heeled boots, were fastened to a ring in the floor. In this position, only protected by my stays, I received a severe whipping across the back, which gave me intense pain, but left no mark, owing to my being tightly laced. After this castigation I was very humble, but before the French mistress would untie my hands, she reduced the size of my waist to fifteen inches.[31]

The frequent appearance of Mademoiselle, the "French mistress" or French governess, is probably significant. Although it is true that most English girls' schools did teach the French language, the appearance of Frenchwomen in these letters might better be understood as fulfilling an important fantasy role.[32] Some of the cross-dressing letters also described the importance of the "clever French maid" who helped transform the male protagonist into a female character.[33]

A number of correspondents set their stories in foreign cities, usually Paris and Vienna. Some claimed to have attended foreign schools; others, to have seen tight-laced men and women on the street. "In France one often sees slender-waisted women," wrote A TRAVELLER. "In Vienna tight-lacing is *de rigueur*."[34] A front-page article in the *Family Doctor* on "National Waists" recalled how, during the Victorian period, "the cultivation of the wasp-waist was carried to much greater lengths on the Continent—notably in Vienna and Paris—than in England."[35]

Why were Paris and Vienna chosen as the sites of tight-lacing? In part, probably, simply because they were foreign, and strange things may occur in distant places, where, moreover, most readers would not have traveled. There is no external evidence to support the belief that tight-lacing flourished in France and Austria. But English people might have fantasized about the Continent at a time when French kisses, French letters, and French dresses had a special cachet.

The enthusiasm for Vienna has a narrower and more obviously fetishistic history and seems to be directly traceable to the famously small waist of the Empress

Elizabeth of Austria (1837–1898)—and to one particular letter to *EDM*, which we will describe later. According to a modern biography, the Empress Elizabeth had a waist measuring 19.5 inches. At 5 feet, 7.5 inches, she weighed only 110 pounds. She was obsessed with dieting, exercise, and tight-lacing.[36] Elizabeth retains prestige even today among corset enthusiasts.

There is no reliable *external evidence* that tight-lacing boarding schools actually existed, no reportage in reputable newspapers like the *Times* on corset torture at girls' schools. Not a single letter names a particular school. The stories, moreover, are often inherently improbable. It is possible, for example, that no one would notice the presence of a cross-dressed boy at a girls' boarding school, but unlikely.[37] The *internal evidence*, both within individual letters and within the fetishist correspondence as a genre, reveals contradictions as well as improbabilities. As correspondents compete with one another, the stories get progressively wilder. It was also not uncommon for correspondents to plagiarize earlier stories, presenting the material as their own experience. In 1933, for example, *London Life* printed a letter entitled "Should Girls Tight-Lace?" that was a copy of a letter published in *Modern Society* in 1909.

Even when elements of a particular story are plausible, fantastic details are superimposed. The "governess" at "Madame La B——'s school just outside Paris" wrote to *Society* in 1899 to describe "Tight-Lacing and the Latest Craze," that of having one's "*tetons*" pierced by "jewelers in the Rue St. Honoré." Some people do pierce their nipples, of course, and this was a popular topic in 1899 among correspondents to *Society*. But when the "governess" says that the practice had been described in *La Vie parisienne* and in "a recent *roman*," I cannot help wondering if she is just repeating an idea that she read about. Nor is it likely that the breast-rings in her pierced nipples, together with "the friction of my *lingerie*," had caused her bust to grow.[38]

Pornographic stories are often described as taking place in institutional settings, such as schools, army barracks, and prisons, because these provide a framework involving uniforms, hierarchy, and punishment. It is not uncommon, however, for people to act out their sexual fantasies. Thus, while I very much doubt whether tight-lacing and cross-dressing boarding schools really existed for children, I think that adult fetishists may well have created this type of setting for themselves. In 1910, *Photo Bits* mentioned "Miss P.B.'s Select Academy for Waist Culture and the Art of Walking in High Heels."[39] Was this a real school, a fantasy, or something in between?

I have read the prospectus of a contemporary English "school" for adult fetish-

National waists, as illustrated in the Family Doctor, *April 7, 1888.* (Peter Farrer Collection)

ists: "MISS PRIM'S REFORM ACADEMY [is] a school for naughty boys and girls age 21 or over . . . including 'boys who would be girls.'" Students can sign up for weekends or longer, and have to purchase uniforms ("allow 30 plus days"), including navy blue gym slips ("tell us if for a TV or girl"), knickers, and so on.[40] At the Torture Garden, I talked to a man who said that he had visited a similar establishment. New York also has Miss Vera's Finishing School for Boys Who Want to Be Girls, also known as the Academy. Miss Vera is the Dean of Students; her friend Miss Dana is Dean of High Heels. Fees ranged from $300 for a private two-hour session (a tutorial?) to $2,000 for a "weekend getaway."[41]

Faludi quotes MORALIST ("lace her tight"), while Kunzle prefers STAYLACE ("the sensation of being tightly laced . . . is superb"). But why should we believe that the *EDM* letters are strictly factual at all? It is well recognized that many of the

letters in present-day sex magazines are made up by the editors, while others represent heavily fictionalized versions of personal experiences. Not all letters signed with female names are actually written by women; indeed, there is a long tradition in pornography of first-person female accounts that were penned by male authors—John Cleland's *Fanny Hill*, for example. Moreover, if modern psychiatrists are correct in insisting that the majority of fetishists are male, then many of the corset correspondents were probably men.

In 1899, A WOMAN OF FIFTY wrote to *Society* to describe her experiences at a "fashionable finishing school" in the early 1860s, during "one of the periodic cycles of tight-lacing, as may be gathered from the correspondence which appeared in 'The Englishwoman's Domestic Magazine' about this time." She went on to refer to many of the cult elements that played a role in the fetishist literature. There was the ritualistic invocation of the sexy and sadistic "mistress" of the tight-lacing finishing school, which was populated by perverse but aristocratic young ladies and occasionally men dressed as women. The ubiquitous French governess, Mademoiselle de Beauvoir, appeared with a "13-inch waist," although otherwise "plump." "Birching . . . was an openly recognized punishment." Breast-rings—the current enthusiasm among a number of correspondents to *Society*—were worn by "three French girls, daughters of a marquise."[42]

As I wrote in my first book, I do not doubt that real fetishists did many of the things they described in their letters: tight-laced, had themselves pierced and whipped, cross-dressed. But I doubt whether they did so under the circumstances that they described: at the tight-lacing boarding school, in the bosom of the aristocratic fetishist family, and at the hands of Mademoiselle de Beauvoir.

Men in Corsets

Another very important theme in the fetishist literature was the use of tight-laced corsets by men. WALTER wrote to the *Englishwoman's Domestic Magazine* in November 1867:

> I was early sent to school in Austria, where lacing is not considered ridiculous in a gentleman as in England, and I objected in a thoroughly English way when the doctor's wife required me to be laced. I was not allowed any choice, however. A sturdy *mädchen* was stoically deaf to my remonstrances, and speedily laced me up tightly in a fashionable Viennese corset. . . . [A]nd the daily lacing tighter and tighter produced

inconvenience and absolute pain. In a few months, however, I was as anxious as any of my ten or twelve companions to have my corsets laced as tightly as a pair of strong arms could draw them.[43]

WALTER's letter cannot be taken at face value. If its manifest content deals with male corset-wearing at the tight-lacing boarding school, its latent content seems to be an erotic fantasy about a boy overpowered by dominant women ("the doctor's wife" and a "sturdy *mädchen*") and forced, against his will, to wear an article of female underclothing. But soon, pain gives way to pleasure in the embrace of a tight corset, while the ignominy of cross-dressing is obviated by its normalization in an alien culture. It is important to emphasize that most men in the nineteenth century did not wear corsets. Men's corsets and belts did exist, however. In the 1820s, in particular, dandies sometimes wore corsets (boned and laced in back) in order to achieve a fashionable hourglass figure—although one must beware of being too credulous about the evidence offered in caricatures. The *Workwoman's Guide* of 1838 says that men's stays were used in the army, for hunting, and for strenuous exercise. According to a modern historian, these stays were often just "a strip or belt of material, as they did not have to contend with female curves."[44] WALTER, however, advocated not belts, but strongly boned women's corsets. In 1909, a male tight-lacer who signed himself WALTER (perhaps in honor of *EDM*'s correspondent) wrote, "I advise all your male readers to beg, borrow, or steal a pair of their sister's (or wife's) corsets and put them on."[45]

The idea of corseted men horrified many correspondents; even votaries like LA GENIE, who approved of (enforced) tight-lacing for girls, insisted that he did not wear stays himself—"rather a disgusting idea."[46] Sometimes men's corsets were justified on the grounds of health, such as a bad back.[47] ANTI-CORPULENCE recommended corsets for "stout" men.[48] A STAIDMAN asked, "Why this prejudice against gentlemen wearing stays?"[49]

In 1886, when A LOVER OF STAYS wrote to the *Family Doctor* to describe how much he enjoyed wearing tight-laced corsets, MARY BROWN responded: "I think 'Lover of Stays' must be a very effeminate man . . . that wishes he was a female. . . . [D]oubtless he would like to go about in a gown and petticoats and pass himself off for a woman."[50] This triggered a number of letters from men who corseted and/or cross-dressed. "Although not a member of the stay-wearing sex, I have worn stays myself for upwards of ten years," wrote one man.[51]

There are too many corset letters from men to cite more than a few key themes, but the issue of female domination is conspicuous. Both BROUGHT UP AS

Advertisement for Madame Dowding's corsets in Society, *October 21, 1899.*
(Shelfmark: N.2288.c.21, Bodleian Library, Oxford University)

A GIRL and A WOULD BE LADY wrote to the *Family Doctor* to say that they had been raised by aunts who forced them to cross-dress—a scenario for which there is some supporting evidence.[52] More dubious are the stories about wives who force their husbands to tight-lace and cross-dress. When SATIN STAYS, for example, married "a lady considerably my senior . . . whose exquisitely slender waist and pretty stilted shoes engaged my fancy . . . she obliged me to sign a document" committing him to satisfy her "in my manner of dress. . . . This I willingly did, never dreaming what it would lead to."[53] (But I think we can guess.) Contemporary studies of transvestites and their wives, however, emphasize that it is the men who choose to cross-dress.

RETIRED COLONEL claimed that "in America [men's corsets] are quite common, and boys wear them the same as girls; hence, no doubt, the fine carriage of American youths and . . . men."[54] But most correspondents focused on the German-speaking male—especially the Austrian or Prussian military man. Although the

"Size 13—on my honor, Herr Baron, we seldom see that here in Berlin." (From *Die Mode in der Karikatur*, 1855)

Austrian army was not an impressive war machine, the Austro-Hungarian Empire did have a plethora of spectacular-looking uniforms, which were often imitated at fancy-dress balls in France and England. Thus, English fetishists of WALTER's generation might well have been familiar with these clothes. Moreover, the Prussian (and later the German) army was extremely powerful. "It is well known that very many Prussian officers wear stays," wrote REFORMER, adding that "nothing becomes a man or boy so well as the erectness produced by wearing stays."[55] In this letter, as in many others, the phallic symbolism associated with corsets and tight-fitting military uniforms was juxtaposed with transvestite elements (petticoats and earrings).

Uniform fetishism was (and remains) a significant subcategory of clothing fetishism, that is often associated with fantasies of dominance and submission. The cross-dresser who socializes with military officers was a popular theme in the fetishist letters. "For a bet in Vienna I once dined with several officers dressed in evening dress . . . and laced into 16½ inches," wrote BROUGHT UP AS A GIRL.[56] "I think it's horrid of men to wear corsets," wrote A KENSINGTON BELLE disingenuously (after boasting of her own 16-inch waist), "but my brother who is in the——Guards tells me a lot do. I know *he* does. Last Autumn he won a large bet by dining, in female attire, in company with a brother officer."[57] In 1909, *Modern Society* printed a series of letters, "Slaves of the Stay-Lace," from correspondents like DORA, who said that her Hungarian maid had previously worked for an Austrian officer who tight-laced and wore 4-inch heels.[58] SMALL WAIST claimed that "corset-wearing in Vienna by the male sex is quite common."[59] In "The Recollections of a Corsetière," the narrator searches Europe for tiny waists, and in Vienna he meets "a laced-in lieutenant," who not only wore a "long military corset" but whose "uniforms were fitted with long corset steels to ensure a perfect smooth fit." The lieutenant also cross-dressed.[60]

An essay on discipline in an Austrian gymnasium of 1930 reveals the difficulties inherent in studying fetishist literature. The author begins with quotations from WALTER. Then, in a rambling and often incoherent account, he suggests that the Germans (including the Nazis) were virile and corset-hating antifetishists, while the tight-laced Austrians were effeminate corset fetishists. Yet Hitler is presented as "one of the most successful fetishists the world has ever seen," albeit deficient in the necessary virtue of hypocrisy. Since the United States is "like Austria and England, a rather well-corsetted country," the author gives it "a good prognosis for successful world domination."[61] Needless to say, this bizarre tract presents no reliable evidence about actual historical tight-lacing in Austrian schools, although

it does offer some insight into the way the corset has functioned as a lightning rod for other concerns.

Some men did (and do) wear corsets, however. The earliest advertisement for men's corsets that I have seen dates from 1899 and illustrates several models, ranging from sleeping and hunting belts to long and heavily boned corsets with military names such as "The Marlborough" and "The Carlton." It appeared in a periodical, *Society*, that also published an extensive fetishist correspondence. There are very few men's corsets in museum collections, although at the Kyoto Costume Institute I examined an "Apollo brand" English corset, made of sturdy beige-colored cloth with "Spartan steels," from the later nineteenth century.

The London Life League, based in Montreal, offers support to men and women alike who enjoy wearing corsets. The league's mimeographed newsletters and corsetry education notes stress that "the appreciation and wearing of corsets transcends gender. . . . The modern male should be the proud heir to a dynasty of experience, first recorded by the bull-leaping Minoan male, and continuing down to the svelte Edwardian dandy and military officer." They admit that corseted men risk "adverse comment" and recommend a combination of personal discretion and public education. Travelers are advised, for example, that electronic metal-detection devices at airports can be set off by a well-steeled corset; if this occurs, it may be wise to imply that it is for "orthopedic" purposes.[62]

Cross-dressers (often middle-aged married men) sometimes wear corsets in private. A few men privately wear what are called "penis corsets," tubes of leather and/or rubber that lace down the middle. Sometimes they also wear "neck corsets." More significant from the point of view of fashion are the "club kids" (especially young gay men) who recently have begun to wear corsets openly and as outerwear.

Unfashionable Fetishism

The corset began to disappear from women's fashion as early as 1907, when the avant-garde French couturier Paul Poiret introduced a neoclassical style of dress. By 1910, younger and thinner women began replacing the boned corset with a rubber girdle and brassiere, while older and stouter women shifted to a long straight corset. Was it a case of "The Vanishing Waist?" asked *Photo Bits:*

> I have just read . . . that "There will be no small waists this season and absolutely no hips. . . ." A shuddering sigh comes up from my over-charged heart. I can

scarcely realise the meaning of this latest edict of fashion. The swelling bosom, the divine waist of few inches . . . the rounded hips—*are to go!* Heaven forbid! In one respect, they will *not* go, but they will be hidden from our sight.[63]

The writer consoled himself with the thought that "nobody laces tighter than the Lancashire millgirl. Good luck to her! She represents the *people.*" In a last-ditch defense, he wildly claimed that someone had told him that there were "signs of a rapid return to extreme 'wasp' waists and that scores who are 'in the know' are secretly practicing the most rigorous tight corsets." But he was clearly kidding himself.

In 1910, *Photo Bits* published several special "Tiny Waist" numbers, one of which envisioned the possible founding of a Corset Club and a Minoan League to promote male tight-lacing. Another proclaimed: "13 Inches—the Ideal." A serial story of male tight-lacing, "The Pearl of Picadilly," recounted "The Adventures of a Wasp Waist," a man who wore a 13-inch crimson corset. There was also an essay, "The Cult of the Corset," and a story entitled "The Hunt for the Thirteen-Inch Waist."[64]

But enthusiasts increasingly placed the golden age of tight-lacing in the Victorian past. The waist sizes described also shrank. The author of "The Vogue of the Wasp-Waist" looked back nostalgically to Victorian waists of 10 and even 9 inches,[65] although one correspondent expressed disbelief "in waists much smaller than my own."[66] In 1933, A WORSHIPPER OF WASP-WAISTS wrote to *London Life:*

Dear Sir,—Like Diabolo, I, too, am a lover of tiny waists for the fair sex. I cannot understand why a man should be thought abnormal for preferring to see a woman tightly corsetted, seeing that the Victorian male was an ardent worshipper of the wasp-waist, which was then, of course, universal.

I am only 27 years old, and am beginning to wonder whether I have not been born thirty years too late, as I see much more sex-appeal in a womanly figure obtained by clever corsetting than in the so-called "natural" figures of today.

A friend tells me, however, that in Paris today there are still to be found many women who display a tiny waist, and consequently I am determined to spend a week or two soon in finding whether this is true.

Perhaps some of your readers who are interested could give me information through your columns.[67]

Thus, although the corset had essentially disappeared from fashion (replaced by the brassiere and girdle), it retained its central place in the fetishist pantheon. The tight-laced actress Polaire, whose tiny waist was featured in *Tatler* and *Photo Bits* in 1909, was recalled again in *London Life* in 1937.[68]

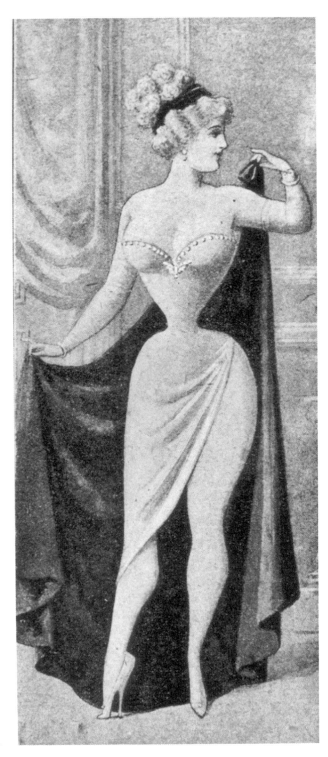

*The modern Venus, as
shown in* Photo Bits, *1910.*

Fetish illustration, mid-twentieth century.

The most famous modern tight-lacer is undoubtedly Ethel Granger, of Peterborough, England, who reduced her waist over a period of years from 23 to 13 inches. A small woman of 5 feet, 3 inches and weighing only about 100 pounds, she began corseting in 1928, under the influence of her husband, "arch fetishist" Will Granger, who wrote and had privately printed a biography of his wife. Chapters titles include "Ethel Makes a Dainty Wife," "What a Little Love Will Do," "High-Heeled and Happy," "Nose Rings," "Torture Tools," "Pierced Tits," and "Thirteen Inches—At Last!"[69]

Will Granger was obsessed with body modification from an early age (although he only briefly experimented with wearing a corset himself). Clearly the dominant figure in their marriage, he not only pressured his wife to tight-lace, but also pierced her body in thirteen places. Her motives for going along with this

Ethel Granger, "The World's Smallest Waist." (Fakir Musafar and *Body Play*)

are opaque, although people who knew her say that she enjoyed it, too. Will's obsession with tight-lacing was such that he was extremely annoyed when Ethel's obstetrician insisted that she stop lacing during her pregnancies. She herself became disillusioned with tight-lacing during the war years, but Will induced her to begin again in 1946, and by the late 1950s, she was back down to 13 inches.[70]

"Fashions Change and So Do We," wrote Will Granger, but, in fact, his dedication to corsetry was largely distinct from fashion. A fashionable phenomenon

like the "waspy" girdle of the 1950s differs significantly from hard-core fetish activity. Although the Grangers' "body play" was initially secretive, they eventually became cult figures within the world of enthusiasts. Ethel was written up in the press in 1957 and 1959 and again in 1968, when the Associated Press published photographs of her 13-inch waist. Finally, she entered the *Guinness Book of World Records* as having the "World's Smallest Waist," which information her husband also had printed on her passport. The publicity attending Ethel Granger's body sculpting effectively valorized the procedure for a number of people. Ethel died in 1982, a few years after her husband, having tight-laced almost to the end.[71]

Tight-Lacing Today

Corsetry is "very erotic," says Fakir Musafar, today's most famous corset enthusiast. "Helpless women with small waists is [*sic*] a sexual turn-on for men"—and women, too, "if they adjust . . . to this body training." Corsetry "enhances sexual experiences. There's nothing like being extremely tight-laced yourself as a male and making love to a woman who's extremely tight-laced . . . all your internal organs and your sexual components are in different positions, with different tensions and so on—there's a mechanical basis for this. It's very ecstatic."[72]

He brought his own waist down from 29 to 19 inches back in the 1950s, inspired by both the *Englishwoman's Domestic Magazine* and *National Geographic*. These two sources of inspiration are reflected in his two primary forms of self-presentation: as a "Modern Primitive" and as the "Perfect Gentleman." In the 1950s and 1960s, Fakir Musafar established a corset business, but there were not enough clients to make it profitable, so he sold the company to the owners of BR Creations, who by the 1980s employed three women to make corsets. "They're selling to straight people now, not just the kinky circuit," mused Fakir Musafar. "Like bridal salons—it's amazing where they're selling these things. They ran an ad in the *New York Times* and got a ton of orders."[73]

Pearl is an English tight-lacer with a 19-inch waist. "Is it a fetish?" I asked. "Maybe," said Pearl. "It is a sensual experience wearing corsets . . . I don't involve my interest in a sexual practice, though." Like many enthusiasts, Pearl grew up in a very religious family, and his interest in corsets dates from his early childhood. "I lived with my grandmother when I was two or three, and she wore a corset every day, because she dislocated her spine when she was young. I used

Pearl, a modern tight-lacer. (Travis Hutchison)

to help her lace it up. It was beautifully made, pink, always pink, that beautiful peach pink satin."

"I'm not doing this to try to be like a woman," says Pearl. (Photographer Travis Hutchison agrees, and says that he feels "very masculine" wearing the corset that Pearl designed for him.) For Pearl, tight-lacing is "about control of yourself. Clothes need to be more disciplinary." Although he finds corsets "comfortable," what he likes is the feeling of "restriction" and the idea that "the garment brings with it certain rules; you can't do certain things. You can't slouch. If I don't put a corset on, it doesn't feel right. I don't like to walk barefoot, either. I like my leather shoes. I sleep in my corset, or in a belt, because it's best to feel it always being controlled. It makes me feel better."[74]

Pearl introduced me to a woman who tight-laces. After we had a long interview on the telephone, I visited Cathie J. and her husband at their home in the northeastern United States. A middle-aged American housewife, Cathie can lace as small as 15 inches. (This measurement is an estimate of her waist size underneath the corset, and assumes that the corset adds another 2 inches, giving an outside measurement of about 17 inches.) On a day-to-day basis, her waist measures 18 or 19 inches on the outside of her corset. She is 5 feet, 6 inches tall and weighs about 130 pounds. To achieve such a small waist, she wears her corset twenty four hours a day, taking it off only to bathe, and this, in turn, has permanently affected her body.[75]

Cathie is married to a surgeon. "There's a rumor going around that he has taken out my ribs!" ("It's not necessary," her husband says, "the ribs are very flexible.") X-rays of her torso appear to show a modification of the lower ribs and possibly a lengthening of the space between spinal rings. She is confident, however, that he would never insist that she do anything medically dangerous.

Her husband has had a lifelong interest in corsets. When they first began dating, thirty years ago, he encouraged her to wear corsets on special occasions. For their wedding day, he had a corset custom made. Cathie had "no problem" with her husband's interest in corsets: "It was just something he liked." She wore corsets occasionally after that, mostly in the evenings. Then about nine or ten years ago, with their children grown up, she and her husband got to know some corset enthusiasts in England and Germany, and became more involved in tight-lacing.

"It was easier for me to leave a corset on all the time." As she explained, "some people like that sudden pressure" that comes when you are rapidly laced up. (Will Granger apparently used to lace Ethel occasionally in front of visitors so tightly

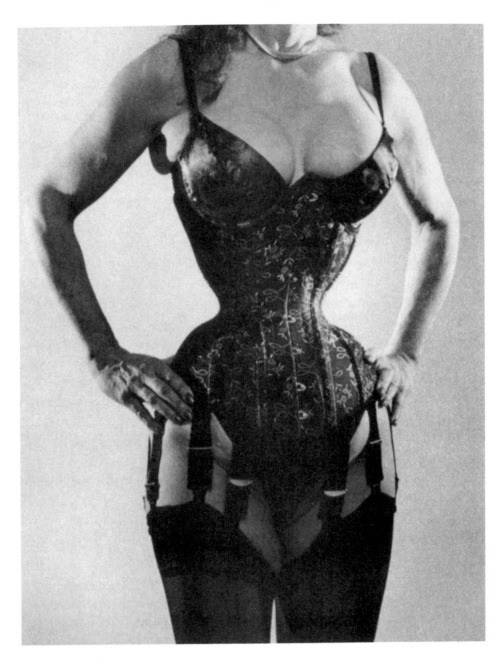

Cathie J., with a 15-inch waist. (Fakir Musafar and *Body Play*)

and so rapidly that she blacked out.) Cathie, however, did not like that dizzy feeling and preferred to lace continually; she usually laces her own corset using a hook and a doorknob to keep tension on the laces.

"When you try to get smaller there is some discomfort, I don't know if you would call it 'pain,' " she says. There is more of a problem with "chafing sensitive skin," occasionally to the point of causing "a blister or minor wound." Her husband "enjoys the visual appearance of corsetry, the way it enhances the figure," Cathie says. "I've always liked it," he adds. (His mother never corseted.) Although the sight of a corseted woman is "sexually stimulating for him," Cathie says that she herself does "not get any great sensual feeling from wearing a corset." It is no more pleasant than wearing any other nice lingerie, she says, not even as sensual as satin.

"My interest is to please my husband," she says, estimating that "ninety-nine percent of the time, women wear a corset because their husband or significant other likes it. At least that's true of my generation." She knows one thirty-something couple in Germany, where, when the man suggested that his girlfriend wear a corset, she said, "If you expect me to do it, then you have to do it, too." So now they both tight-lace.

"Corsetting is frequently a couples' phenomenon," notes a recent study. "Our research suggests that among vanilla couples who enjoy corsetting, the wives often become converted to the aesthetic under the husbands' influence." (In other words, among heterosexual couples where the man is not a cross-dresser and where neither partner is involved in sadomasochism, the husband is the one with an interest in corsets.) As Cathie told the authors of that study, "If I'd been married to somebody else who wasn't interested in [corsets], it's not something that I would have picked up. And if he said tomorrow that he wasn't interested anymore, it wouldn't be a problem for me."[76] But she modified this statement slightly when we talked: "If he died, I would probably still wear a corset, but maybe not to the extreme. After you've been doing it for a long time, your body gets used to a corset. Now if I leave my corset off for more than a few hours, my back aches. I need the support." Besides, all her clothes are custom made to fit a corseted figure. "If I stopped wearing a corset, I wouldn't have anything to wear!"

"Some people try to equate it with bondage or body modification," says Cathie, "but that's not our bag." She firmly distanced herself from the corset enthusiasts who were into "kinky" things such as cross-dressing men wearing corsets. She does think, however, that "the reasons for wearing a corset are more diverse for men." The Fakir, for example, is "doing it to test limits." Cathie also knows a

few single women in their twenties who wear corsets because they "just like the look. It's popular as a fashion statement." These younger women tend to wear their corsets "on the outside of their clothes," sometimes in conjunction with other fetish styles like leather and latex.

Cathie and Pearl introduced me to Lauren, a twenty seven-year-old woman who wears a 19-inch corset. "I like the way it feels," said Lauren, "like someone's holding me. And I love the way it looks." Unlike Cathie, who tight-laces for her husband's pleasure, Lauren insists, "I wear a corset for *myself*, not for my mate." She compares tight-lacing to ballet: "Ballet is culturally acceptable and corsets aren't, but in both cases you train the body. Ballet is hard on the feet, but the result is accepted as being beautiful."

Tight-lacing, like ballet, is "about strength and grace," says Lauren. "It's feminine but very strong. I'd love to dispel the myths about corsets. I have no health problems. You just need to do it in a healthy way and allow your body to adjust. The only problem I have is if I don't exercise, then I get a weak feeling." "How do you feel about the new fashion corsets?" I ask. Lauren pauses. "It's hard for me. Part of me wants to say, '*please*, this is a lifestyle, not a fashion.' But it's worth it if someone comes to a better understanding about corsets."[77]

As corsetry has become semi-fashionable, Cathie has noticed a significant change in the corset balls she attends. The first ball, in England, consisted of about twenty heterosexual couples: the men in tuxedos, the women in elegant evening dresses worn over corsets. Recent balls, such as the 1994 corset ball in Vienna, have drawn a larger and more mixed crowd, including male cross-dressers and women wearing corsets as outerwear.

Corsets in Vogue

When the corset reappeared in fashion, Vivienne Westwood was one of the first designers to exploit the charisma of the forbidden. "It is her corset, first seen pushing breasts up into a ripe cleavage in 1985, that has been her most significant contribution in the last ten years," declared *Vogue*.[78] Westwood was inspired by eighteenth-century stays, rather than the more familiar Victorian hourglass corset: "Fashion always requires something new yet draws from the past."[79] Although her corsets are visually powerful, they are not very structured. As Pearl says, "They are plastic and quite lightweight so they appeal to a younger way of thinking about comfort. They don't lace up, they just zip up."

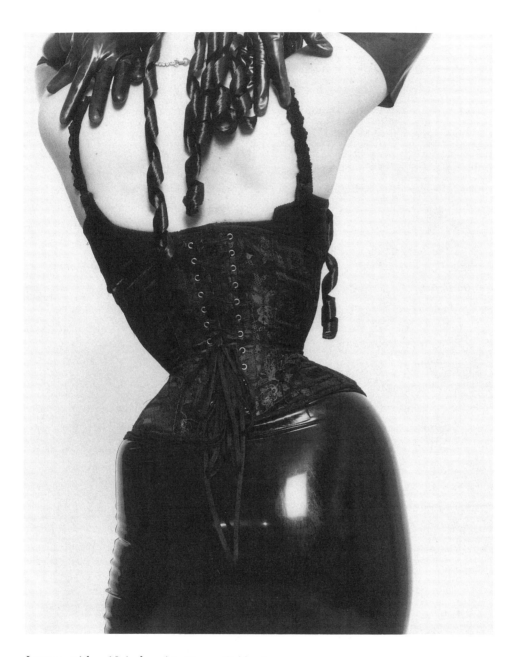

Lauren, with a 19-inch waist. (Aaron Cobbett)

It is precisely the lacing, however, that has attracted many other designers. As early as the 1950s, French couturier Jacques Fath had created a pink satin evening dress with corset lacing up the back. In the exhibition "Infra-Apparel" at the Costume Institute of the Metropolitan Museum of Art, curators Richard Martin and Harold Koda juxtaposed Fath's gown with contemporary garments, such as a corset bathing suit by the Italian design house Fendi.

The French designer Jean-Paul Gaultier is probably most notorious for having designed Madonna's shell-pink, lace-up satin corset with projectile breasts. His influential spring 1987 collection featured a number of corsets, girdles, and brassieres. He has also created several rubber corset dresses with lacing all the way up the back—a style already utilized in pornographic photography of the 1930s. Gaultier has also designed a variety of jackets (for men as well as women) that lace up like corsets.

"The first fetish I did was a corset," recalls Gaultier. "That was because of my grandmother." As a child, he frequently lived with her, and he remembers finding a salmon-colored, lace-up corset in her closet: "I thought, 'My God, what is that?' . . . Later I saw her wearing it and she asked me to tighten it." She told him about tight-lacing at the turn of the century, and he was "fascinated" by what he regarded as "one of the secrets."[80] Gaultier's perfume is packaged in a bottle shaped like one of his corsets.

Ever since the mid-1980s, corsets have been a recurrant theme in contemporary fashion. The French fashion designer Thierry Mugler is particularly important because he has made the corset an integral part of his theatrical *femme fatale* designs. Never afraid to go over the top, Mugler has shown aggressive corsets with spiked breasts and leather corsets with attachments that closely resemble nipple rings. He has also done glittery evening corsets, structured plastic bustiers that echo Roman body armor (adapted to the female torso), and numerous other corset/bra/bustier styles. Mugler has also incorporated corset seaming into other garments, such as black leather jackets.

Azzadine Alaïa, the Tunisian-born designer who works in Paris, has also used corsetry in his work. In 1991, for example, he showed leopard-skin–patterned corsets and stockings. In 1992, he created very beautiful leather corsets in red and dusty rose, as well as accessories such as purses that were shaped like little corsets. When not designing corsets, as such, Alaïa has often favored wide, cinched leather belts. Betsey Johnson, an American who creates inexpensive, body-conscious styles for younger women, and the French designer Chantal Thomass, who is known for her lingerie fashions, both design corsets. Couturiers

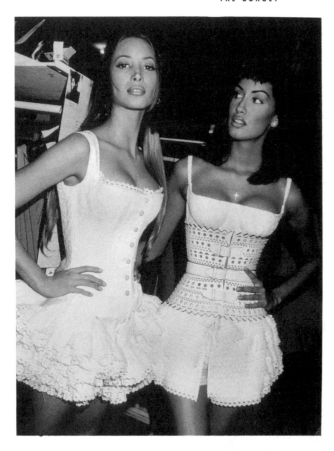

*Corset- and lingerie-inspired
fashions by Azzedine Alaïa,
1992.* (Roxanne Lowit)

like Christian Lacroix, Ungaro, and Valentino create glamorous and expensive corsets.

Karl Lagerfeld has made corsetry a centerpiece of his work for Chanel. "You can't wear these clothes without a corset," declared Lagerfeld. "They're so fitted that without a corset all the buttons would pop off."[81] By 1994, the corset had reappeared both as outerwear and as underwear. Even mainstream department stores like Saks Fifth Avenue ran advertisements asserting that "the corselette has emerged as the . . . ultimate accessory."[82]

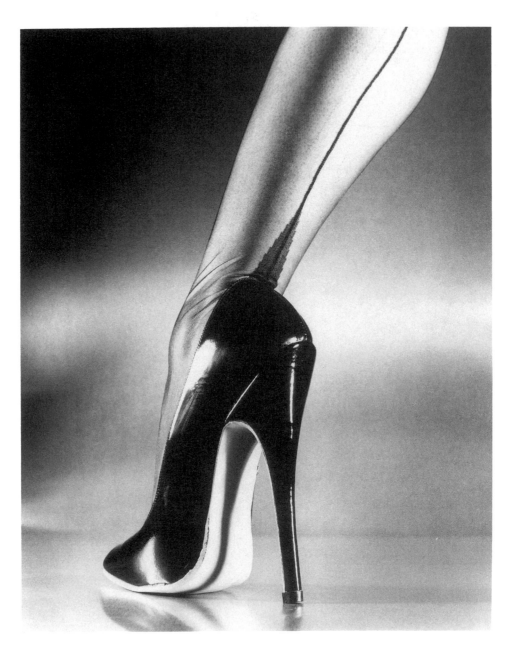

The Shoe, as seen in Skin Two. (Chris Bell)

four

Shoes

According to an early version of the Cinderella story, the evil stepsisters cut off their toes and heels to fit into Cinderella's glass slippers, but were betrayed by a trail of blood. In William Klein's satiric film *Qui Êtes-Vous, Polly Maggoo* (1965), a professor explains that the hidden meaning of the Cinderella story is "the value of tiny feet and beautiful clothes." He triumphantly concludes: "So there you are: fetishism, mutilation, pain. Fashion in a nutshell."

Although this is obviously an exaggeration, many people would be inclined to agree, at least with respect to high heels. The artist Camille Norment's sculpture *Glass Slipper* is made of shards of broken glass. Norment herself thought of the Cinderella story only after she had completed the work; her initial idea was to create a sculpture about clothing as bondage and about the vulnerability of the body.

Yet high-heeled shoes also exert a powerful charm for many people. "I'm a shoe fetishist," one fashion journalist told me proudly (meaning only that she liked shoes). There is a little bit of Imelda Marcos in many women, and many men exhibit an almost Pavlovian response to the sight of a woman in high heels. Are they all fetishists? How does hard-core fetishism differ from the widespread enthusiasm for "sexy" shoes and "playing footsie"? This chapter will attempt to explain why the foot and shoe play such an important role in the erotic imagination. Historically, the obvious comparison is with bound feet.

In the West, as in China, small feet have been popularly associated with feminine beauty, while big feet and heavy boots are equated with masculinity. High heels, in particular, have been explicitly compared with bound feet.

Glass Slipper *by Camille Norment.* (Camille Norment)

The 3-Inch Golden Lotus

The practice of foot-binding in China bears many of the marks of a cultural quasi-fetishism. Chinese erotic literature contains accounts of men fondling, kissing, and licking bound feet. The 3-inch "golden lotus" foot was celebrated as the erotic ideal: "Look at them in the palms of your hands," wrote one Sung poet, "so wondrously small that they defy description." A woman's tottering steps were also considered sexually attractive, and foot-binding was thought to tighten the muscles of the vagina. The eighteenth-century Jesuit Father Ripa wrote of the Chinese: "Their taste is perverted to such an extraordinary degree that I knew a physician who lived with a woman with whom he had no other intercourse but that of viewing and fondling her feet." [1]

If Father Ripa's acquaintance *really* had no other sexual intercourse than fondling his mistress's feet, he would have been regarded as distinctly peculiar by his Chinese contemporaries, who placed a heavy emphasis on procreation as well as

on the supposed longevity-enhancing effects of frequent and prolonged sexual intercourse. Nevertheless, the story is at least superficially similar to modern Western accounts of foot and shoe fetishism.

A recent report on contemporary sexual behavior, for example, included the story of a woman who unknowingly married a foot and shoe fetishist. To her horror, he spent their wedding night clipping her toenails and kissing and licking her feet:

> I blurted out, "Make love to me, I want you!" He replied, "I am making love to you" and he ejaculated. . . . What made me totally freak out was what he tried to do with my toes. You know the way guys hold a billiard cue between their fingers? Well, Mr. Foot started putting his penis between my toes and moving it back and forth, and got all worked up . . . it was too weird.[2]

Whenever she tried to initiate genital intercourse, he became impotent.

Foot-binding has usually been interpreted as a gruesome form of female oppression and/or as a "kinky" type of sex. Yet scholars are revising the traditional picture of foot-binding, which has come down to us primarily through Western missionary accounts and erotic literature—both sources with built-in biases. As Dorothy Ko points out, "Foot binding is not one monolithic, unchanging experience that all unfortunate women in each succeeding dynasty went through, but is rather an amorphous practice that meant different things to different people. . . . It is, in other words, a situated practice."[3]

While a full account of foot-binding is beyond the scope of this chapter, the

Chinese shoe for a bound foot.

phenomenon can be understood only by placing it back within its historical context and recognizing its multiple and shifting meanings. Foot-binding apparently arose at the Chinese imperial court during the tenth century, when it was associated with dancers. Initially, it seems to have involved little more than the wearing of tight socks, perhaps not unlike the toe shoes worn by ballet dancers. In the Sung Dynasty, the custom spread throughout the upper classes as a mark of status, becoming, at least in some cases, much more physically deforming. By the fourteenth century, foot-binding had penetrated even the peasant population. It did not disappear until the early twentieth century.

Foot-binding was a painful and debilitating procedure that severely limited a woman's physical mobility. The four little toes were pressed down under the ball of the foot, leaving only the big toe to protrude. The forefoot and heel were pushed together, moving the big toe down and the heel bone forward. Bones were broken, and the arch formed a high curve, creating a deep cleft in the sole of the foot. In silhouette, it gave the effect of a high-heeled shoe.

The sexual symbolism of this seems obvious, and, indeed, erotic literature indicates that the toe was used in sex play as a phallic substitute, while the cleft was utilized as a pseudo-vagina. The man would put the entire foot into his mouth, and the woman would stimulate the man by touching his penis with her feet. The shoe was also the focus of erotic attention. Made of brightly colored and embroidered silk, and often perfumed, the shoe concealed the foot and ankle and was incorporated into various rituals, such as drinking games.

Until recently, it was believed that only the very poorest Chinese women (and members of other ethnic groups, like the Manchus) escaped being mutilated. Yet it now seems that "although some girls had their feet bound in the extreme and painful golden-lotus style, others had theirs bound in less painful styles that 'merely' kept the toes compressed or limited the growth of the foot but did not break any bones."[4] The 3-inch bound foot may have been almost as rare as the 16-inch waist.

A few Chinese males also apparently bound their feet. "Most were the 'adopted' boys of adult homosexuals," writes William Rossi in his popular compendium, *The Sex Life of the Foot and Shoe.* Lumping together several categories that may not accurately describe the historical reality, he adds: "Chinese homosexuals, transvestites, and professional female interpreters, while not actually having bound feet, delighted in simulating the lotus foot by tightly strapping their feet and squeezing them into small, lotuslike shoes and imitating the sensuous willow walk."[5]

Foot-binding seems to have been closely associated with Neo-Confucianism and the social subordination of women. It was a way of enforcing a woman's chastity, a mark of conspicuous leisure, and a sign of Chinese cultural identity. Missionary efforts played a part in the demise of foot-binding, but the meaning of the practice also changed within Chinese society. Whereas in the Sung Dynasty, foot-binding was valorized as a way of emphasizing the virility and civility of Chinese men, by the twentieth century many Chinese men had reinterpreted foot-binding as a "backward" practice that hindered national efforts to resist Western imperialism. Some, like the novelist Li Ruzhun, also attacked foot-binding on the grounds that it oppressed women. His novel *Flowers in the Mirror* included a sequence about a country where women ruled and men had their feet bound. Organizations like the Natural Foot Society had to struggle to change the idea that unbound female feet were "big" and ugly. There is some evidence that the introduction of Western high-heeled shoes, which give the visual illusion of smaller feet and produce a swaying walk, may have eased the erotic passage away from the bound-foot ideal.

Should foot-binding be considered "fetishistic"? Freud thought that it was, and it may well be that castration anxiety was in China partially assuaged by the culturally normative practice of foot-binding. But the meaning of any given practice is contextually determined, and not all Chinese men were equally enthusiastic about foot-binding. The Chinese novelist Feng Jicai recently wrote a novel, *The Three-Inch Golden Lotus*, based on his extensive knowledge of historical foot-binding, which describes a woman who marries into a family where the men

English caricature comparing Chinese and French shoes.

exhibit an obsession with bound feet that greatly exceeded the norm within their own culture.

Foot-binding certainly intrigues modern Western fetishists. In the 1970s, there was a foot-fetishist organization called The Lotus Club, in honor of the legendary 3-inch lotus foot. And today articles describe how to "bind" someone's feet. But this says more about modern fetishists than it does about the historical practice that they idealize. Many contemporary fetishists like to associate their individual psychosexual enthusiasms with traditional practices in other cultures, yet there seem to be significant differences between modern fetishism and its antecedents. Nevertheless, Chinese foot-binding may usefully be compared with the development of shoe eroticism elsewhere in the world, for although there are important distinctions, there are also striking similarities.

An Exaggerated Eroticism

The popular perception of the nineteenth century focuses on the idea of sexual repression, and it is widely assumed that Victorian sexual "prudery" spawned myriad hypocritical perversions. "The campaign to conceal the leg was so effective that by mid-century men were easily aroused by a glimpse of a woman's ankle," wrote historian Stephen Kern in *Anatomy and Destiny*. "The high incidence at this time of fetishes involving shoes and stockings further testifies to the exaggerated eroticism generated by hiding the lower half of the female body."[6]

Philippe Perrot, author of *Fashioning the Bourgeoisie*, also argues that "in the nineteenth century, female bosoms and behinds were emphasized, but legs were completely hidden, distilling into the lacy foam of underwear an erotic capital, the returns on which could be gauged by the cult of the calf and by the arousal caused by the glimpse of an ankle."[7] Historical analyses of nineteenth-century fashion often employ an economic trope, and it is suggested that capitalism exploits the obsession with bodies in order to market new commodities.

It is a crude and misleading stereotype to suggest that the long skirts of the Victorians "caused" widespread foot and shoe fetishism. Women's skirts, after all, had been long for centuries—in the "permissive" Paris of the eighteenth century as well as in allegedly "prudish" Victorian London. Legs were certainly regarded as being sexually attractive. In *The Fleshly School of Poetry*, Robert Buchanan argued that "sensualism" was spreading dangerously through society:

It has penetrated into the very sweetshops; and there . . . may be seen this year models of the female Leg, the whole definite and elegant article as far as the thigh, with a fringe of paper cut in imitation of the female drawers and embroidered in the female fashion! . . . The Leg, as a disease . . . becomes a spectre, a portent, a mania . . . everywhere—the Can-Can, in shop-windows.[8]

Kern suggests that this is evidence of sexual repression, but it might more logically be interpreted as evidence of growing sexual display or, perhaps, the spreading commercialization of sexuality. There is, moreover, no reason to think that foot and shoe fetishism was more common in the nineteenth century than it is today. Shoe fetishism seems to have emerged, however, in the eighteenth century.

The French writer Restif de La Bretonne (1734–1806) was much closer to what we might consider a "true" (Level 3 or 4) fetishist. In his novel *Le Pied de Fanchette*, Restif described how the narrator stole the rose-colored slippers of his employer's wife, which were so appealing with their little pink tongues and green heels: "My lips pressed one of the jewels, while the other, deceiving the sacred

Stocking advertisment, ca. 1900.

97

end of nature, from excess of exultation replaced the object of sex." In other words, after kissing one "jewel," he ejaculated into the other. According to a recent study, "[Restif's] daily diaries reveal even more clearly than his stories that he was a shoe voyeur, a shoe stealer, and a shoe collector."[9] He particularly liked high heels.

The Cult of the High Heel

In a recent article entitled "Hell on Heels," Ann Magnuson described both "the agony and the ecstasy" of high-heeled shoes, and concluded that "what makes us different from the poor Chinese girls who were robbed of their mobility is that when we've had enough, we can walk away."[10] The height of shoes, like their size, has erotic connotations. The most striking shoe of the Renaissance was the Venetian *chopine*, an enormously high platform shoe that was associated particularly with courtesans. Platform shoes (for men and women) have existed in many cultures, where their significance is by no means limited to eroticism. By increasing the apparent stature of the wearer, they can signify high status. When not too high, platform shoes, like the Japanese *geta*, can even serve functional purposes, such as raising the wearer out of a muddy street.

There is no question, however, that very high shoes inhibit the wearer's movements, a form of "bondage" that some people find erotic.[11] Sometimes even the appearance of restriction is perceived as erotic. In 1992, the House of Chanel sold cork-soled platform sandals with ankle straps, inspiring an article in the *New York Times* in which fashion historian Anne Hollander asked what was so "sexy, perverse, and delicious" about this look. Musing about "untold erotic practices," she suggested that an elegant ankle harness presents the foot "as a beautiful slave."[12]

In the seventeenth century, European shoemakers modified platforms to create the high-heeled shoe. In the beginning, high heels were worn by both men and women. As men's fashions became more subdued, however, high-heeled shoes became associated with women. The erotic appeal of high heels cannot, therefore, be separated from their association with "femininity." It is important to stress, however, that women's fashion does not always emphasize the high heel.[13] Shoe fetishists, however, usually do.

The *Englishwoman's Domestic Magazine* offered many testimonials to the high-heeled shoe, including several that explicitly compared the style with foot-

Venetian courtesan in chopines (platform shoes) and underpants, ca. 1600. (From *Le Corset*)

binding. "One can understand about the torture endured by the Chinese ladies . . . [but] no one will, I think, deny the piquant and graceful effect of the High-heeled Shoe."[14] A small, "neat" foot in a "delicate" shoe, giving a "graceful" walk were among the clearest enthusiasms of many *EDM* correspondents.[15] They anathemized the "large, clumsy, heavy" heels of men's shoes, preferring narrow heels "as high as possible," which gave "a high instep" and "an arched waist."[16] One correspondent insisted that he had "seen fair Parisiennes walk with ease on heels quite three inches high."[17] Notice how the numerology of foot size seems to have been transposed to the size of the heel.

"High heels having succeeded the corset question in the ladies' 'Conversazione,' will you allow me to express my opinion upon this latter as upon the former subject?" wrote WALTER. (You remember Walter, who described tight-lacing at a boys' boarding school in Austria.) He liked the "graceful mode of walking" induced by high heels, especially the way they caused a lady to "point her foot." Indeed, he himself had "adopted ladies' boots . . . [and] gradually increased the height of the heels [to 3 inches]."[18]

Long before fashion emphasized high heels, fetishists did, and they have consistently advocated heels significantly higher than the fashionable norm. According

to shoe historian Mary Trasko, fetishists have always emphasized "the extreme and ignored fashion trends."[19]

"The love of high heels is one of our 'kinks,' and I think a very harmless one at that," wrote a correspondent to *London Life* in 1933.[20] Within the fetishist subculture, high heels were second only to corsets in popularity. Indeed, high heels, tight corsets, and cross-dressing formed a common combination. HAPPY HEELS, for example, claimed to have pursuaded her husband to wear high heels and corsets while at home.[21] Mr. X said that he wore 8-inch heels and a 19-inch corset.[22] SUBMISSIVE WIFE endured tight corsets and stilt-like heels to please her husband. SIX-INCH HEELS also "Dress[ed] to Please Hubby," but she also claimed to please herself "even more." "I cannot see myself submitting unless I enjoyed it."[23]

Heels are getting higher as skirts get shorter, claimed one correspondent to *Photo Bits* in 1910.[24] But the real picture was not that simple. Some of the fetishist literature on high heels was obviously fantastic. In 1910, *Photo Bits* published the serial story "Peggy Paget's Patent Paralyzing Pedal Props," fetish shoes with 18-inch heels and a "stilt" or "prop" under the sole in front.

Fetish shoe with a heel of almost 8 inches, Austria, ca. 1900. (Musée International de la Chaussure de Romans, France)

Oh, the tap of those "props" and "heels" on the hard floor! Oh, the ecstasy—the indescribable ecstasy that throbbed my every vein as I walked! Oh, the delight—the unutterable delight—that consumed me as the mirrors around the walls reflected my regal height and the erect pride with which I " 'dotted!"[25]

A person wearing such shoes was not necessarily supposed to be able to walk, however. Standing on point (not unlike a ballet dancer), with arches radically curved, the wearer could barely hobble. A fetish boot from turn-of-the-century Vienna has an impossibly high heel, which was designed to be inserted (like a dildo) into the fetishist's anus. Fetishistic pornography often describes how the male is scratched, stabbed, and penetrated by the woman's high heels.

The Shoe as Weapon—and as Wound

"The high heeled shoe . . . has become an object of devotion that borders on passionate worship," declared *High Heels* in 1962. Clad in a high-heeled shoe, "the foot becomes a mysterious weapon which threatens the passive male; and he glories in being so conquered." The high-heeled shoe is a "symbol of love"—and also "a symbol of aggression." "It signifies power. It indicates domination."[26]

Primitive gender stereotypes are typical of fetishist fantasies: "Nature had decreed that the male is aggressive while the female remains passive. But this situation has been reversed in the past few decades."[27] Although couched in terms of "female equalization," the image of the dominant female probably has more to do with the psychic reality of male–female relations within the fetishist's natal family. "The whole idea of a female's wearing high heels is to emphasize her naturally dominant and aggressive personality," wrote one correspondent.[28] "I consider men are real slaves," HIGH-HEELED defiantly told *London Life*, adding, "A man should be allowed to choose which kind of shoes he likes."[29]

"The bare foot . . . holds no secrets!" But once covered, it becomes "mysterious" and "forbidding"—and therefore fascinating. The leather "is like firm, hard skin!"[30] The man who worships high heels "is actually humbling himself before the superior sex." He regards woman with such "awe and reverence" that she seems "untouchable" and he feels grateful to kiss her shoes, finding this a satisfying "form of humiliation."[31]

There is also the giantess or crush fantasy, which envisions women as huge giantesses crushing tiny, insignificant men underfoot. *Leg Show* includes a number of photographs and drawings of powerful female feet, some naked, others in

heels, crushing and squishing everything from bananas to snails and bugs. (Videos are also advertised, which include "wet, slurpy sound effects.") One particularly striking series of photographs shows a woman's foot in a black high-heeled shoe being besieged and attacked by dozens of tiny plastic soldiers.[32]

Richard von Krafft-Ebing believed that "the majority—and perhaps all" shoe fetishists were masochists. Mr. X, for example, wanted to "lie at a lady's feet and smell and lick her shoes."[33] Havelock Ellis presented the case of a man whose erotic life focused on women's legs and feet, "exquisitely clothed," and on being "trampled on with utmost severity." C. P. wrote:

> The skirts should be raised sufficiently to afford me the pleasure of seeing her feet and a liberal amount of ankle, but in no case above the knee, or the effect is greatly reduced. . . .
>
> The treading should be inflicted . . . all over the chest, abdomen and groin, and lastly on the penis, which is, of course . . . in a violent state of erection. . . . I also enjoy being nearly strangled by a woman's foot.[34]

The strangling fantasy that C. P. enjoyed when the foot pressed on his throat suggests some significant connotations. Certainly, the pressure on the penis recalls the pressure of the corset, the constriction of a tight glove, and so on. C. P. even derived "a strong erection" from seeing grass "rise again" after a woman's "foot has pressed it."[35] He did not like boots, however, and had "an unconquerable aversion to red in slippers or stockings; it will even cause impotence."[36] Attracted by the shoe as weapon, he was repelled when it symbolized the wound.

Some shoe fetishists, however, are fascinated by physical mutilation. A man from Oregon wrote to the Biz-zarre Club about his interest in "extreme" and "unusual" shoes: "I am a student of shoe design specializing in orthopedic styles for the lame or deformed."[37] *London Life* published a number of letters about the "monopede kink."[38] The photographer Helmut Newton appeared to be evoking this type of fetishism when he shot Jenny Capitän dressed as a "cripple" in a full-leg cast and neck brace, posed in front of an unmade bed in the Pension Dorian, Berlin.[39]

"Panty Raid," an example of transvestite pornography, includes a number of fantasies about fetish shoes. When the dominant female "stamped her dainty but powerfully shod foot, tiny sparks escaped from the stiletto seven-inch heel!" Each shoe also had "an open-toe through which peeped a gleaming red nail." (Illustrations in shoe-fetish magazines often show the female toenails as cruel red talons or claws.) The captive male in the story was dressed as a woman as punishment:

FAR-OUT FASHION

"*Far-Out Fashion*" (From *Bizarre Shoes and Boots*, 1984; Centurian/Spartacus)

"Bruce nearly gagged when both of his feet were punished as they were inserted into the high arched instep of these white patent leather shoes." The most striking aspect of the shoes was their blatant castration imagery: "The vamp was decorated with an unusual design: a miniature guillotine, glimmering in a rhinestone setting."[40]

Booted Master

There are no rhinestones and stiletto heels in pornographic novels like *Boot Licker*, *Boot-Licking Slave*, and *Booted Master*, but the titles give a sense of this genre, in which boots symbolize a big penis. Boots with heavy soles and heels that smell of sweat and leather are ultra-masculine: "The black leather engineer boot is the boot for men who know that you are what you wear on your feet." A boy must learn to be "worthy of the boots of a man."[41]

In *Booted Master*, the tough biker Nino mocks Brian's effeminate shoes: "Sneakers! . . . You little pussy! . . . And I suppose you got a pair of red satin panties on under your jeans, too?" Motorcycle clubs, Nino says, have "a dress code just like the dress code which demands a jacket and tie for a man at a fine restaurant, or a certain style to get into Studio 54." He ties Brian up, with a sneaker tied around his genitals, "to teach you about boots." This segues into a scene of licking boots: "They'll be like mirrors . . . you'll be able to look down and see your peter in 'em." The taste is of "dirt, leather, cum, shit, and piss."[42]

"Let me feel your boots around me," a man says. But Brian insists that men who have sex with other men are *not* "queer or gay. . . . They just did it with guys . . . for fun." Wearing boots is a masculine privilege, for studs only. "You didn't think you could fill my boots did ya, punk?" mocks Nino. Then he is supplanted by a man in cowboy boots of "polished leather with ingrained designs . . . tall heels and pointed toes." The man also wears "a pair of cowboy chaps still smelling of bull semen and an opened shirt, exposing a muscled chest." Boots can taste like velvet.[43] Slaves lick their masters' heavy black leather boots "like a baby licks a pacifier."[44]

Boots have also been associated with lesbians. In contemporary Brazil, the word for a dyke is *sapatao*, which literally means "big shoes." One Brazilian man explained: "The shoe has the connotation of the foot, that the man who has a large foot, he . . . has a big prick. . . . It's a popular proverb." But "of all the terms for the dyke, 'army boot' [*coturno*] is the strongest," added another man, because

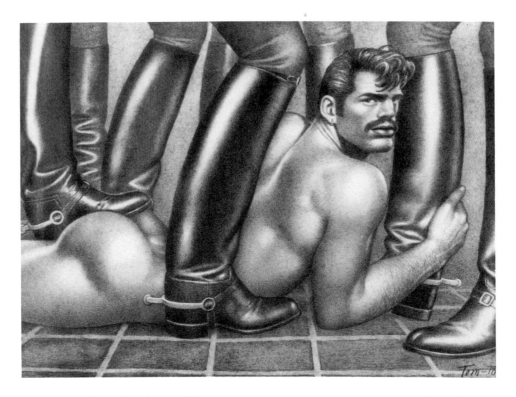

Drawing by Tom of Finland, 1978. (Image used by written permission of the Tom of Finland Foundation, P.O. Box 26658, Los Angeles, Calif. 90026)

"it's the symbol of machismo." A soldier puts on "boots that come up to here, a thing to step in the mud with, to go to battle. . . . So it's very much a man's thing! Understand? So, the army boot is a shoe that stands up to everything and is strong." Conversely, the Brazilian slang term for a "femme" lesbian is *sapatilha* (slipper), "because *sapatilha* is the shoe that ballerinas use."[45]

Boots have been strongly correlated with both masculinity and powerful phallic femininity for more than a century. A SUSCEPTIBLE BACHELOR wrote to *EDM* that boots, "as emblematic of strength and resistence," were "decidedly masculine." He preferred "delicate curving sandals," although whether for himself or his lady friends is unclear.[46] NIMROD associated booted women with Amazons: "Ladies' riding-boots should be Wellingtons or Napoleons," worn with chamois trousers. Spurs (another enthusiasm for many *EDM* correspondents) should, he argued, be clearly visible.[47] A twentieth-century transvestite reported that he liked the look of women's boots "because it hides ankles (bony and therefore not feminine enough) and emphasizes calves (flesh)."[48]

A rare case of female fetishism involved a general's daughter attracted by "the shiny riding boots of her father." She chose to marry an ugly old man "just because he wore very high riding boots." "A man clad in boots and sitting atop a horse is the only man," she asserted. Conversely, a man in low civilian shoes was "no man at all in her eyes." She was violently repelled by a man's naked foot, especially the big toe. "She herself preferred to wear high shoes because of the virile and erect appearance it gave her and also because of the *pleasant sensation of being tightly laced in.*"[49]

Shoes and Sex

"Many close-ups of pretty feet slipping into, in . . . and out of sexy spike heels," promises an advertisement for fetish videos.[50] The shoe can function as a symbolic substitute for the penis, and also for the vagina into which the phallic foot is inserted. Freud thought that the shoe was frequently fetishized because it was the last (acceptable) thing the boy saw when he looked up his mother's skirt before his eyes met the horrifying female genitals.

But in his Pulitzer Prize–winning book, *The Denial of Death*, Ernest Becker argues that "the foot is its own horror; what is more, it is accompanied by its own striking and transcending denial and contrast—the shoe." Other body parts also have their corresponding fetish objects: The genitals are veiled by lingerie, the fleshy torso and breasts are armoured in corsets, but the foot-and-shoe form a particularly striking unit. Whereas the foot is a low and dirty "testimonial to our degraded animality," the shoe—made of soft and shiny polished leather with an elegantly curved arch and pointed toe, lifted above the ground on a hard spiked heel—"is the closest thing *to* the body and yet it is not *the* body."[51]

In support of his theory, Becker quotes from a case history in Médard Boss's *The Meaning and Content of Sexual Perversions*. It describes a man who believed that "sexual intercourse is a great disgrace for humans."[52] Boss's patient was also repelled by naked feet. He was very much attracted to clothing fetishes, however, particularly ladies' shoes and boots:

Whenever he saw or touched [ladies' boots and shoes] "the world changed miraculously," he said. What had just appeared as "grey and senseless within the dreary, lonely and unsuccessful everyday, then suddenly drifts away from me, and light and glamour radiate from the leather to me." These leather objects seemed to have "a strange halo" shedding its light upon all other things. "It is ridiculous, but it feels

like being a fairy prince. An incredible power, Mana, emanates from these gloves, furs and boots, and completely enchants me." . . . Naked women or a woman's hand without a glove or especially a woman's foot without a shoe . . . seemed to be like lifeless pieces of meat in a butcher shop. In fact, a woman's naked foot was really repulsive to him. . . . However, when the woman wore [the fetish] she . . . grew above the "pettiness and vicious concreteness of the common female" with her "abhorrent genitals" and she was raised into . . . "the sphere where superhuman and subhuman blend into universal godliness."[53]

There is much to be said for Becker's theory, and yet it overemphasizes the differences between the foot and shoe.

Many fetishists are attracted to *both* the body part and its covering. Some work to glamorize the foot with pedicures, creams, and nail polish; others are attracted particularly to "red, swollen, dirty, sweaty" feet.[54] Some fetishists claim to "worship" feet and shoes; others seem to want to punish the feet by forcing them into shoes that are "beautiful," but also painful or crippling. One man who liked to "direct the stream of semen . . . into the opening of the shoe" (a man's patent leather shoe) was severely depressed when he noticed "a slight crack in one of the shoes." It was "as if I had seen the first wrinkle in the face of a beloved woman."[55]

Repulsion and attraction alternate. "I even get turned on by the sight of my own feet," declared one man, communicating via Internet.[56] By contrast, a recent biography of the novelist F. Scott Fitzgerald reveals that "the sight of his own feet filled him with embarrassment and horror," and he tried never to let other people see his naked feet. Yet Fitzgerald was sexually excited by women's feet. In a scene from *This Side of Paradise*, he uses the image of a man's ugly feet to symbolize evil and sexual immorality: "The feet were all wrong. . . . It was like weakness in a good woman, or blood on satin." His biographer argues that Fitzgerald's phobia about feet, "which stick out stiffly and were strongly associated with sex," was related to his belief that his penis was inadequate.[57]

Fetishism, Becker argues, "represents the anxiety of the sexual act," and the fetish itself functions as a "magical charm" that transforms the terrifying reality of "species meat" into something "transcendant."[58] The intense repulsion experienced by fetishists is extreme, like the overidealization of the cultural fabrications that fascinate them. Yet who would doubt that physical sexuality seems at least a little threatening to almost everyone? Performance anxiety is a male fear, and this may be one reason why fetishism is almost always a male perversion. If a woman is afraid of sex, she may become "frigid," but she can pretend to have an orgasm (if that is regarded as desirable). A man's failure is harder to conceal. So he "hyp-

notizes himself with the fetish and creates his own aura of fascination that completely transforms the threatening reality." The fetish is "a magic charm." [59]

"In many cases one finds that perverse activity is more freely exercised when certain aesthetic conditions are fulfilled," observed one psychoanalyst many years ago. Just as a man with whipping fantasies insisted on a whip that was exactly the right size, shape, and color, so did shoe and underwear fetishists insist that their objects had to "conform to certain rigid aesthetic laws of pattern, color, line and so on." He added:

> The rigidity of such standards is reminiscent of the severe canons upheld by some critics or exponents of the fine arts. Indeed, if one did not know what was the actual subject matter . . . it would be very difficult for the hearer to distinguish certain diagnostic discussions of the conditions for perverse sexual gratification from an aesthetic discussion of "good" and "bad" art. [60]

Some psychiatrists suggest that there may, in fact, be a relationship between "creativity and perversion." They argue that "perverts" are especially drawn to art and beauty, and their compulsion to idealize is related to their need to disguise anality. Thus, the fetish object is often both smelly and shiny. [61]

Already by the nineteenth century, shiny black leather was especially prized. Krafft-Ebing's *Psychopathia Sexualis* (1886) includes several case histories of shoe fetishism. Neglected and maligned as inaccurate and anecdotal, these little stories cry out to be analyzed as narrative texts.

> Case 113. *Shoe-fetishism.* Mr. von P., of an old and honourable family, Pole, aged thirty-two, consulted me in 1890, on account of "unnaturalness" of his *vita sexualis*. . . . At the age of seventeen he had been seduced by a French governess, but coitus was not permitted; so that intense mutual sexual excitement (mutual masturbation) was all that was possible. In this situation his attention was attracted by her very elegant boots. . . . Her shoes became a fetish for the unfortunate boy. . . . He had the governess touch his penis with her shoes, and thus ejaculation with great lustful feeling was immediately induced. [62]

The explanation of the etiology of fetishism given here is extremely problematic. Many men's first sexual encounters involve mutual masturbation while clothed, but they do not usually become shoe fetishists.

"In the company of the opposite sex the only thing that interested him was the shoe, and that only when it was elegant . . . with heels, and of a brilliant black." These are precisely the characteristics overwhelmingly preferred by shoe fetishists today. When Mr. von P. saw women on the street wearing such shoes, "he was so intensely excited that he had to masturbate. . . . Shoes displayed in shops,

and, of late, even advertisements of shoes, sufficed to excite him intensely." He was advised to marry, but

> the wedding night was terrible; he felt like a criminal, and did not approach his wife. The next day he saw a prostitute. . . . Then he bought a pair of elegant ladies' boots and hid them in bed, and, by touching them, while in marital embrace, he was able to perform his marital duty . . . [but] he had to force himself to coitus; and after a few weeks this artifice failed.

He felt guilty toward his wife, "who was sensual, and much excited by their previous intercourse." But even had he been willing to "disclose his secret" (which he was not), and if his wife "were to do everything for him, it would not help him; for the familiar perfume of the *demi-monde* was also necessary."[63]

This scenario resembles certain twentieth-century accounts[64]—although the modern fetishist-husband often tries to get his wife to go along with his sexual obsessions. The literature on prostitution indicates, however, that the shoe fetishist is still a recognized type.

Foot and shoe fetishism is widely believed to be the commonest type of fetishism existing today.[65] As one publisher put it, "When we started our magazine on sex fetishes, we expected to cover the whole range. But our mail and other feedback quickly told us that the foot and shoe fetishes outnumbered any other fetish group by at least three to one."[66] Pornographic titles include *Foot Worship, Foot Torture, High-Heeled & Dominant, High-Heeled Sluts, Spikes Domination, Spurs, Stiletto, Super Spikes,* and *Unisex Shoes & Boots. Foot Torture* is about a female jogger who is taken to a man's apartment and made to remove her clothing down to her underpants and sweat socks. "After smelling her socks he licks her bare feet, ties them up and places them over a Hibatchi! Then he tickles them and. . . ." This scenario would seem to have only a limited appeal, and, indeed, a major survey of pornographic publications revealed that less than 1 percent were devoted to shoes, boots, and feet.[67] But Marilyn Monroe was not referring to 1 percent of the population when she (supposedly) said, "I don't know who invented the high heel. But all women owe him a lot."

Foot Worship

Dian Hanson, the editor of *Leg Show* (one of the best contemporary fetish magazines), warned her readers that there was a "gulf of misunderstanding" between men and women: "Since normal male sexuality intimidates women, imagine what

fetishes do to them." When she asked a number of women "if they knew some men were turned on by seeing their feet in sandals, the most common reaction was disbelief. Followed by fear. Some women said the information made them want to stop wearing sandals, made them afraid to wear sandals." She wanted to reassure women that only "the unbalanced few" needed to be feared; in most cases involving fetishism, the women "had all the power."[68]

When I have lectured on shoes, some women in the audience have also become agitated, asking, "What kind of shoes can I wear that *won't* attract fetishists?" But almost every kind of shoe seems to have its enthusiasts, including ripped old sneakers. Nevertheless, certain styles evoke most interest.

For many years, high boots have been "the trademark of prostitutes specializing in sadomasochism."[69] By 1994, Ann Magnuson could joke with the readers of a fashion magazine that designers like Marc Jacobs had "crossed Emma Peel with Betty Page to come up with . . . boots that would look smashing with a rubber mac and a horsewhip." Patent leather boots with spike heels were "for the dominatrix in everyone." Wearing these heels, she reported, "I felt a surge of power, knowing that I could lay waste any man I chose to destroy." She fantasized: "Down on the floor, you worm! I said *now*, you worthless CEO!"[70]

In recent years, fashion has frequently emphasized what one fetish magazine called "cruel shoes."[71] As a writer for *Bizarre* put it, "Check out some of these latest fashions and tell us that women aren't getting into that dominant feeling."[72] One professional dominatrix explained that, like her transvestite clients, she had to learn how to walk in 5-inch heels, but she preferred them for her work: "It pushes up your ass. Also you can use your high heel as a torture item." Heels also make a woman taller, "which is an advantage over men."[73]

Since exposure implies accessibility, "naked" shoes are also regarded as sexy. Slingbacks are popularly known as "fuck me shoes" because they present a naked rear view of the foot. Frederick's of Hollywood named one shoe "Open 'n Inviting." "Open to Suggestion" is a "provocative open-toed pump" that is "sensually punched for a really nude look."

According to image consultants, open-toed shoes "encourage men to think of women as a sexual partner rather than as a potential chairman of the board," reported the *Wall Street Journal*.[74] An extra one-sixteenth of an inch reveals the crack between the toes, which apparently can remind men of other kinds of cleavage or, perhaps, other "slits" in the female body. Or as Ann Magnuson reported, "The shoe lewdly exposed my toe cleavage in a display vaguely reminiscent of some meat by-product at my local butcher shop."[75]

The foot is perceived as a surrogate body, whose different parts can be exposed. Glamorous evening pumps have "a low-cut throat line," reported Frederick's. A "vampish fantasy" highlights a split vamp, open toe and ankle strap. The great shoemaker Salvatore Ferragamo once designed a satin shoe with the vamp "cut away to show the instep in precisely the same fashion as Dior's neckline." He also designed a shoe with a clear "crystal" oval inserted into the sole. When the wearer held her foot at a certain angle, other people could see the bottom of her foot.[76]

Exotic is another key term in the Frederick's of Hollywood vocabulary: "EXOTIC leopard print on SENSUOUS Fur." It may implicitly evoke "exotic" sex practices: "A HIGH-STEPPING sandal in EXOTIC leather in alligator print PROVOKES his desires." A snakeskin sandal is "SSS-insational" (note the accent on *sin*). Bondage is also erotic: "A sexy ankle strap twists seductively around your shapely leg." One sandal has a "captivating 'cage' back," while another features a "sexy chain strap." Certain materials catch the eye: "Patent leather SHINES seductively day or night."[77]

The popularity of certain fetish objects is not random. There are cultural and historical reasons why certain clothing items are often chosen as fetishes. High heels are strongly associated in our culture with a certain kind of sexually sophisticated woman, which is why they are favored by prostitutes and cross-dressers. By contrast, low heels have come to imply the absence of female sexual allure. According to the magazine *High Heels*, "Flat is . . . a dirty word! And you'll find nothing 'flat' in this issue of HIGH HEELS except the tummies of the models—who wouldn't be caught dead in 'flats,' who all have FULL bosoms, CURVY torsos, ROUND hips, LITHE legs, and . . . HIGH HEELS!"[78]

Many characteristics commonly associated with feminine sexual attractiveness are accentuated by high-heeled shoes, which affect the wearer's gait and posture. By putting the lower part of the body in a state of tension, the movement of the hips and buttocks is emphasized and the back is arched, thrusting the bosom forward. High heels also change the apparent contour of the legs, increasing the curve of the calf and tilting the ankle and foot forward, thus creating an alluringly long-legged look. Seen from a certain angle, a high-heeled shoe also recalls the pubic triangle.

There are probably biological reasons why fetishes tend to have a strong visual appeal. Shiny black leather shoes catch the eye, and black stockings show up against white skin. There is considerable evidence that the male pattern of sexual arousal is more visual than that of the female. We now know that infants can

Fake-pony-skin shoes with spurs by Thierry Mugler, 1991. (Roxanne Lowit)

perceive black on white before color, and males may "imprint" early on contrasts that graphically delimit parts of the body. Male arousal is also more sharply defined, perhaps because the penis gives an immediate response.

Many women also love shoes and avidly collect them. Yet this female enthusiasm seldom parallels the specifically erotic practices of male shoe fetishists (such as licking shoes) or even the visceral response of ordinary fetishizing men (women seldom have an involuntary orgasm when they see a man in nice shoes). Nor do women seem to have the fantasies associated with male shoe fetishists (such as the giantess squishing little bugs). Nevertheless, shoes certainly provide tactile stimuli for women. As Ann Magnuson put it,

> The bones in my ankles cracked . . . and my Achilles tendons bent backward. . . . Hobbling down the avenue, I became acutely aware of . . . my body. My breasts jutted forward, while my back was severely arched. My ass felt bigger than a Buick, and my thighs, or rather my *flanks*, swung back and forth like a couple of sides of beef. . . . Are these shoes disempowering? Do they enslave us? Are we rendered helpless by wearing them?

The answer is yes! Yes! Of course! What other point would there be in wearing them? [79]

(The heels also made her feel "mythically omnipotent," while the difficulties involved in wearing them decreased with practice.)

Whereas men seem to "imprint" early in their lives on certain types of shoes (such as stiletto-heeled pumps), women apparently respond more consciously to the cultural construction of shoes as objects of desire. Their interest in particular types of shoes is often related to the current fashion. Already in the 1960s, Yves Saint Laurent showed thigh-high crocodile boots, and Mary Quant designed corset-laced boots. In the 1970s, English and Italian fashion shops like Biba and Fiorucci showed high platform shoes. The 1980s saw both fantasy shoes, like Thea Calabria's "Maid Shoe," and classic styles, like pink satin evening mules by Manolo Blahnik. The 1990s witnessed the revival of all these period styles and especially 1950s stilettos, the classic "bitchy" shoe. The spread of "downtown" gay male style has also become increasingly conspicuous at the highest levels of fashion: from Versace's bondage gladiator boots to Chanel's triple-buckled leather combat boots, which resemble the ones worn by motorcycle cops (except for the entwined Cs stitched on the toes). Avant-garde designers like Vivienne Westwood and Jean-Paul Gaultier have been notably inspired by fetish gear. Westwood designed platform shoes so high that model Naomi Campbell fell down during her show. Gaultier mines all the kinks—from rubber boots to weird creations with multiple spikes.

Fashion writer Holly Brubach once wrote an essay, "Shoe Crazy," asking why so many women loved shoes. Freudian theories may "account for the thrill some men get out of the shoes women wear," she argued, but they fail to explain "the thrill *women* get." As she put it, "No woman with a normal, healthy shoe drive would content herself with a closetful of phallic symbols." [80] I agree.

The shoe combines masculine and feminine imagery on many levels, from the stiletto heel penetrating the fetishist's body to the foot sliding into an open shoe. Pornography frequently labels the woman in high heels as a slut, thus positioning her as an accessible sexual object. (If she wears prostitute shoes, then she's asking for it.) Conversely, the discourse in women's fashion magazines focuses on the fantasy that men will worship at the feet of a beautiful woman. Equally important is the role shoes play in the creation (and violation) of gender stereotypes. "I adore girls in heels," says fashion photographer Mario Testino. "They can play and wear high heels, and we can't." High heels are "the ultimate symbol of womanhood," declared journalist Frances Rogers Little. And Testino agreed, "It's the one thing that differentiates men from women." [81]

Underwear as fetish. (Copyright © Eric Kroll, 1994)

five

Underwear

I n 1994, a Times Square establishment called the Lingerie Lounge advertised a new twist on the strip show:

Keep A Breast of the Latest in Sexy Fashions. Bare Elegance. Beautiful Girls Modeling Hot Sexy Lingerie. Peek in on Girls Taking Their Clothes Off and Trying on Sexy Lingerie in our

LINGERIE LOUNGE

Surround yourself with beautiful Fashion Models in various stages of undress. . . . Our girls are never really nude, they always have their garter belts and stockings on![1]

The women's fashion magazine *Mirabella* then reprinted the Lingerie Lounge flyer on a page of fashion news that showed the latest lingerie-inspired fashions.

This chapter will explore the erotic appeal of underwear, as both fetish and fashion. After a brief section on underwear eroticism in general, the chapter will be roughly divided into sections devoted to different garments, such as underpants, stockings and garter belts, slips, brassieres and girdles. The focus will be primarily on female underwear, but men's underwear will also be considered. The distinction is not always clear, however, since one of the erotic functions of underpants is to blur the visible distinctions between men and women. We will also look at the phenomenon of underwear-as-outerwear, which has become a major fashion trend over the past decade. It may be significant in this respect that the performers at the Lingerie Lounge are described as "Fashion Models."

*Underwear as outerwear
by Dolce and Gabbana.*
(Roxanne Lowit)

It Is the Veiled, Secret Part

This is not intended to be a history of underwear, but some historical background is necessary to place the subject in context. The development in early modern Europe of a specialized category of underclothing was an important historical stage in the evolving eroticism of dress. In place of the traditional paradigm of the naked and the clothed, there was now an intermediate position, since a person in underwear was simultaneously dressed and undressed. The origin of underwear was practical, however, not erotic. "The perceived need for underclothing as distinct from main garments amongst the nobility . . . developed in the Middle Ages," and was motivated in large part by the desire to protect expensive outer garments from the sweaty, dirty body underneath. Linen undergarments also pro-

tected the body from being irritated by abrasive wool clothes and provided an extra layer of warmth.[2]

Underwear began to become the focus of sexual and sartorial interest by the eighteenth century, a process that accelerated in the second half of the nineteenth century; the years between about 1890 and 1910 were "the great epoch of underwear."[3] Emile Zola described the lingerie on display at a Paris department store that looked "as if a group of pretty girls had undressed, piece by piece, down to the satin nudity of their skin."[4] Another writer, Octave Uzanne, compared a woman in lingerie to a flower, "whose innumerable petals become more and more beautiful and delicate as you reach the sweet depths of the innermost petals. She is like a rare orchid, who surrenders the fragrance of her mysteries only in the intimacies of love."[5]

Month after month, the fashion press elaborated on the theme: "Lingerie is an enthralling subject." The English fashion writer Mrs. Eric Pritchard even argued that "the Cult of Chiffon has this in common with the Christian religion—it insists that the invisible is more important than the visible. . . . Dainty undergarments . . . are not necessarily a sign of depravity." "The most virtuous among us are now allowed to possess pretty undergarments without being looked upon as suspicious characters," wrote Pritchard, who even blamed failed marriages on a wife's unwillingness to wear seductive lingerie. A woman might be "the most virtuous" of wives, but if she were "without mystery and without coquetry," she would be far from attractive to her husband—who might well stray in search of another "petticoat."[6]

French writers were even more emphatic about the erotic appeal of lingerie. According to the Comtesse de Tramar, the act of undressing marked "the amorous stations of desire." If the wife was also to be her husband's lover, she should recognize the "essential importance" of erotic underwear: "It is the veiled, secret part, the desired indiscretion conjured up; the man in love expects silky thrills, caresses of satin, charming rustles, and is disappointed by an unshapely mass of rigid lingerie. . . . It is a disaster!"[7] In *Tous les secrets de la femme*, the Baronne d'Orchamps agreed that "nothing equals the voluptuous power of feminine underwear." "At the apparition of these veils . . . [an] ineluctible rapture . . . comes over the masculine brain." Their "vaporous ingenuity and involved style add to the mysterious and tempting power of the desired treasures in proportion that the woman feigns to protect and distance them."[8]

The sexual power and charm of the naked body seemed to "rub off" on underwear, which then added an additional *frisson* of excitement all its own. By artfully

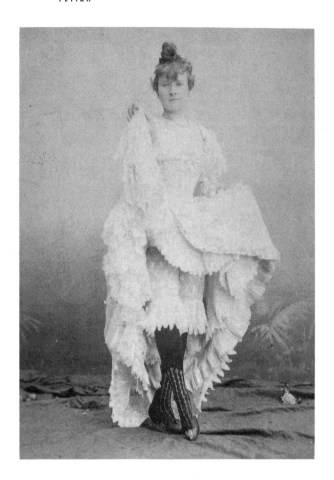

La Goulou in frilly under-
pants and petticoats, ca. 1895.

concealing the body, especially the genitals, underwear heightens sexual curiosity, holding in promise the thrill of exposure. Concealed from sight, like the body that it touches, underwear also alludes to undress as a prelude to sexual intimacy. But this is no more than the "normal" fetishizing that seems characteristic of so much of the sexual imagination.

The correspondence in periodicals like *Society* was more overtly fetishistic. SATIN WAIST declared that the compression of his red satin corset was "more than compensated for by the delightful freedom of the lower limbs, and the musical 'swish' of petticoats."[9] "Petticoats! The word has ever a fascinating sound, has it not? . . . [I]t is an essentially feminine garment," wrote another enthusiast.[10] "Every man who *is* a man has a perfect passion for frills and 'frilly' things."[11] The theft of petticoats is the theme of stories like "The Strange History of a Lace Petticoat."[12] Meanwhile, the clinical literature reports cases of petticoat fe-

Fashion from Gianni Versace's "bondage" collection, 1992. (Roxanne Lowit)

Leather at the gay-pride parade. (Robert Fox/Impact Visuals)

Exotic bondage. (Centurian/Spartacus)

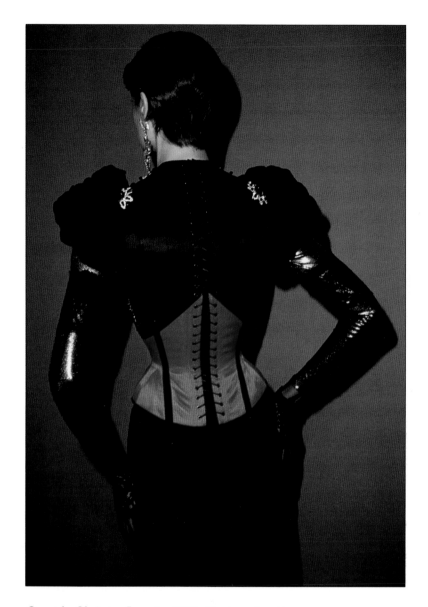

Corset by Christian Lacroix, 1994. (Roxanne Lowit)

Madonna in a corset by Jean-Paul Gaultier.
(Archive Photos)

Corset by Vivienne Westwood, 1987–1988.
(Vivienne Westwood)

Corset by Karl Lagerfeld for Chanel, 1992. (Roxanne Lowit)

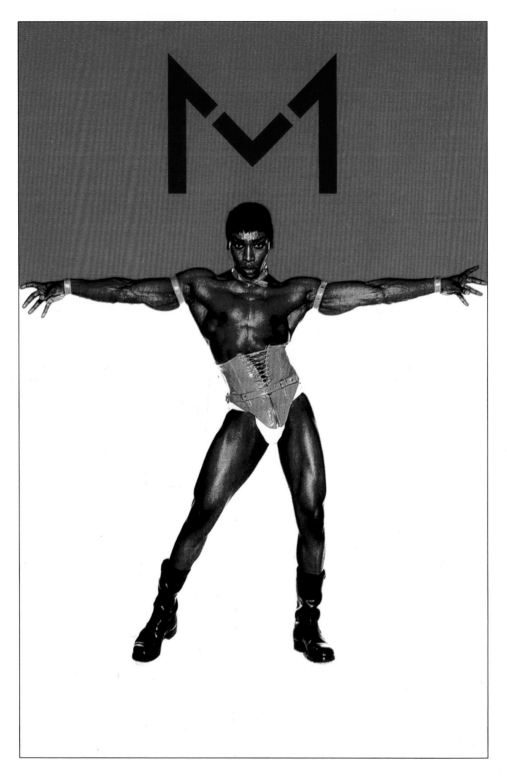

Photograph of Roy for Murray & Vern. (Copyright © Peter Ashworth, 1993)

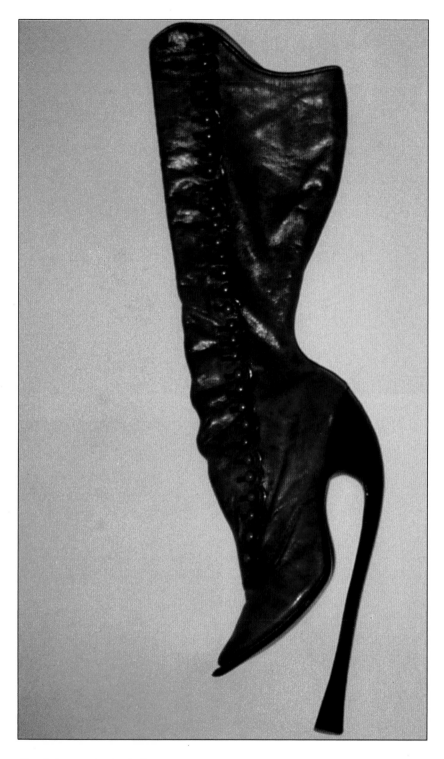

Fetish boot with a heel of almost 11 inches. Vienna, ca. 1900. (Photograph by Elizabeth Eylieu; Collection Guillen; Musée International de la Chaussure de Romans, France)

Rubber dress and leather trenchcoat by Marc Jacobs, fall 1994. (M. Chandoha Valentino)

Red motorcycle boots by Chanel, 1992. (Roxanne Lowit)

Girdle and shoes. A similar picture appeared in Leg Show. (Copyright © Eric Kroll, 1994)

Dolce and Gabbana, 1991. (Roxanne Lowit)

Underwear from the Ghost collection, 1994. (M. Chandoha Valentino)

"Panty Raid." (Division of Rare Book and Manuscript Collections, Carl A. Kroch Library, Cornell University)

Fake-fur panties by Vivienne Westwood, 1994. (Roxanne Lowit)

"Fetish girl" in latex. (Copyright © Eric Kroll, 1994)

Second-skin fashion at Thierry Mugler, 1991. (Roxanne Lowit)

Satin, leather, and lace. Anna Sui, spring 1995.
(Roxanne Lowit)

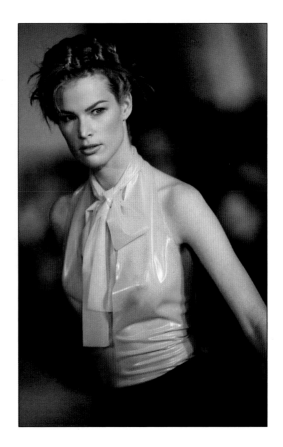

Rubber becomes fashionable. Marc Jacobs, fall 1994.
(M. Chandoha Valentino)

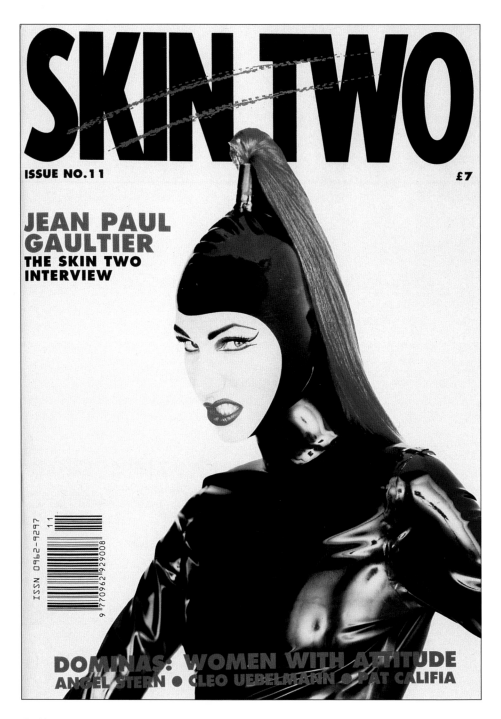

SKIN TWO

ISSUE NO.11

£7

JEAN PAUL GAULTIER
THE SKIN TWO INTERVIEW

ISSN 0962-9297

DOMINAS: WOMEN WITH ATTITUDE
ANGEL STERN ● CLEO UEBELMANN ● PAT CALIFIA

Rubber gear by Kim West. (Photograph by Kevin Davies)

Corset and chaps by Thierry Mugler, 1992.
(Roxanne Lowit)

Motorcycle bustier by Thierry Mugler, 1992. (Patrice Stable JFP)

"Naughty Nurse." (Aaron Cobbett)

Anna Sui, spring 1995. (M. Chandoha
Valentino)

The construction of femininity. (Centurian/Spartacus)

High heels. (Archive Photos)

Fetish shoe from the 1930s. (Photograph by
Elizabeth Eylieu; Collection Hellstern;
Musée International de la Chaussure de
Romans, France)

Black lace mask and gloves by Anna Sui, spring 1995. (Roxanne Lowit)

Dress with back lacing by Jean-Paul Gaultier, 1991. (Roxanne Lowit)

Corset by Thierry Mugler, 1992. (Roxanne Lowit)

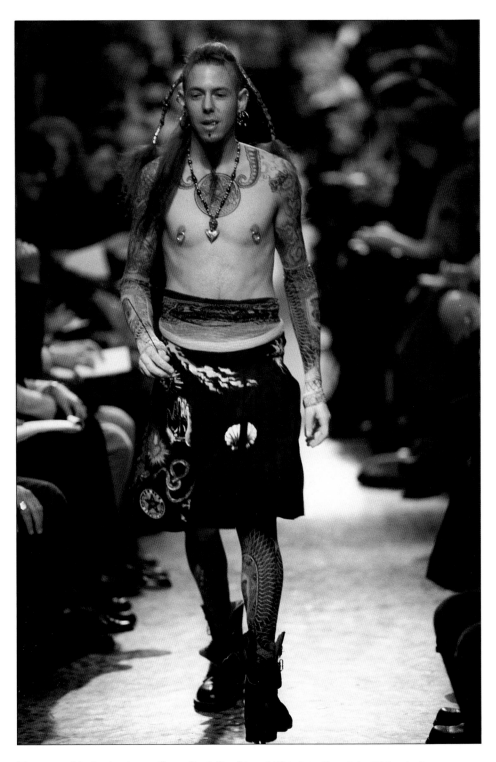

Tattoos and body piercing at Jean-Paul Gaultier, 1994. (M. Chandoha Valentino)

tishism, such as the German peasant who masturbated with his mother's or sister's petticoats, saying that "the petticoats were, for him, the same as a woman." (At the age of thirty, when he was arrested for the theft of petticoats, he never had had intercourse with a woman.[13])

It would be a mistake to think that underwear fetishism was a phenomenon only of the fin de siècle. It is true that fashion changed dramatically after about 1910, and the mystery of rustling petticoats tended to give way to what were now lightheartedly referred to as "undies." But although the fashion for sartorial *froufroutage* was replaced by a new emphasis on body exposure and "candid" sexual display, the fetishizing of underwear continued to exist.

"Men like girls who like lingerie," declared stripper Lily "Cat Girl" Christine in a 1956 article provocatively entitled "My Under Pretties." It is not surprising that a stripper should extol the charms of lingerie, since the striptease artfully expoits the tantalizing effects of strategic concealment. Yet there is a defensive undertone in her insistence that "I don't go for the [Marilyn] Monroe 'no-underwear' slogan." Underwear had become "a controversial topic," she continued, because "a microscopic sized minority of girls have made headlines about not wearing anything under their dresses. But they do. They just think its more sexy and exciting to say they don't."[14]

Is it sexier with or without underwear? Opinions obviously differ, but a sizable number of men apparently like to linger at the stages prior to genital exposure and intercourse, and feel that a woman who is partially clothed is more alluring than one who is stark naked. Magnus Hirshfeld found that out of 1000 men, 350 said that they were most attracted to the naked body, 400 voted for partial nudity, and 250 preferred the fully dressed body.[15] Prostitutes still emphasize the use of lingerie. One dominatrix told the psychiatrist Robert Stoller that she wore three pairs of underwear. Removing the opaque top layer excited the client, who was then surprised and baffled to find that her genitals were still concealed, which reinforced the woman's position of "control."[16]

Women sometimes allude to the tactile and psychological appeal of underwear. As the Cat Girl put it, "I love lovely underthings and feel exquisite undergarments make a woman feel all woman."[17] But for men, there seems to be more of a leap from the sensual to the sexually symbolic. As one cross-dresser put it, "fine and silky underwear" made him feel "like a brilliantly entertaining prostitute." And another said that "even the mere names of pieces of clothing . . . had something magical."[18]

From Pants to Panties

Venetian courtesans wore underpants during the Renaissance, but the style was not widely adopted because of the historical association in the West between pants and masculinity. Long regarded as a "demi-masculine" article of dress, underpants were worn first by prostitutes, dancers, and little girls. Respectable women only gradually adopted underpants over the course of the nineteenth century for reasons of modesty, warmth, and "hygiene." As late as the 1870s, some French writers still argued that "*le pantalon* . . . is a man's article of clothing" that elegant women should abstain from wearing.[19] When the issue of impropriety faded, however, underpants quickly became fashionable and were increasingly made in elegant materials, such as silk. "So light, so brief, with cascades of Valenciennes lace and frills of ribbons, these *pantalons* . . . drive a lover crazy better than the immodest state of nudity," declared one French novelist in 1887.[20] Although some men complained that the opportunity to glimpse women's genitals had decreased as women adopted underpants, a new voyeurism directed toward the underpants themselves was born. Much of the appeal of high-kicking dances like the *can can* and the *cahut* derived from the exhibition of the dancers' frilly underpants and petticoats.

As underpants ceased to be identified with masculinity, they became associated with the sexual allure of the female genitals. An enthusiasm for women's underwear is linked with cross-dressing, and many transvestites have emphasized the appeal of feminine "panties," in contrast to the unappealing characteristics of both men's pants and underpants. Diane Kendall, the American correspondent for the English transvestite magazine *Repartee*, titles her column "Pampered in Panties" and often writes about "the ecstasy of wearing panties." In one column she declared: "Couldn't many of us say, 'My panties, my panties, my kingdom for a sweet pair of panties—and a woman who will put me in them.'"[21] Not all panties are equal, however. "There is a GREAT difference in panties," Kendall told me. "Most are not all that pretty." Her favorite brand she describes as "precious, very feminine, darling, lovely, sweet, adorable, yummies" and "so pretty!" Much as she loves her other items of lingerie, "panties are the crème de la crème, the very foundation (no pun intended) of dressing in wonderful girls' clothes. Many of us, most of us I would guess, got their start [cross-]dressing by first putting on a pair of panties."[22] Clinical studies also indicate that cross-dressers often begin

with one article of clothing (often underwear or shoes) before adopting a complete female costume. One transvestite, who had begun masturbating with his mother's underwear at the age of twelve, recalled: "I began to want more than women's panties."[23]

Although underwear plays a role in the history of fetishist literature, it does not seem to have been quite as popular as high heels or tight-laced corsets. LOVER OF LINGERIE wrote to *London Life* in 1933 to request "an increase in the 'undie' correspondence." There were many letters on high heels, tight-lacing, and rubber mackintoshes, he observed, but he would like to see more "detailed descriptions of entrancing undies." He praised in particular the letters that looked back longingly to Edwardian underpants: "None were better than the many letters dealing with the charm of the snowy white cambric knickers of several years back, with

Fetish underpants by the Diana Slip Company, ca. 1935.

their glorious fine lace and gay ribbons—which, alas, seem to have gone, never to return."[24]

Many underwear fetishists have nostalgically favored the luxurious, frou-frou styles associated with the Belle Epoch. In the 1930s, the Diana Slip Company designed and sold a variety of fetishistic underpants, including several of historical inspiration, such as the "Pantalon 1905" and "Le Frou-Frou." The company also sold other panties emphasizing fabric and color symbolism. The "Pantalon Amoureuse" was made of black lace appliquéed with a red satin heart. There were also "eccentric" models, made of rabbit fur or fake leopard fur.

"Undercover News," a story of transvestism written in the 1960s, describes "cute panty briefs of leather that could be locked to the body with a tiny lock and key, one-piece chemisettes of diaphanous latex that fitted like a second skin . . . and other ingeniously made intimates."[25] Underwear here both evokes bondage and replaces the body itself. Irving Klaw's famous erotic photographs include both decorative versions of conventional underwear and items resembling chastity belts. Frederick's of Hollywood and Ecstasy Lingerie, by contrast, emphasized easy access with "crotchless panties," "accentuated with black lace." A rubber-fetishist magazine featured both protective and crotchless panties, the latter with a choice of air-filled "lips" or "a frilly slit." "Candy pants," edible bikini-style underpants for men and women, were a fad in the 1970s. Approved for human consumption by the Food and Drug Administration, flavors included hot chocolate, banana split, and wild cherry.[26]

Underwear Bandits and No-Panty Cafés

"Mr. Z. was a 27-year-old lawyer who contacted us because of occasional bouts of impotence," reported sex researchers William Masters, Virginia Johnson, and Robert Kolodny in a case study entitled "The Underwear Bandit." He "had a striking fetish for women's panties," without which he experienced almost no sexual arousal. Moreover, "only used panties with a female odor would excite him." "Over the previous decade, he had stolen more than 500 pairs of panties." Even on his honeymoon, he slipped away to a laundromat, stole some panties, and masturbated with them.[27]

Krafft-Ebing also reported on a forty-five-year-old shoemaker who was caught

stealing women's underwear; the police found more than 300 petticoats, che-
mises, and drawers (underpants) at his residence.[28] The impulse to collect (often
to steal) numerous examples of the fetish object has been frequently observed in
the clinical literature. Stekel referred to it as the fetishist's "harem cult."[29]

An article in the *Economist* reported that "police in Japan are trying to curb an
unsavoury trade." Apparently, businessmen had stocked ninety vending machines
in Tokyo with used underpants "guaranteed to have been worn by a Japanese
schoolgirl." More than $200,000 worth of used panties had already been sold, at
¥3,000 (almost $30) each. The police were investigating whether the businessmen
could be prosecuted for selling antiques without a license or, alternatively, for
committing fraud, if it could be proved that the panties had not, in fact, been
worn by schoolgirls.[30]

It is commonly believed that fetishism is a specifically Western perversion, but
the evidence indicates otherwise. Although Japan does not have a history of
Judeo-Christian "puritanism" about the naked body, this does not mean that it
has no body taboos; there is, for example, a strong legal prohibition against the
visual representation of female pubic hair. Underpants are, of course, an imported
Western fashion that became popular in Japan only in the early twentieth cen-
tury. But as early as the 1920s, the Japanese writer Nagai Kafu described *no-pan
kisa* (no-panty cafés), where the waitresses wore no underpants. In 1981, Ian Bur-
uma reported on similar cafés, designed to expose the waitresses' underpants;
frilly panties decorated the walls, and there were panty auctions. Nicholas Bornoff
also mentioned a faux no-panty café in Osaka, with a special glass ceiling; patrons
sat in a room below and rubbernecked. The waitresses allegedly wore panties
decorated with drawings of the female genitals, and the business was closed down
after one actually took her panties off. Unsuspecting Japanese women at public
events are also subject to an extremely instrusive degree of voyeurism: "One video
artiste even invented a special mini-dolly which could allow an upward-pointing
camera to be moved along the ground by remote control." The ubiquity in Japan
of panty voyeurism is so great that not only specialist fetish magazines, but also
mainstream periodicals cater to it.[31]

When panties replace genitals as the primary source of erotic exitement, psy-
chiatrists tend to speculate that there is an underlying phobia with respect to
either the female genitals or the act of intercourse. Because the genitals are con-
cealed by underpants, there is a tantalizing ambiguity—brilliantly exploited in
Eric Kroll's photograph of a woman who seems to have a penis in her pants.

Pornography indicates that a fetishistic interest in underpants is also frequently related either to an interest in anal intercourse or to a sadomasochistic obsession with the buttocks as the site of corporal punishment.

Underpants also provide tactile and olfactory stimuli. The feel of underpants is frequently mentioned in erotic sources and may be related to fabric fetishism. The sexologist Magnus Hirshfeld recorded a tragicomic case involving a woman whose husband wanted her to wear flannelette knickers during their sexual intercourse. Flannelette is "nice and soft," he argued. But she was "miserable" because she regarded the fetish as a personal insult. "Now, if he had asked me to wear silk!" said the lady, "but a common material like flannelette!" (Eventually, he wore them himself, saying that "he wanted to occupy the woman's place during the act."[32])

Some studies of fetishism suggest that fetish objects can be roughly divided into "smellies" and "touchies." The fetishistic interest in the smell of used panties is highly significant, because it demonstrates that those characteristics that appeal especially to fetishists may not always be those that other men and women most enjoy. Although many women like lingerie, most would be disgusted by the thought of anything but clean underwear. (And yet disgust and desire do seem to be closely related in the unconscious.) Smelly fetishes may indicate an obsession with bathroom functions, which would seem to imply an "infantile" perspective on sexuality. Coprophilia may be associated with buttocks fetishism and, by extension, panty fetishism. It is quite common, though, for both men and women (and mammals in general) to respond sexually to certain types of olfactory stimuli.

The erotic significance of underpants in any given case is contingent on a variety of contextual elements. To a considerable extent, voyeurism directed toward underpants falls within the realm of "normal" fetishizing male sexuality. Pornographic magazines carry titles such as *69 Hot Panties*, *Panty Babes*, and *Panty Passions*. *Peek-A-Boo Pussy* and *Pussies & Lace* might also allude to panty fetishism. Homosexuals may also fetishize male underpants, which veil the sight of the other man's penis. Sexologists note that some men "collect panties from sexual conquests, and some men take a pair of their lover's underwear with them when they travel. . . . This is true in gay relationships also." But there seems to be a difference between those men who masturbate, *faut de mieux*, "associating the panties with a specific person," and "true" fetishists who are primarily aroused by the smell or feel of the panties themselves.[33]

Panty Raid

"Panty Raid" is a story written for transvestites. Robert Stoller has analyzed it in his essay "Pornography and Perversion," reprinted in *Perversion*. I would like to continue his interpretation, focusing specifically on underwear imagery. The story begins with the hero, Bruce King, making a one-man panty raid on a college sorority as part of his fraternity initiation. He is both nervous and excited:

> Suppose he did not succeed in this panty raid? Suppose he failed to come back with the booty—a pair of lacy-fringed bloomers or skin-tight peach panties, the silk-and-satin slip with red bows for straps, perhaps a panty-girdle or two, not to mention the thigh-length black mesh stage hose! His buddies at the fraternity might think less of him.[34]

As Stoller has pointed out, the plot device of a fraternity initiation serves to normalize and valorize the protagonist's act of stealing women's underwear. After all, real fraternity boys have conducted panty raids, so one needn't think there is anything bizarre about stealing women's underwear. It is not an inner compulsion, but his "buddies" who are forcing him to do it.

"He stealthily made his way around to the rear entrance" of the sorority. There, hanging on a clothesline, was "the lingerie he would soon possess." And now I would like you to notice the highly detailed description of the various items of lingerie:

> He stared at the waist cincher combined with a panty. The shirred edging was embroidered with tiny silk and satin blue roses, matching the velvet blue of the reinforced crotch. Beside it was a star white honest-to-goodness baby doll outfit. The straps of the bra part were milky-white, looping around the armpits; the sheer fabric was bewitching as it flounced in the cool wind. Four tiny heart-shaped buttons of pure silk were on the front. The lace front paneling matched the pleated Bikini panties. Bruce grinned. It sure would be interesting to see a girl wear such a baby doll outfit! And to catch her by surprise would really make him a hero!

Stoller argues that this fantasy expresses a high level of hostility toward women, a point I would not dispute. But hostility toward women is a standard feature of much pornography; I would rather have you think about how the author's lavish attention to clothing details would bore most readers. For transvestites, however,

the descriptions of materials, trimmings, and designs are enthralling in and of themselves.

But why should "milky-white" bra straps be exciting? Most transvestites are heterosexual, Stoller notes, although they also identify with women. "Considering intimacy with a living woman to be desirable but dangerous, they substitute her inert clothes for her living skin."[35] In place of the breast, they focus on the bra; in place of silky skin, "pure silk"; instead of a living virgin, "virginal white" panties. If panties equal genitals, then the emphasis on lacy, frilly panties may allude to curly public hair. Every sartorial detail corresponds symbolically to a physical or emotional aspect of femininity: "soft," "blushing," "pure," "skin-tight."

Suddenly, just as he is reaching for a pair of lacy panties, Bruce is surrounded by sorority girls, "some wearing satin slacks, others silk shorts"—hardly the usual coed styles, but answering to the transvestites' enthusiasm for exaggeratedly feminine fabrics. The "victorious vixens" seize Bruce, who struggles, but is quickly overwhelmed and bound with "silken robe belts." He cries for help, but his mouth is "filled with a silky-soft sheer stocking." But women are not only soft—their long sharp fingernails gouge into his "muscular flesh."

The amazons' leader, Lori, combines male and female attributes: 6 feet tall, "proudly erect, her heaving bosom thrust forth," she wears "a tight fitting buckled beauty of a pure satin dress," with a pleated skirt "which shivered like so many leather strings with each movement." Notice the key adjectives: *tight* and *buckled* (for constriction and bondage). Notice also how the author seems to shift fashion fantasy in midstream: Lori's dress is satin, but it looks like leather strings (whips?). "Lori's waist was captivated by a hugh [*sic* for huge] patent leather belt of shining black; the contrasting silver buckle resembled a lock, with a tiny keyhole which defied entrance and exit." Shiny black patent leather is a classic fetish material, and the black/silver contrast is not uncommon. But the buckle is especially interesting; a psychoanalytical reading would stress that this hole will not be penetrated.

And, in fact, although the cover illustration shows the women dressed in their underwear, in the story itself Bruce alone is stripped of his outer apparel; "he was thankful he wore protective boxer shorts." The women then produce a pair of "virginal white" rubber panties, padded at the hip—a grotesque conflation of feminine and infantile clothing. "Sandra hooked both thumbs at the waistline of this awesome figure-training, skin-tight, rubbery pantie—and S-T-R-E-T-C-H-E-D! It yawned like a baby's mouth and snapped back with a little 'pop.' " They pull off his boxer shorts ("good boys shouldn't wear such sloppy things"), leaving him

only his athletic supporter, which they mockingly compare to a G-string. "Behave yourself, or we'll take that away too." The "innocent looking panties" into which they force him are "excruciatingly tight . . . bondage." According to Stoller, this fantasy re-creates the transvestite's traumatic childhood memories of being forcibly stripped of his masculinity by hostile female relatives.

The fantasy attempts to repair this humiliating trauma by eroticizing it. The cross-dresser identifies with the aggressor and, in effect, declares that he is successful as a woman, while still remaining a man with an erect penis. Certainly, Bruce began to enjoy the transformation: "Bruce stepped into the silky legs of the bloomer. It felt cool, silky-soft, sensuously intimate." In a sense, he is having sex with the feminine underpants. But he is also identifying with the feminine role and rejecting masculinity as inferior: "He rather enjoyed such soft, filmy fabric; it was so unlike the harsh, chafing and sloppy men's boxer trunks which are anything but attractive."

He admires himself in the mirror: "His hips undulated seductively beneath the transparent bloomers. . . . Now he could understand why so many women spent their last dollars upon filmy lingerie. It made them so . . . so . . . seductive!" Mirror-sex plays an important role in fetishistic masturbation. But Lori smirks, hinting at a homosexual subtext: "You're beginning to look good already. The other boys in the frat house will give you a rousing welcome when you come back . . . dressed like a perfect lady!" Feminine clothing makes him modest, "and he tasted the resentment often swallowed by meek females when their privacy is invaded." He, too, suffers to look beautiful: The tight garter belt "bit with sharp teeth-like pain into his hip-bones." But it was worth it: He would "fool the boys into thinking he was a girl. . . . Clothes can make the man! And these clothes made him feel just great!"[36]

Men's Underwear

Men's underwear has seldom carried the same erotic connotations as women's underwear, for the reason that men's *bodies* have not usually been interpreted primarily in sexual terms—although the fetishizing of male underwear has a significant history within the gay subculture. In contrast to the wide variety of female undergarments, there are few male garments, principally underpants and undershirts, most of which have tended to be quite plain—although, again, there is actually more variety in color, material, and style than one might assume.

Moreover, even plain white cotton T-shirts and briefs can carry an erotic charge.

The white cotton undershirt, for example, was an important gay signifier as early as the 1930s. Richard Martin, the curator of costume at the Metropolitan Museum of Art, has analyzed how the undershirt became a fetish garment of "the homospectatorial imagination." Because the exposure of the undershirt was associated with working-class men, the garment acquired connotations of virility, especially since it also delineated the musculature of the male torso.[37] Already by the 1950s, the image of Marlon Brando in a white undershirt helped popularize this appeal within the heterosexual imagination as well.

Gay erotica has also emphasized the appeal of genitals bulging provocatively from within a pair of underpants or a jock strap. Generally speaking, the scantier the underwear, the greater its perceived erotic appeal. Boxer shorts are looser and cover more area than briefs, so boxers have usually been perceived as more conservative and less erotic. The development in the 1960s of the men's *bikini* brief, therefore, marked a significant advance in erotic design. Although there are entire books devoted to the sex appeal of women's bikini bathing suits, it is less commonly recognized that both bikini underwear and swim trunks have also been an erotic style for men.

For women and men alike, the bikini has functioned primarily as the scantiest permissible *cache-sexe*, but for men it also represented an intense "crotch-consciousness." In this respect, its appeal is similar to that of tight blue jeans—another clothing item that gay men fetishized as early as the 1930s. By the 1960s, heterosexuals also acknowledged that blue jeans exercised a "strong sex appeal." According to Rodney Bennett-England, author of *Dress Optional*, "The more tight-fitting the jeans, the greater the emphasis of leg contours and, as the *Penthouse* reader so aptly described it, the 'overt bulge of masculinity.' "[38] To improve the bulge, some men used padded jock straps.

A variety of erotic underwear styles for men existed by the 1960s. "There are transparent briefs, kinky briefs, soft leather briefs, underwear made of rubber, PVC and many other fabrics that offer sexual excitement or stimulation," noted Bennett-England.[39] Mail-order catalogues advertised items such as the "Posing Strap. . . . Gives the maximum support with a minimum of brief." There were also sheer shorts and boxers "for your private muscle building sessions!" And even the so-called diaper: "Show your physique off to advantage in our jersey diaper—one size only because it's adjustable to any size thru its tie sides!" (Available in "Jungle Red" or "Flesh.") Jock straps came in black, white, jungle red, flesh, pink, yellow, light blue, and kelly green.[40]

By the 1970s, even large manufacturers like Jockey had begun to emphasize the erotic appeal of men's underwear. Then in the early 1980s, Calvin Klein began advertising underwear for men and women. At first, however, the mainstream press focused on the fact that Klein was marketing men's-style underwear—to women. *Time* reported nervously on Klein's "Gender Benders," complaining that the string bikini looked like an athletic supporter, while the boxer shorts still had a "controversial" fly opening. "It's sexier with the fly," said Klein. *Women's Wear Daily* described men's-style underwear as "the hottest look in women's lingerie since the bikini brief."[41]

But the puritanism and homophobia of American society made it seem shocking to emphasize male sexual beauty. Bruce Weber's photographs of god-like men clad only in their underwear were thus much more profoundly radical than his images of women in androgenous underwear. Beginning in 1982, Weber and Klein collaborated to produce the first openly erotic men's underwear advertisements. Soon gigantic billboards loomed over the cityscape, depicting half-naked muscular male torsos in pure white underpants that bulged provocatively.[42] It was said at the time that Klein had put the "balls" back in underpants.

A decade later, Klein saw a photograph on the cover of *Rolling Stone* of the rap singer Marky Mark wearing a pair of underpants. (Stripping down to his Calvins was part of the singer's stage act.) Soon Steven Meisel was photographing Marky Mark for Klein's underwear advertisements. One of the most overtly sexual photographs showed the scowling bare-chested performer wearing white mid-thigh underpants and grabbing his crotch. It had already become a fashion for young urban men to wear their trousers hung low, revealing the waistband of their underpants. Now the style was even incorporated into the women's fashion show at Chanel, and soon many types of "designer" underpants appeared.

In the past, it was the mark of a slob to walk around the house in his underwear. But by the 1990s, mail-order catalogues were filled with photographs of people lounging around in their underwear. The emergence of men's underwear as *fashion* reflects changing roles for men and a continued breakdown of sexual taboos. There is still a powerful taboo against penis exposure, however, so underwear exposure is the closest you can get to full male nudity. There is also the "style factor." Fashion has become increasingly body-conscious, and underwear implies the body more closely than does any other garment.[43]

All this is not evidence of underwear fetishism per se, only the usual male fetishizing, since the focus is still overwhelmingly on the body. But fetishism and fetishizing overlap. There are gay "underwear fetish fans" who are "turned on

Times Square billboard, 1982. (Andy Levin)

red hot by undies,"[44] although they seem to be fewer than those who are turned on by leather, rubber, and uniforms. Photographs of men in underpants may serve primarily as an adjunct to penis fetishism.

Black Stockings and Pointed Bras

A list of men's sexually oriented periodicals at the Kinsey Institute included *Black Garter, Black Lace, Black Satin, Black Silk Stockings, Black Stockings, Lingerie Libertines, Nifty Nylons, Nylon Jungle, Rouge, Sable, Satan and Lace* (that's *satan*, not *satin;* a magazine for transvestites and transsexuals is called *Satin and Lace*), *Silk, Silk Stockings, Silky, Silky Sirens, Skirt, Slip and Garter, Stocking Parade, Velvet,* and *Velvet Touch.* Not all were fetish magazines (*Velvet* was more like *Penthouse*), but many shared a focus on themes that appeal especially strongly to fetishists.

Many of the titles sound quaint because garters, although long associated with sex, have essentially disappeared (except for weddings), while stockings have largely been replaced by the more impenetrable barrier of pantyhose. An article in the men's magazine the *Nylon Jungle* raised the issue of the threatened demise of a long-standing fetish object. Garters had long since vanished, the author argued, but they had been replaced by garter belts, whose straps "tracing their taut resolute line over the thigh contours, have proved to be every bit as popular with male beauty-lovers as frilly leg bands were." But were garter belts and stockings now to be replaced by pantyhose? The magazine insisted defensively that "sales of pantyhose have been disappointing, except among under-21s and the 'with-it' college crowd. The average American woman, where she is permitted a freedom of choice, seems to prefer the garter belt . . . and refuses to be talked into expensive fads."[45] By 1967, however, this was patently untrue.

The modern girl had "a problem," insisted another writer: She was trapped in "lingerie limbo . . . torn between her love for all the wonderfully delicate bits of feminine wear and the new go-go mod styles that have a male influence." Her girlfriends were constantly trying to talk her into "going mod all the way . . . but she balked at the heavy hose and other wooly type garments imported from England." The only good aspect of mod fashion were the white go-go boots, "which go so well with her nylons."[46]

This is another interesting example of the fetishist tendency to prefer old-fashioned garments. It could be argued that fetishists simply "imprint" on the clothing of their mothers' generation. Indeed, it has been playfully suggested that

future fetishists are even now becoming obsessed with Reeboks.[47] But this is too simplistic. Certain garments (like high-heeled shoes, stockings, and garter belts) have particular characteristics that lend themselves to being fetishized.

The legs are the pathway to the genitals. Stockings lead the viewer's eyes up the legs, while garter belts frame the genitals. For many men, the effect is like arrows pointing to the promised land, an effect accentuated when the stockings have seams up the back. "Hot Legs—The ups and downs of the stocking and garter industry fully exposed!"[48] But the tops of stockings trace a line across the thighs, just as a gunslinger draws a line in the sand to indicate: Go no farther! Black stockings, in particular, graphically isolate part of the leg, and stop a few inches below the genitals.

It is no accident that so many underwear magazines have the word *black* in the title. Black is a symbolically significant color. For one of Wilhelm Stekel's patients (who liked to imagine women fighting), "the black stocking symbolizes the branded, sinful woman. The white stocking is a symbol of purity."[49] But black also provides the greatest contrast with light-colored flesh. Indeed, more than a century ago, *La Vie parisienne* warned that men who really like black underwear "need to see white skin emerging from a black sheath, because white skin in itself hardly arouses them any more."[50] I have not systematically studied fetishistic pornography using black models, but it seems to show a greater reliance on white, yellow, pink, and red underwear.

Not only color but also materials carry erotic connotations. "The gossamer-thin fabric of fully fashioned nylon or silk, clinging enticingly to smooth limbs, represents the most refined essence of 'second skinism' imaginable," writes Stephanie Jones. Sheer black stockings, in particular, are "part of the protective armour of those beautiful but untouchable creatures whom submissives love to worship." Or, as Terence Sellers observed in *The Correct Sadist*, stockings are "resonant of forbidden women. The stockings's combination of silky invisibility with delicate restraint quickens the slavish heart with its tantalizing irony. The flesh of a woman's leg is made firm, uniform and tense by a stocking."[51] As silk and even nylon have declined in popularity, attention has increasingly focused on rubber. In the American comic strip "Subjugated in Rubber," the dominant female tells her cross-dressing male companion: "Quit squirming until I slip these delightful thin rubber stockings on your scrawny legs to ensheathe your unsightly villous limbs in scintillating slick latex."[52]

"True" stocking fetishists are apparently "quite rare," although many men have a "preference" for stockings.[53] Stockings or pantyhose are also sometimes associ-

ated with fantasies of asphixiation, involving either strangling the woman or auto-strangulation for erotic purposes. Pornographic images frequently pair black stockings with long black gloves. Like stockings, gloves are rarely chosen as the primary fetish object, but they are frequently incorporated into a fetish costume or fantasy.

The fetishist correspondences not infrequently mentioned "long, tight kid gloves."[54] There were also occasional references to "punishment gloves" that could be locked, "tight-laced gloves" lined with Vaseline, and the whipping of tightly gloved hands.[55] According to the Goncourt diary, the German kaiser demanded that a Parisian cocotte "wait for him . . . stark naked except for a pair of long black gloves. . . . Those black gloves, of course, are a characteristic of sadism. . . . And they recall the black stockings in [Felicien] Rops's obscene etchings."[56]

"Covering the organs of touch . . . gloves . . . emphasize sexual insinuations by simultaneously reining in and stimulating desire," writes Philippe Perrot.[57] Nineteenth-century etiquette journals warned that it was improper to touch a lady's bare hand, while pornography associates the hand with masturbation (hence the expression "hand job"). In the Middle Ages, references to scented gloves evoked the female genitals, and gloves were exchanged between lovers, much as engagement rings are today.[58]

Just as shoe fetishists are fascinated by the aesthetic and structural details of the fetish object, so also are glove fetishists, who may favor particular materials (such as kid, velvet, satin, leather, and rubber), colors, or designs. Gauntlets and surgeons' gloves have their enthusiasts, for example, and there are those who like gloves with the fingers cut off. Strippers frequently use gloves, and Rita Hayworth's famous scene in *Gilda* used the removal of a glove to allude to a striptease while evading the censors.[59]

"The gloved hand becomes a symbol of power much as a booted foot," argued one book on fetishism.[60] Some of the same erotic charge is attached to long gloves as to high boots. Gloves that extend up to the elbows or even to the armpits (such as opera gloves) tend to be regarded as much sexier than short gloves. Nor is this belief restricted to fetishists: In the late nineteenth century, *Godey's Lady's Book* advised readers:

> For formal occasions greet your escort completely attired and ready to depart. Your gloves should be donned in the privacy of your boudoir and of course worn during the entire evening. . . . However, afternoon gloves are short and can, on occasion,

be put on in the presence of your escort since the shortness of the glove deprives the act of the immodest intimacy connected with formal, longer gloves.[61]

It does not take too Freudian an imagination to see the similarities between a hand and arm inserted into a long rubber glove and a penis sheathed in a condom.

It may be harder to see that the breast can also be perceived as a phallic symbol. Yet in "Undercover News," the body of the female character is described in phallic terms: "Her breasts stood out pointedly like the horns of an angry bull ready to gore through its imprisonment."[62] Its bras had "perfect points," boasted a Frederick's of Hollywood catalogue; "magic circles separate and shape each breast . . . urging them UP and OUT for lots of front projection."[63]

The correlation between breast and penis also exists in other cultures; the Sambia of New Guinea, for example, explicitly associate semen and milk.[64]

Big breasts seem "fancy" to some men, while small breasts seem "plain"—a fairly obvious projection upward of anxiety about both penis size and female genitalia.[65] Breasts, of course, are also the most important secondary sexual characteristic of female mammals, and are thus a prime symbol of feminine sexual attractiveness. It has often been argued that "breast fetishism" is especially ubiquitous in America, whether because of bottle-feeding, widespread sexual prudery, or the cultural "worship of the Mother and all she symbolizes."[66] This is much too simplistic, yet a degree of fetishizing of the breasts is definitely normative within the society. There are many pornographic titles like *Big Bazooms*, *Tit Fuckers*, *Titty Milk*, and *Mother Jugs*.

"One might reasonably expect that brassieres would be almost as popular as underpants," writes one sex researcher, "but inexplicably they are seldom fetish items despite our culture's emphasis on breasts as sexual centers of interest."[67] Perhaps this is not so inexplicable, however, since the breasts are not nearly so tabooed as the genitals. *Life* once ran a cover story entitled "Hurrah for the Bra!" and it is hard to imagine a mass-circulation American magazine featuring a close-up of underpants. Some feminists have recently bared their breasts in public demonstrations: "Breasts are not sexual organs," argue the protesters.[68] Conversely, in ancient Rome, professional prostitutes were extremely reluctant to remove the *strophium* (a proto-brassiere), even during sex.[69]

The brassiere as we know it is a twentieth-century invention that appeared around 1906, when the corset no longer functioned adequately as a bust supporter. Although any kind of brassiere can be fetishized, certain styles have a

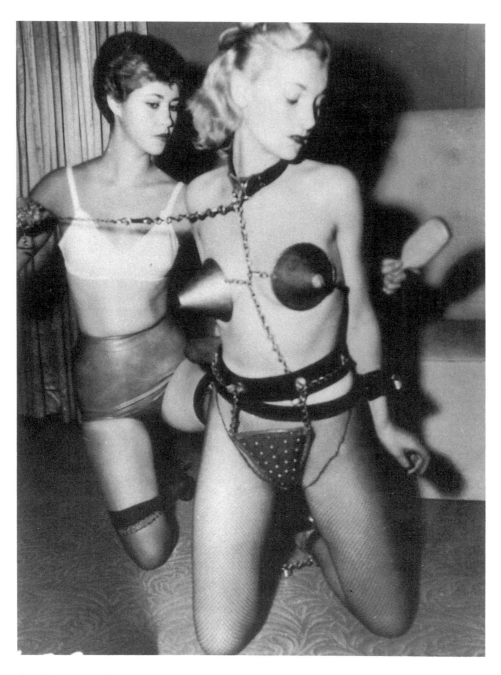

Cone bra and cache-sexe. (Paula Klaw/Movie Star News)

more obvious appeal. Generally speaking, the more pointed, structured, shiny, revealing, big, nipple-exposing, and/or decorated the brassiere, the more likely it is to be fetishized.

"You know the cone bra I made for Madonna?" said Jean-Paul Gaultier. "I made the first one for my teddy bear . . . because he had no bra I had to invent one. I did it with paper and pins." When Gaultier first began showing his fashions, some journalists accused him of being sexist. The cone bra, in particular, looked like the kind of fetish underwear worn in Irving Klaw's notorious bondage photographs. But Gaultier insisted that "it was like a fantasy exaggerated. . . . It was a joke and at the same time it was radical and nice." He admitted, though, that the cone bra was also, perhaps, "a little aggressive."[70] The torpedo-shaped breast is not necessarily fetishistic, however. In the 1940s and 1950s, bras with circular whirlpool cups were fashionable, and Gaultier has obviously drawn on the history of brassiere design, just as he has been inspired by structured girdles of the 1950s and early 1960s.

Gaultier put men in high heels, "and I put them in fishnets and in corsets—but they were corsets for men." He made it clear, however, that the cone bras worn by Madonna's showboys were not his idea: "That was Madonna. I don't put bras on guys."[71] As a quintessentially female garment, brassieres appeal strongly to transvestites, however. In "Panty Raid," it is the brassiere that really begins to turn Bruce into a woman:

> "See, Bruce," she dangled it before him, as if threatening his manhood, "this brassiere has in-up pushup pads and foam rubber shapemakers. This low-plunge front gives real cleavage; to a girl, it's breathtakingly sinful. To you," she made a throaty laugh, "it'll be very wicked. It's lightly underwired in the cups which are made of pure satin. The front has hooks which are kept firm to your masculine chest by rubber sides—but your chest is undergoing a transformation. It'll soon be a nicely shaped bosom."[72]

Structured foundation garments (like corsets, girdles, and brassieres) that "support," shape, and confine parts of the body are especially likely to be fetishized. One cross-dresser reported that "only those [women's garments] that 'captured' flesh are interesting to him: girdles, bras, stockings."[73]

The hard and "nasty" side of structured bras and girdles appealed strongly to the punks, who were reacting against the bra-less hippy generation. The punks subversively reappropriated the much maligned symbols of sexual repression and defiantly wore thrift-store bras and girdles as outer clothing. Indeed, the entire trend of underwear-as-outerwear, which has played such an important role over

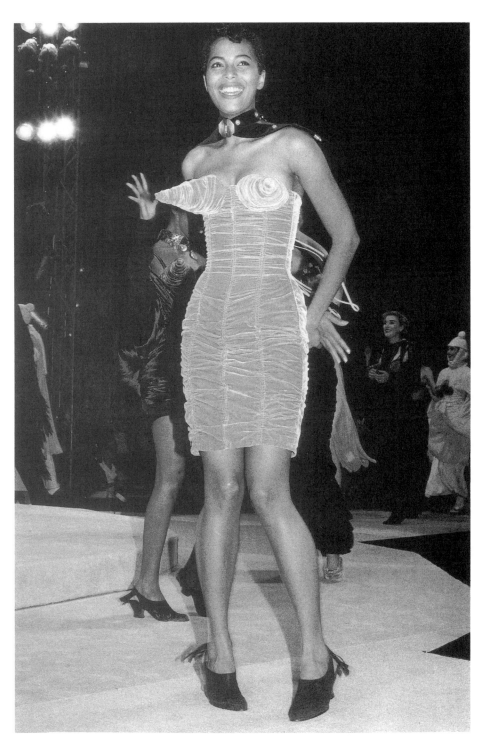

Dress with cone breasts by Jean-Paul Gaultier. (Roxanne Lowit)

the past decade, must be understood in part as an attempt to demystify sexual taboos. (Vivienne Westwood was also inspired by the use of brassieres as status symbols in the Third World.) Once the exposed brassiere had emerged as an avant-garde style, the mainstream fashion industry followed suit.

But within this different context, the constructed meaning of the style was transformed. According to designer Josie Natori,

> It used to be shocking to wear a bustier. Now it's nothing. . . . Women are much more daring. . . . It used to be that you could just express yourself in the bedroom, now you can express yourself all day long. Women are saying, "I used to burn my bra. Now I'm going to flaunt it."[74]

But the discourse on lingerie-inspired fashion is polarized.

Is the exposure of underwear really "sex as liberation"? Fashion journalist Charlotte DuCann has complained that the fashion industry

> assumes that by flaunting her crotch, a woman is asserting some kind of individual freedom. Well, she isn't; it just makes her look like a prick-teaser. Nor is the fashionable flirting with S&M a sign that woman is strong, for there she is using her sex not as a liberating force but as a controlling power (this is in no way to be confused with the ironic bondage of punk).[75]

Freudian Slip

Underclothes are described in the garment industry as "intimate body fashions." Because underpants cover the genitals, they receive the most attention from underwear fetishists, but slips, camisoles, petticoats, nightgowns, and negligees are also associated with nakedness and sex.[76] "The woman's chemise . . . is the white symbol of her modesty, that one must neither touch nor look at too closely," warned one writer in 1861.[77] But by the 1890s, lingerie was increasingly being made in more diaphanous fabrics, decorated with lace and embroidery, and dyed in seductive colors. "These frills cost more than my dresses," boasted the 1950s stripper Cat Girl. "I really splurge on sumptuous satin nighties and sheer negligees."[78]

By the 1970s, "people used to go right into the lingerie department and buy a little slip to wear to go discoing," recalled Paul Cavaco of *Harper's Bazaar*. In the 1980s, the hard appeal of brassieres and girdles dominated fashion, but by the 1990s the focus was back on soft lingerie, like the slip dress. According to Josie

Decorative underwear. (Paula Klaw/Movie Star News)

Natori, "Lingerie-inspired clothing is here to stay, because . . . it's provocative in a positive manner."[79]

Feminists have objected to the public display of underwear and to eroticized images of women in underwear, on the grounds that they constitute a type of visual sexual harassment. The revival of "sexy" lingerie has also been interpreted as part of an antifeminist backlash. While describing it as "the merchandizing exploitation of a cliché," Betty Friedan also noted that "it is true that women are becoming free to express themselves as women."[80] The problem is that one cannot control the way others "read" one's clothed appearance. As fashion journalist Woody Hochswender put it, "Hookerish street looks, we are told, are examples

of designers giving modern women a style that co-opts the stereotypes and actu-ally liberates the wearer. Speaking as a man, I can definitely say that this is a subtle point that will be entirely lost on my fellow animals."[81]

The fashion for underwear-as-outerwear is significant because it violates tradi-tional taboos, which distinguish sharply between public and private behavior. Miniskirts permit "frequent glimpses of underpants," so panties will soon lose much of their "erotic allure," worried one writer a quarter of a century ago.[82] This turned out not to be true, but body exposure did escalate. Underwear has long been perceived as secret, sexual clothing. Yet it is increasingly paraded down the catwalk.

An element of upscale striptease was introduced even at conservative couture

Underwear as outerwear by Gianni Versace, 1994. (M. Chandoha Valentino)

140

houses like Dior, where a model walked down the runway, opened her satin cape, and revealed a necklace and jeweled underpants. Designers with a younger clientele are even more daring. Ghost's Fall 1994 collection featured "eye-scorching underwear" by Deborah Marquit "that practically eclipsed the clothes."[83] Skirts were slit to above the belly button, and tops were open down the front to reveal red lace panty briefs, neon bras, and thigh-high black stockings. Thierry Mugler has made underfashions out metal, leather, and latex. But the kinkiest underwear of recent years is probably Vivienne Westwood's fake-fur panties, which dramatize the role that materials play in fashion and fetishism.

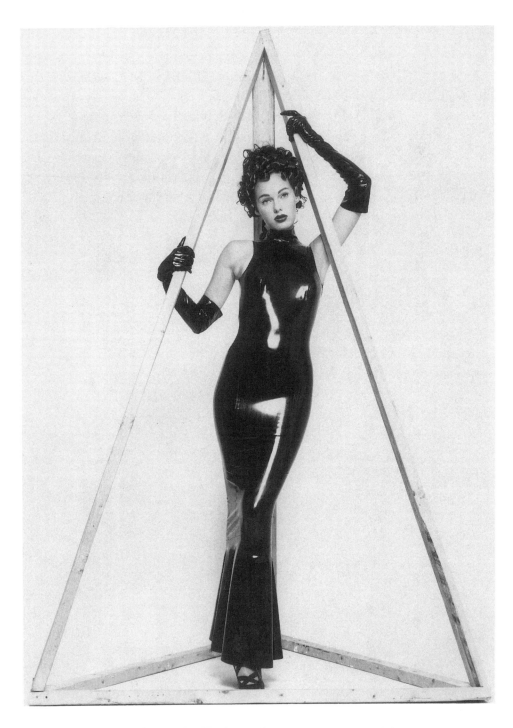

Rubber dress by Syren from Body Worship, 1994. (Amy Gunther, model/Partner Agency; photographed by Aaron Cobbett)

six

Second Skin

"To put it bluntly, rubber is power and sex," argued *Vogue*'s Candice Bushnell after trying on various tight, shiny outfits.[1] Only a few years ago, rubber was a "hard-core" fetish fabric, and it was a bit kinky when the January 1989 issue of British *Vogue* carried a "Skin on Skin" feature devoted to "the sensuous precision of smooth black leather," showing clothes by such august fashion houses as Gucci and Chanel.[2] Today fashion discourse increasingly weds feminist rhetoric with fetishist imagery. Supermodel Naomi Campbell posed in stiletto heels and a rubber dress, and calmly noted that the dress "makes a squeaky sound when you put it on. You're supposed to put on talcum powder first so it won't stick." Asked whether her clothes were demeaning to women, Campbell replied, "Grown women can do whatever they please."[3]

Certain materials have a powerful erotic appeal by virtue of their tactile, olfactory, and visual characteristics as well as their symbolic associations. But the popularity of specific fetish materials has changed over time, in part because of technological developments, such as the invention of polyvinyl chloride (PVC). There also seems to have been a historical shift from "feminine" to "masculine" materials. In the nineteenth and early twentieth centuries, the focus was on soft materials, such as satin and fur, which are primarily associated with women's clothing. But by the late twentieth century, hard materials, especially leather and rubber, have tended to dominate. This is not an absolute change, but the shifting emphasis is significant for its implications about the psychology of erotic sensations and sexual images of the self. This chapter will survey the history of material fetishism, ending with a look at the human skin itself, tattooed and pierced.

Venus in Furs

Leopold von Sacher-Masoch (after whom "masochism" is named) begged his mistress "to wear furs as often as possible, especially when . . . behaving cruelly."[4] In his notorious erotic novel, *Venus in Furs*, the idolized woman is never absolutely naked, but always in some form of fetishized adornment: "At the sight of her lying on the red velvet cushions, her precious body peeping out between the folds of sable, I realized how powerfully sensuality and lust are aroused by flesh that is only partly revealed."[5] Scopophilia (voyeurism, erotic gazing) is here linked with tactile eroticism (velvet cushions and a sable fur coat).[6]

"The supple furs greedily caressed her cold marble body. Her left arm . . . lay like a sleeping swan amid the dark sable, while her right hand toyed with the whip."[7] Woman is both cold as death and warm as fur. According to Masoch, a woman in a fur coat was like a "great cat, a powerful electric battery." The sensation of fur against skin is peculiar and prickling, charged with static electricity. It has been explicitly compared to the sensation of flagellation: "In this sense, also, furs and the whip go together." The penetrating odor of fur attracted Masoch, who told his wife that he longed to plunge his face into the warm smell of her furs, which he associated with the idea of woman as "one who commands" and, perhaps, woman as beast.[8]

Fur is warm, beautiful, and prestigious. But as one fur fetishist, N. N., told Krafft-Ebing,

> The mere aesthetic effect, the beauty of costly furs, to which everyone is more or less susceptible, and which . . . also plays so important a *rôle* in fashion . . . explains nothing here. Beautiful furs have the same aesthetic effect on me as on normal individuals. . . . Such things, when skillfully used enhance female beauty, and thus, under certain circumstances, may have an indirect sensual effect.[9]

But the "direct, powerful, sensual effect" that he experienced as a fetishist "is something entirely different from simple aesthetic pleasure"—although "that does not prevent me from demanding in my fetish a whole series of aesthetic qualities in form, style, colour, etc." Indeed, he liked only "very thick, fine, smooth and rather long hair, that stands out like that of the so-called bearded furs," such as sable. He disliked short furs, such as seal and ermine (although they were expensive and prestigious), nor did he like "hair" that was "overlong."[10]

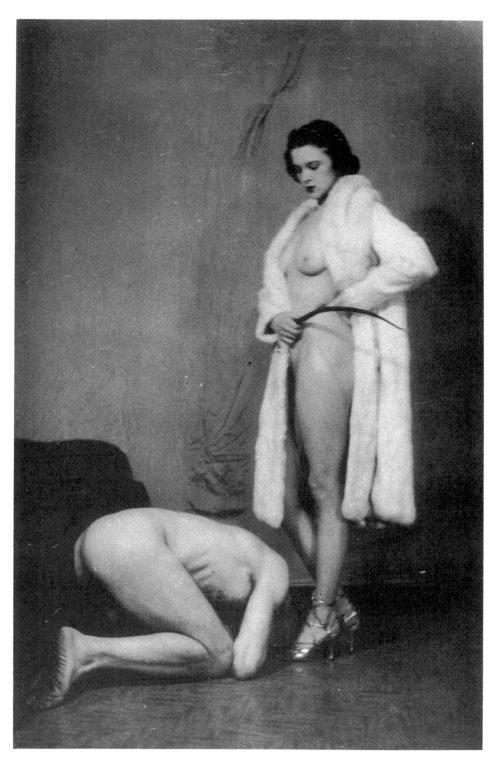

Man licking the shoe of a woman in a fur coat, ca. 1937. (Kinsey Institute)

Freud believed that fur and velvet symbolized the pubic hair, in the midst of which (according to the male child's fantasy) he *should* have seen a penis. Slang terms such as *pussy*, *beaver*, and *fur pie* support this association. Significantly, N. N. found the idea of a man wearing fur "very unpleasant, repugnant, and disgusting." Nor did he like to see "an old or ugly woman clad in beautiful furs, because contradicting feelings are thus aroused."[11]

Fur fetishism seems rather rare. Magnus Hirshfeld reported a case of a man who loved "fur and crutches!"[12] Another twentieth-century case involved a Canadian engineer whose sex life primarily consisted of wrapping himself in a fur coat, looking in a mirror, and masturbating. "One night he broke into a fur store, undressed himself, and indulged in an orgy of fur eroticism." Then he began stealing fur coats. After he got out of jail, he took to wearing a fur diaper around the house.[13]

Velvet fetishism is also uncommon, although Krafft-Ebing reported a few cases. "In a brothel a man was known under the name of 'Velvet'. He would dress a sympathetic [prostitute] with a garment made of black velvet, and would excite and satisfy his sexual desires simply by stroking his face with a corner of her velvety dress, not touching any other part of the person at all."[14] There were a fair number of letters about velvet in the *London Life* correspondence, many with a sadomasochistic edge. "Velvet forms an excellent disciplinary material," wrote one person.[15] "But that is to miss the real fascination of velvet," argued another correspondent:

> Velvet is an ultra-feminine fabric—the exquisite beauty of its lustrous pile, its delicious ripple of silky sheen, and voluptuous depths of ravishing shade, show up to best advantage in the frocks . . . of the opposite sex. This is because there is more draping . . . and consequently more thrilling play of light and shade in the folds.
>
> It is rather peculiar . . . that this divine material seems to have no psychological attraction for women. They wear it in the fashion, and certain type of women, aware of its seductive effect upon men, use it as their stock in trade.[16]

The letter was signed BLACK VELVET.

Velvet's thick, soft pile easily evokes the idea of sensual pleasure. Certain drinks are described as going down like velvet, and the word *velvet* is slang for money won in gambling. The cult movie *Blue Velvet* used an old popular song to evoke the idea of decadence.

The Fascination of Satin

"The Fascination of Satin is a Fetish, and a thorough-going one at that," declared Cosmopolite in 1911. "The strange and mysterious attraction this material, with its overshot woof and the highly finished surface, has for the most virile and clean-minded of men, is an unfathomable puzzle." Apart from its "appeal to the eye," what was its charm? "Can any lady . . . give me a hint? . . . [D]o you think the lures of your exquisite femininity are enhanced by it?" This "new fetish" did not seem to be a common one, and the enthusiasm for "rich, costly, shimmering satin" seemed to exist quite apart from the more usual fetishes for "Tiny Waists, High Heels, etc." Still, Cosmopolite had received a certain number of letters on the subject. ENCHANTED dressed his wife "in nothing but satin—morning, noon, and night. . . . 'If I saw her in anything else,' he writes, 'I believe I would hate her!'" [17]

In *Nana*, Emile Zola's famous novel about prostitution in Second Empire Paris, the heroine's friend goes by the name Satin. During his brief career as a fashion journalist, the poet Stéphane Mallarmé signed many of his articles with the pseudonym MISS SATIN. Satin is a material usually made of silk, but more recently also nylon, polyester, and other fibers, woven in such a way as to produce a glossy surface and a soft, slippery texture. There are many other types of silk with different properties. Taffeta, for example, is a crisp, smooth plain weave; chiffon is diaphanous; and so on. But all silks are smooth, soft, lustrous, and luxurious. And since the early nineteenth century, they have tended in Western countries to be reserved for women's apparel.

Krafft-Ebing described several cases of silk fetishism: "On 22nd September, 1881, V. was arrested in the streets of Paris whilst he interfered with the silk dresses of a lady in a manner which aroused the suspicion of his being a pick-pocket." In actuality, he was engaged in "touch[ing] the silk gowns of ladies, which always produced ejaculation. . . . What gratified him more than being with the prettiest woman was to put on a silk petticoat when going to bed." [18] Some fetishists behaved in a more hostile manner. "In July, 1891, Alfred Bachman, aged twenty-five, locksmith, was brought before Judge N., . . . in Berlin" for having cut ladies' silk dresses with a knife. "The culprit defended himself in a peculiar manner. An irresistible impulse forced him to approach women wearing silk dresses. *The touch of the silk material gave him a feeling of delight.*" Although Bachman "had often been punished

before" and admitted entertaining a "great hatred of the whole female sex," he received a sentence of only six months' imprisonment.[19]

Gaëtan Clérambault's *Passion érotique des étoffes chez la femme* described three women who had "a morbid attraction, principally sexual, for certain fabrics, especially silk, and on the occasion of this passion, some kleptomaniac impulses."[20] In a recent essay, "Masquerading Women, Pathologized Men," Jann Matlock questioned Clérambault's insistence that only men could be fetishists and suggested that his patients might have been female fetishists, not just hysterics and kleptomaniacs who stole fabric and masturbated with it.[21] The fact that Clérambault himself seems to have had an obsessive passion for fabric complicates the issue further.

The enthusiasm for satin and silk tended to wane as the twentieth century wore on, although a trumpet player wrote to the Biz-zarre Club to say that satin and taffeta were his favorite fabrics. He added that he had "always been a slave when it comes to women."[22] Pornographic paperbacks like *Punished in Silk* (about a burglar who is captured by "a beautiful blonde vixen" and forced to cross-dress) and *Mistress in Satin* also emphasize the association with powerful femininity.[23] The transvestite story "Undercover News" contrasts several fetish fabrics. The dominant female, Sadia, is described as wearing a "steel grey suit of shining leather." The submissive TV wears a "white satin waist cincher," a "lilac colored sheath of stretchable rubber," and a taffeta petticoat—all examples of the "exotic and ultra in feminine fashions."[24]

The Rubber Devotee

Rubber is a smooth, waterproof, elastic material, made by chemically treating the sap of the rubber tree. (There are also similar synthetic substances.) One of the commonest uses for rubber has been to make raincoats and hats, although it is also used for domestic items like rubber gloves and, indeed, wherever waterproofing is important (e.g., for rubber panties, rubber sheets, and rubber tubes). There were, obviously, no rubber fetishists before rubber clothing was invented (in the nineteenth century). An advertisement in a London newspaper of 1870 offered a "GENTLEMAN'S NIGHTSHIRT with attached NIGHT CAP in MACINTOSH CLOTH." It allegedly "induced a free and healthy perspiration . . . and cured rheumatism."[25] Rubber baby pants date from before the First World War, as do

occasional "health" clothes. By the 1920s, a variety of rubber clothes were available in Germany, England, and the United States.

The single most popular rubber fetish was the mackintosh, a rubberized cloth raincoat. One of the oldest fetishist organizations in the world is the Mackintosh Society, which is based in England. Letters about mackintosh enthusiasm appeared in *London Life* as early as 1926 and continued for many years. SILK MAC wrote, "My hubby and I are looking forward so much to . . . the letters from macintosh fans . . . and the lovely descriptions of gorgeous macintosh outfits." Her husband especially liked to hear the "lovely rustling swish of rubber. . . . I could see how he enjoyed every movement I made, so you can guess that I was very happy, too, as long as I gave him so simple a pleasure." Then they turned on the gramophone and danced, their macs swishing and rustling, as she anticipated giving him a "lovely macintosh evening."[26]

RUBBER LOVER reported that he and LADY RUBBER LOVER had similar thrilling experiences.[27] Many correspondents described themselves as heterosexual couples. Although we cannot automatically believe the letters (quite the reverse), external evidence supports the picture of a shared clothing fetish. Some readers, like CHROMIUM KID, were skeptical, however:

> I am a new reader of your little paper, and I think it very amusing, as I thought that only we Americans ran snappy little rags like that! I think the macintosh fans are very funny, because either they are indulging in a good "leg pull" or we are missing a thrill over here. A couple of us tried "maccing," but the cold, slippery, rubberised inside of the macintosh gave me—not a thrill, but a chill.[28]

MACAMOUR replied tartly that "it is absurd for a non-sensitive person . . . such as 'Chromium' to endeavour to make the wearing of macintosh material a new 'craze' just because it is indulged in by a few as a luxury." Significantly, MACAMOUR regretted that no special mackintosh clothes were available readymade. "Being a mere male, I cannot make the garments that appeal to me, and have seeked [sic] in vain for an understanding person who could do so for me. Neither have I met a partner who could share the thrill of maccing."[29] There were, however, some small cottage industries beginning to produce rubber shirts, corsets, and other "garments that elastically fit the figure."[30]

What was "the mystery of mackintosh"? "I . . . feel so safe when I have its scented rubber folds tightly wrapped around me," reported one person. "And when the fascinating rustle drowned every other sound it was heavenly."[31] With the outbreak of the Second World War and "the threat of air raids," enthusiasts

like OILSKIN wrote to suggest that dressing in rubber prepared one against "gas attack." He submitted a photograph of his wife wearing a jacket, trousers, hood, gloves, gas mask, and high-heeled shoes.[32] Gas masks of Second World War vintage are still sold in a number of fetish clothing shops. (But at the London fetish shop Skin Two, I overheard two young, art-student types disparaging "those old mackintosh people.")

Meanwhile, in North America in the 1950s, the Biz-zarre Club circulated letters from "rubber devotees." One correspondent even broke into verse: "Compelled by moods he can't explain, yet bound by senseless fear, / He longs to wander in the rain, encased in rubber gear." Describing himself as a " 'little boy,' age 28 . . . At times a 'naughty boy,' " but basically a "soft, kind-hearted guy," he said he was look-

OILSKIN's *wife dressed in rubber, as seen in* London Life. (Peter Farrer Collection)

ing for a "stern but gentle gal / To 'baby' him, but 'make him mind,' and also be a pal."[33] One clinical study of a mackintosh fetishist quoted him as saying, "The difference between a macintosh and a woman is this—the mac has no power over me and can't hit back. Being inanimate, it can't withdraw its affection."[34]

The author of *The Kinky Crowd* suggested that rubber fetishists tended to be either "infantile" or "masochistic."[35] The masochists, he argued, were responding to painful but exciting childhood memories of medical paraphernalia, while the infantile rubber lovers had, in childhood, become fixated on rubber as a result of contact with objects like rubber pants, bedsheets, and the nipples for baby bottles. Bedwetters, in particular, had humiliating memories of rubber sheets. These ideas were not popular with rubber fetishists. As the editor of *Rubber News* put it, "No matter how true it may be . . . no matter how important it may be in your mind, WE WILL NOT PRINT any letter that traces a liking for rubber back to infantile bedwetting!"[36]

Rubber lovers sometimes had problems sharing their enthusiasm. Mr. P (from London) wrote to *Rubber News* to report that his friend Doris was happy to don a thick latex rubber "punishment suit" and submit to being gagged and "tied in a complex way with white nylon cord, which shows up nicely against the black." But another Mr. P (from Belfast) reported that although his wife was willing to wear a shiny blue PVC raincoat, he had not yet told her about the "leather hood and ball gag" that he had bought "and used furtively" on himself. Nor had he figured out a way to suggest that she wear a corset: "Could something be done here, emphasizing her figure for my pleasure? What joy the prospect offers if only she responds, dare I dream of my H shrouded in rubber, constrained, submissive, impotent?" The editor of *Rubber News* sent him a copy of *A Wife's Guide to the Rubber Craze* ("invaluable for rubber fans with a domestic problem"). Another Mrs. P (from Somerset) believed that "if wives only knew the hold they can exercise on their husbands by wearing rubber, more would do so; after all what is the difference in wearing rubber or silk panties if they please you." Her husband might "look at other girls in macs . . . but we have a mutual secret which we share and nothing can make up for that."[37]

Many rubber fans like to be tightly encased in their fetish material, from head to toe. Indeed, with rubber, as with corsets, we might in many cases speak of a *constriction fetish*. Rubber, however, like all the fetishes, has multiple sources of appeal. "It 'feels' nice, which is important to people living in an insecure world." Rubber garments "are KIND to you, carressing your skin, comforting and soothing." But "worn next to the skin," rubber is also "pleasantly stimulating."[38]

Two women in rubber gear,
ca. 1960. (Kinsey Institute)

Rubber is, of course, a slang word for condom, and it has been suggested that "the rubber suits [fetishists] wear represent a condom. When they put them on, they feel like giant, animated penises. This would be tremendously exciting to a man who was psychically castrated."[39]

Since about 1970, manufacturers have tended to replace rubber with plastic, but this did not end rubber fetishism so much as it expanded the category to include rubber, plastic, PVC, and latex. The invention of PVC was especially important because it made the "wet look" possible, adding a new twist to the old

enthusiasm for raincoats. As early as 1960, fashion designer Mary Quant did a wet-look collection. Rubber entered fashion again in the 1980s via the high-tech school of design. From industrial-rubber floor coverings, it was only a step to rubber jewelry and accessories. Although ostensibly an "industrial" look, rubber clothing inevitably also carried the idea of fetishism.

In recent years, rubber and plastic fetish clothing has fallen into two basic categories: (1) stereotypically female and infantile attire, and (2) second-skin garments. The first category has little direct relationship with contemporary fashion. Frilly white rubber aprons for "sissy maids" and plastic panties (in colors such as pink, pale blue, yellow, and clear) for "adult male babies" have a limited appeal.[40] But other types of rubberized garments (usually in black and red) have had much more of an impact on fashion. Although rubber fetishists carry body enclosure to extremes, the skin-tight silhouette has proved attractive to a wide audience, especially as mainstream fashion has become increasingly body conscious.

Latex clothing has blurred "the line between fetish and fashion," reported Robert Stoller's SM informant Ron. "Becky and I have only recently begun to experiment with this . . . because it's not an original, authentic fetish of ours. . . . Mostly it's fashion . . . it looks sexy." They noticed a fetish influence on swimwear; then club kids began experimenting with wet-look vinyl and latex fashions. But the experience of wearing latex also proved significant: It "turns your whole body into a lubricating erogenous surface."[41]

People with "a primary rubber fetish" are attracted to this physical side: It is "very confining" and "unbelievably hot"; "the clothes are very uncomfortable." "I admire rubber fetishists for . . . their courage in being so out-of-the-closet about something deeply rooted in their childhood," says Ron. "I think latex fetishism is very much [about] constriction and containment. Latex deals with their alienated, hostile feelings toward uncontrollable bodily functions. . . . Too strange even for me." If latex is "introverted" and "auto-erotic," leather (Ron's fetish) is more "symbolic," a "statement to society," "like being tattooed and pierced." But latex and leather do "interact": "[T]he things that make leather attractive are even more true of latex: that it's confining, that it feels like skin but isn't. . . . Tight-fitting leather is pretty defining. But tight-fitting latex is like being sprayed with paint."[42]

Rubber and leather fetishes often coexist. In one case study of 1914, a Swiss fetishist became excited just by looking in the window of a rubber-goods store; he enjoyed tying rubber tubing around his penis and scrotum, inserting rubber tubes in his rectum, and covering his penis with condoms. He also liked wearing

"leather aprons, a leather-lined corset (which he made himself) . . . a leather headgear and mask . . . black leather gloves," and so on. His favorite fetish object was the glove. He said that "the rubber had a more tactile, the leather a more optical, effect on him."[43]

Leathersex

Leather is the skin of an animal that has had the hair removed and has been tanned. It has long been used to make objects such as harnesses, saddles, and whips, as well as items of clothing, such as shoes, belts, jackets, blacksmith's aprons, armor, gloves, and handbags. Leather clothing existed even before the Neolithic period, but leather has been a fetish material only since the nineteenth century, and most early accounts subordinate it to shoe fetishism. Early fetishists stressed the smell and shine of leather, with patent leather being particularly valued. In the twentieth century, however, the symbolic associations of leather have become increasingly important.

Leather seems to enter the mainstream of fashion history via the German connection. "If we're . . . looking for the roots of the black leather jacket in the twentieth century, then we have to look no further than the German aviators of World War I," writes Mick Farren.[44] After dutifully citing the Red Baron's leather flight jacket, however, Farrell moves on to more significant associations with the Nazis. In his history of the black leather jacket, there are numerous references to the Gestapo and the SS, along with photographs of Hitler, Rommel, Göring, and a Luftwaffe fighter pilot—all in black leather.

The mystique of the motorcycle is also strongly associated with leather and sex, a connection that we will later explore at greater length. On a purely functional level, motorcyclists wear leather because of its durable and protective qualities. If a bike tips over or crashes, leather clothing offers considerable protection. But already by the 1950s, leather motorcycle gear was strongly associated with motorcycle gangs, as in Marlon Brando's movie *The Wild Ones*. Black leather has also long been associated with sadomasochistic sex. In the 1920s and 1930s, many pornographic photographs showed people dressed in black leather and engaged in SM activities. Not all sadomasochists are into leather (nor are all leather fetishists into SM), but there is considerable overlap.

Although many leather fetishists are heterosexual, a significant gay "leatherman" subculture also exists. *The Leatherman's Handbook* contains a wealth of

Illustration by Stephen for the Gold Coast, 1964. (Kinsey Institute)

information about the symbolism of leather clothing. Particularly interesting are the results of a questionnaire that Larry Townsend distributed, although unfortunately he gives no indication of his methodology or even the number of respondents. Those surveyed were asked to respond yes or no to the statement "I like leather," followed by various categories of clothing: "jackets, jeans, caps, belts, [followed by the types of belt] wide, studded, kidney, Sam Brown, [then] gloves, chaps, shorts, jocks, aprons, sheets, thongs, masks, gags, other, boots, short, tall, extra tall, dull, polished, oiled, clean, dirty, new, old, engineer, motorcycle, cowboy, cop, lineman, logging, jodhpurs, construction, lace up, spurs, other."[45]

Many other sources also indicate the long-standing popularity of leather clothes, especially those with military, motorcycle, or cowboy associations—items like the Sam Brown belt (which crosses the chest), the so-called Master hat, and heavy boots. At the Mineshaft, a homosexual SM club in New York, there was traditionally a dress code, forbidding patrons to enter if they were wearing suits, ties, dress pants (including chinos and designer jeans), rugby shirts, "disco-drag," formal shoes, or sneakers. If patrons did not arrive wearing leather, they could put the offending clothes in the checkroom and enter seminaked. A leather body harness is "good for parading around in bars," declared the catalogue *Leather and Things*, which also advertised leather chaps (that laced up the sides), leather chastity belts (that laced up the penis), and executioner's hoods (the Masochist's version had no eye, ear, or nose holes), as well as leather dog collars, studded bracelets, and a fur-lined leather blindfold.[46] The Marquis de Suede (a custom leather manufacturer) made items like masks and straitjackets.

"You're really heavily into leather, aren't you?" asked the protagonist of the gay SM novel *Hard Leather*.

> "You know the kind of sex I like don't you?"
> "I think so. Real rough, so it must seem. From the way you're dressed."[47]

The Gay Men's Popular Fiction collection at Cornell University includes a variety of titles, mostly from the late 1970s and early 1980s, a few from the 1960s, on leather-related themes: *Leather and Sex, Hard Leather, Leather Hustler, Leather Sadist, Leather Lust, Breaking into Leather, Leather Whipper, Leather Drifter, Leather Bound and Beaten, Leather Licker, Leather Slaves, Lust for Leather, Leather Boy, Hellbound in Leather, Leather Sucker, English Leather, Leather Bound, Slave to Leather, Leather Closet, Kiss of Leather, Run Little Leatherboy, The Leather Queens, Into Leather*, and *Leather Lover*. Video titles included *Leather Boys, Leather Lover, Leather Narcissus*, and *Leathermen*.

Townsend wrote: "Big man . . . Big man in leather . . . You gotta earn the

right to wear it . . . can you take what you like to give?"[48] But according to Michael Grumley, author of *Hard Corps*, "There is surface leather and deep leather, real leather and patent. . . . The hard corps leather sensibility involves the use of leather in both sex display and SM ritual." For some masochists, "the most potent leather would be that tanned and dried from one's own hide, from the flesh of one's own body."[49] But although leather undeniably had "attitude," in reality wearing leather did not necessarily imply any position on SM.

Moreover, although leather functions as an international sign for sadomasochism, it has also come to signify homosexuality. In an article in the *Village Voice*, Vito Russo joked about how "leather 'gear' has become synonymous with queer." Leather was both "savage" and "civilized," and therefore well suited to "Huns, hostesses, and homosexuals." He repeated the campy old joke:

Q: Why do motorcycle gangs wear leather?
A: Because chiffon wrinkles so easily.

Leather was both "a symbol of the counterculture and an emblem of status."[50]

"Leather was gay sexuality stripped of being nice," recalled the novelist John Preston. Because it was confrontational, it was radical. At a certain point, though, like many men were who were "really into S/M," Preston "stopped wearing regimental leather." "It's a better bet to dress *against* the fashion, if you really want rough sex."[51] For lesbians also, leather evokes both SM and gay sex. The "leather dyke" is as familiar today as the "lipstick lesbian." Lesbians did not merely copy the leatherman look. They combined it with elements from punk street fashion to create a powerful new style.

"When leather becomes fashionable, it loses its bite," Grumley complained.[52] But it is precisely because it has a bite that leather became fashionable. "Kinky" leather clothing moved onto the fashion runways in the 1960s, when Yves Saint Laurent became the first major designer to make leather fashionable. Leather was especially fashionable in the 1970s, as both homosexuality and sadomasochism ("the last taboo") became much more widely accepted. A rash of pornographic movies appeared with titles like *Angelique in Black Leather* (for heterosexuals) and *Nights in Black Leather* (for homosexuals), as well as art films like *Maîtresse*, which featured leather and rubber dominatrix costumes by Karl Lagerfeld.

Punk street style and high fashion alike emphasized leather. Genevieve Reynolds said that she first knew she was "a leather fetishist . . . when I was in a punk fashion store in the chic part of Los Angeles. I'm eternally grateful to punk fashion because it made lots of leather and accessories easily available to us perverts!"[53] By the early 1980s, leather was ubiquitous.

"Leather clothing used to be linked mainly with motorcycle toughs, Gestapo thugs and the S-M crowd." But now "it's the 'fabric' everyone wants . . . the denim of the '80s . . . but luxe!" Leather is versatile, going from day to night, and it doesn't wrinkle. But the real reasons for its appeal had more to do with its symbolism. Leather had the "attitude" and "integrity" of denim. "Women feel good in leather," Armani told *Newsweek*. "It is such a sumptuous material . . . women are ready to spend fortunes for leather." And it is sensual. "Nothing else feels like leather next to your skin," said Donna Karan. "It's the ultimate sensuality! And a marvelous texture contrast with silk, chiffon, tweed."[54] Soon the black leather jacket was reborn as an apricot suede blouson.

According to British fashion writer Colin McDowell, the origin of leather's appeal lies in the fact that "the unaroused male penis [is] pink and pathetic." Leather provides a reassuring symbol of virile male sexuality. Not only does a

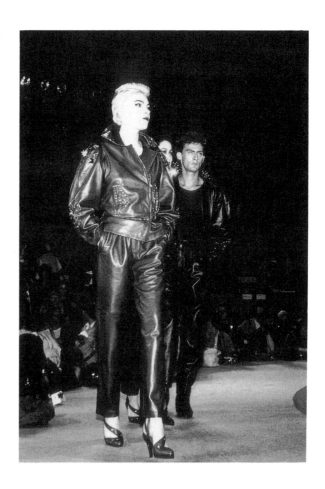

Leather by Thierry Mugler, 1977. (Roxanne Lowit)

Scott in leather, 1994. (Travis Hutchison)

leather jacket "disguise" the body's "inadequacies" and provide a sense of "heightened sexual awareness," but it also functions as an icon of butch, raunchy, even brutal, masculinity—and raw power.[55]

Today the preferred fetish material remains leather, which has become an international "sign" of "radical sex" as in the term *leathersex*. The attraction of leather is overdetermined: The sensory characteristics associated with it include a hard, shiny feel; a distinctive smell; and a creaking sound. Symbolically, leather is equated with pain, power, "animalistic and predatory impulses"—and masculinity. But there are gradually shifting fashions in fetish costume. The "ultimate fetish material," argues sex radical Pat Califa, "would combine the protective qualities of leather (its effect as armor) with rubber's ability to conform to the body's shape and heighten sensory awareness."[56]

Tattooing and Piercing

The fetishistic appeal of a second skin extends to decorating the body itself. Practices such as tattooing and piercing are of ancient and worldwide historical significance; they are not necessarily fetishistic or erotic. In many traditional cultures, they are ritualistic insignia and/or social markers. Fetishistic body modification is different, since it is undertaken by the individual for personal reasons, often having to do with erotic pleasure and pain.

Today tattoos and body-piercing have become increasingly stylish; even fashion models get delicate piercing, and modern bohemians sport pierced lips, cheeks, nipples, tongues, and genitals. Yet it was only twenty years ago that the piercing of Robert Mapplethorpe's nipples was genuinely shocking. It is interesting, therefore, to see how fetishistic body modification began to be publicized in the early twentieth century. Already in the 1880s, letters to the *Family Doctor* described "boys having their ears, noses, and breasts pierced, and rings inserted in them, at a foreign private school."[57] In 1899, there was a rash of letters in *Society* on "the latest fashionable craze," for men and women to have their breasts pierced.[58] *London Life* reported extensively on the "Pleasures of Piercing" in the 1930s. AUNTIE'S IDOL wrote:

> My young man wanted me to have my nostrils and cheeks pierced to please him, and as he has given me a lovely pair of white kid boots with 8 inch heels laced up the back, I decided to have them done. . . . The feeling was thrilling. . . . It's wonderful what

pleasure one can get out of being pierced and of wearing rings and pendants from one's ears, cheeks and nose.[59]

In the 1970s, enthusiasts argued that "during the Aquarian Age man's natural inclination to decoration will flourish. Tattooing and piercing will be very popular. . . . As we 'civilized' people have no . . . rites of passage . . . many individuals find a void in their lives which the piercing experience often fills."[60] Charles Gatewood, a photographer whose book *Primitives* documents twenty-five years of subculture body modification, argues that "body art has to do with taking control of your life and your body . . . transforming to facilitate personal change and growth." In the 1970s, it was partly just hedonistic escapism, he says, but now piercing is related to "a lot of New Age thinking."[61]

Piercing entered contemporary culture via the gay, SM, and fetish subcultures. Pierced and tattooed "leather boys and girls" at the Los Angeles club Fuck! told a journalist: "This is about being in people's faces. It's me saying, 'I *am* a freak. I *am* queer. I'm *not* like you.' " Part of it was pure "shock value" and directly related to "the punk thing."[62] By the 1990s, body-piercing had moved into the mainstream.

"Fetish or Fashion?" asked the *New York Times* in an article describing how top fashion models Naomi Campbell and Christy Turlington had had their navels pierced. Jean-Paul Gaultier used heavily tattooed and pierced models to show a collection featuring tattoo patterns on sheer T-shirts and both real and fake piercing jewelry. According to Gaultier, "It was not only about that primitive thing, but also about decoration. I like the idea of the body as a piece of art . . . It is the punk influence, but it is also something spiritual."[63]

"The idea of beauty is changing radically," some argue. Shaved heads, tattoos, pierced navels, even pierced tongues and genitals have become more common.[64] As with any fashion trend, the shock value of body play then declines. And, indeed, piercing and tattooing may already be somewhat passé: "Nose rings no longer merit a second glance on the street." While some turn to laser treatment to remove their tattoos, others have moved on to new types of body modification, such as branding, "the stuff of cattle drives."[65] A public exhibition of branding was recently canceled in New York (for legal reasons), and branding is also practiced as an initiation rite at some African-American fraternities.

There are rumors that a fad for minor amputations has begun in Europe. The most ubiquitous type of skin decoration, however, continues to be make-up, especially lipstick. In fact, a case could be made that cosmetics are one of the more popular sexual fetishes.

Catwoman on the cover of a fetish magazine. (Peter Czernich)

seven

Fashion, Fetish, Fantasy

The clothes that we choose to wear, like our conscious lives in general, are for the most part firmly under the control of what psychoanalysts call the Reality Principle (i.e., you can't always get what you want). Our lives, therefore, necessarily involve tacking between the Pleasure Principle and the Reality Principle. In fantasy, however, we are free from reality testing and can openly pursue pleasure.[1] There are also times in social life when clothing functions as a kind of masquerade costume, subversively disguising the individual in the apparel of a fantasy self.

Some fetishists carry their clothing fixation beyond individual fetish objects, adopting entire specialized ensembles that incorporate a variety of clothing fetishes: a corset over a leather catsuit with high-heeled boots, long gloves, and so on. To initiates, these costumes convey rather precise meanings about the kind of sex offered and/or solicited, and the theatrical play within which sexual contact will occur. Even when the sexual activity is limited to masturbation, the fetishist may use a mirror as an aid to fantasy.

The costume is thus part of an elaborate erotic drama. Participants in these ritualized sexual encounters tend to wear costumes drawn from a limited range of dress-up roles, among the most common being the dominatrix, the master, the slave, the biker, the cowboy, the man in uniform, the nurse, the maid, the harem girl, the amazon, and the boy-girl. This type of sartorial role-playing involving gender and sexual stereotypes bears obvious similarities to mainstream cultural phenomena. Specialized costume houses report that many clients go for fantasy "fashions with a high sleaze factor—femmes fatales, French maids, show girls, sexy nurses, [and] sexy policewomen."[2] Many of these fetish costumes also have

fashionable counterparts whose psychological significance and cultural symbolism can be analyzed.

Who Wields the Whip?

The 1992 "bondage" collection presented by the Italian fashion designer Gianni Versace was controversial. Was it "Chic or Cruel?" asked James Servin in the *New York Times.* Some women took offense at Versace's SM clothes, describing them as exploitative and misogynistic. But other women interpreted the dominatrix look as a positive amazonian statement—couture Catwoman. You will recall that in the movie *Batman Returns,* Michelle Pfeiffer's Catwoman is costumed in skintight rubber to resemble a dominatrix. To get a PG rating, the producers did cut the scene where she tied Batman to the bed, but her lessons with a "whipmaster" are prominently displayed. Versace himself insisted that "women are strong" and argued that as women have become liberated, this includes the freedom to be sexually aggressive. Asked to comment on whether Versace's fashions empowered or degraded women, Holly Brubach (then the *New Yorker*'s fashion columnist) wisely said: "It could go either way. Either the Versace woman is wielding the whip, or she's the one who's harnessed and being ridden around the room wearing a collar and a leash."[3]

Pornographic photographs from the early twentieth century already display the classic iconography of fetishism, in conjunction with the theme of dominance and submission. The vocabulary of images employed is standardized and instantly recognizable. Just as there are monsters and murders in horror films, horses and guns in Westerns, so in a certain genre of pornography, there are high heels, corsets, leather, lingerie, and whips. I would suggest that a connection exists between this type of pornographic imagery and contemporary fashion, which increasingly foregrounds issues of sex and power. The feelings of unease that some women experience when confronted with fetish fashion bear significant similarities to the much more vocal debate over "pornography" and the attempt to censor art that allegedly degrades women or depicts images of "perversion." Conversely, the attraction that many women have to fashion—and fetish fashion, in particular—may be related to their desire to assert themselves as independent sexual beings.

Significantly, the dominatrix fantasy was actively embraced by a segment of the fashion press, as editors gambled that the image of a powerful and sexy woman

Who wields the whip? ca. 1935. (Kinsey Institute)

would appeal to more female readers than it offended. Thus, the fashion magazine *Harper's Bazaar* jokingly captioned one photograph: "Heavy metal, light bondage: The dominatrix's straps and stilettos will not be denied. . . . Black wool/silk bra top about $2100, black spandex and leather hot pants, about $700, and stilettos with thigh high straps, all from Gianni Versace."[4]

Only a few observers commented on the immediate antecedents of Versace's collection: the SM leatherman look popular ever since the 1970s with some gay men. Versace himself recalled that fifteen years before, he had shown a "similar collection" in Dallas, "and they turned the lights up on us. They said these clothes belonged only in a leather bar. And now, last night, there were 200 socialites in bondage!"[5]

Drawing on a design vocabulary associated with leathersex, Versace created a collection that renewed the look of fashionable leather by exploiting the charisma associated with "radical" sex. The collection was less about women's issues than about rebellious, transgressive, unapologetic, pleasure-seeking, powerful in-your-face *sex*. There are, therefore, two issues that must be addressed: (1) the feminist critique of "sexist" fashion, and (2) the "co-opting" of radical sex by the fashion industry. For not only did feminists object to the style, so did fetishists.

"Versace wrecked that whole look," complained Randall, owner of the Caped Crusadist, a custom-made-leather store in Seattle. "Trendy fashiony stuff is out. Now people are into a much harder look." "There's lots of competition about who can come up with the best fetish costume," agreed a much-pierced customer in another Seattle leather store.[6] Many feminists, meanwhile, criticized fashion in general (and the new fetish fashions, in particular) for being conformist, consumerist, and, above all, sexist. "I doubt Versace polled 3,000 women" before designing his clothes, commented Susan Faludi.[7]

Contrary to popular belief, however, this is *not* simply a matter of "sexist" fashion designers exploiting women or "ripping off" sexual minorities. Let's be clear about this: Versace is not the issue. I have chosen to discuss his bondage collection because it received so much press, but many avant-garde designers are exploring fetish themes, including women like Vivienne Westwood and Betsey Johnson. And the designers, in turn, are getting many of *their* ideas from street fashion and subculture styles. As the English feminist Elizabeth Wilson points out, "The existence of street fashion demonstrates that a desire to adorn one's body is not simply the result of being duped by the fashion industry and capitalism."[8]

A Fetish Is a Story Masquerading as an Object

It is no secret that sexual fantasies are both extremely common and often "perverse." Such fantasies may be conscious (as in daydreams) or unconscious (revealed only by neurotic symptoms). Perverse fantasies may be repressed; or, if the circumstances are favorable, they can be transformed into manifest behavior.

Obviously, people who dress up as, for example, master (or mistress) and slave are acting out a fantasy of some sort. But fantasy is a complicated concept. As commonly used, the word *fantasy* denotes imagination, illusion, exaggerated or unreal images. Thus, feminists like Susan Faludi argue that Italian fashion designer Gianni Versace creates "fantasy clothes" that cannot be taken "too seriously."[9] But fantasy is not just "unreal." Fantasy also has a particular psychological meaning, involving the fulfillment of psychic needs. According to psychoanalysts, conscious sex fantasies overlie certain original fantasies on themes such as castration, seduction, and the primal scene.[10]

In her important essay "Pornography and Fantasy," Elizabeth Cowie writes, "What is portrayed [in fantasy] is not the object of desire, but a scenario in which certain wishes are presented." The pornographic image of a woman touching her genitals does not trigger "an automatic stimulus-response" in a heterosexual male viewer. Rather, it is the staging of "a scene of desire" and a "sign" whereby the "image of female genitals stands for something else, the man's pleasure." Among the wishes expressed in this image, Cowie suggests, are the following: She waits for me, she is already excited, she is showing me her genitals because she wants to see mine.[11]

What is true of "normal" sexual fantasy is also true of fetishism—and of fashion. Many people assume that it is "natural" for a man to be aroused by the sight of a woman's naked breasts, and "unnatural" to be excited by her feet or shoes. But human sexuality involves more than an instinctual response to a programmed stimulus; we do not go into "heat" and mate like animals. Human sexuality is constructed. But contrary to what many feminists believe, it is not learned in the sense of acquiring a set of roles. Boys do not look at *Playboy* and learn to like big breasts and view women as sex objects any more than girls look at *Vogue* and learn to become anorexic and passive.

This is such a crude "monkey see, monkey do" model of human behavior that

it is amazing it has achieved such wide currency, except as an ideological response to the equally reductionist instinctual model. The nature/culture controversy itself is simplistically conceived, as though it were even possible to separate the two. Sexuality is, of course, a biological and evolutionary phenomenon. (Sex is why we are not single-celled organisms that reproduce by dividing.) But human sexuality is also characterized by the desire for pleasure, and people engage in various pleasurable but nonreproductive behaviors, including masturbation, homosexuality, kissing, oral–genital sex, and the so-called perversions.

Sexual arousal is experienced as being instantaneous, but according to psychoanalysis, sexuality "arises in the emergence of fantasy," as from "the most natural biological events emerge polymorphous pleasures." The infant nurses; feeding is self-preservation. But the sucking is also pleasurable, and the breast becomes the "object of desire," not simply in and of itself, "but as a signifier of the lost object which is the *satisfaction* derived from sucking the breast."[12] The shoe, like the breast, is a symbol of pleasure. But the fetish is not only a symbol.

"A fetish is a story masquerading as an object," writes Robert Stoller.[13] Although the dialogue may be carefully scripted and endlessly rehearsed, the text itself (or, rather, the subtext) remains largely unconscious to the fetishist. The adult male fetishist knows perfectly well that women do not have penises. Nevertheless, on an unconscious level, he may still be fearful about sexuality, and especially when he feels emotionally threatened, he may seek to reassure himself about his manliness by choosing a sexual partner whose frightening feminine aspects are disguised behind a "veil" of phallic signifiers. As Louise Kaplan puts it, he needs a fetish, such as a corset or a pair of thigh-high boots, to "pave the way" if he is successfully to "enter that temple of doom called the vagina."[14]

Many psychiatrists believe that the "Phallic Woman" is, in fact, "the ubiquitous fantasy in perversions." Behind all perversions, in other words, we find an attempt to deal with an otherwise unbearable castration anxiety. "Acting out" the fantasy that women really do have a penis or phallic equivalent is frequently a phase in the perversion. Although fantasizing or looking at pornography would be safer than taking the risks associated with play-acting, "the need for acting out . . . derives its strength from the *orgastic affirmation of the truth of the primal fantasy*, on the one hand, and by the participation of the outside world on the other. By actually engaging *dramatis personae*, the fantasy becomes indisputable reality."[15]

Clothed in Power

We will begin with the costume of the dominatrix, both because it is the single most important fetish costume and because it has exerted the greatest influence on contemporary fashion. When I arranged to meet the Baroness Varcra, she said that she had red hair and would be wearing "either a velvet dress with a rubber corset over it—or standard dominatrix gear." Myopic as I am, I recognized her from a distance of fifty feet. "It's important for a Dominatrix to create a 'look,' because most of this business is PR," says Mistress Jacqueline in her as-told-to memoir, *Whips and Kisses: Parting the Leather Curtain.* Items like custom-made form-fitting leather minidresses, studded leather jackets, and thigh-high boots help create a "definite image." Clients' tastes vary, but, in general, the ideal look is "a balance of leather and lace."[16] According to Madame Sadi, a dominatrix should "never bare her breasts and always wear elegant clothing (high heels, preferably boots, and gloves)."[17] Although, in fact, a dominatrix may sometimes show an expanse of naked thigh or bosom, it is more common for her to be almost completely covered by a second skin—from the mask that partially or completely covers her face down to her stiletto-heeled boots.

Her entire body, in other words, is transformed into an armored phallus. High-heeled shoes, boots, and gloves are obvious phallic symbols, as is the whip or riding crop that she often carries. In addition, the dominatrix often wears a corset, which is also a phallic symbol, despite being shaped like the female torso, since its boning makes it hard and stiff. A corseted person stands erect. Her victim (client) may also wear a corset, however, since this item is frequently associated with rituals of bondage and submission and with transvestism. Thus, it is not a question of static symbolism (X equals phallic symbol), or even of multiple phallic symbols, but rather of an entire erotic drama.

The costume of a dominatrix also implies a scenario in which certain wishes are expressed. She wears a mask: Therefore, she is anonymous; I don't want to know with whom I'm having sex, and if I don't know, then perhaps she doesn't know who I am either. She looks menacing. In pornographic literature, masks are associated with torturers, executioners, and burglars. Therefore, I am the victim, so I'm innocent, or, if guilty, then I'm already being punished for having sex, so I don't need to feel ashamed.

The presence of a whip implies a wish that someone should be beaten. But who? And why? Freud's famous essay "A Child Is Being Beaten" throws light on

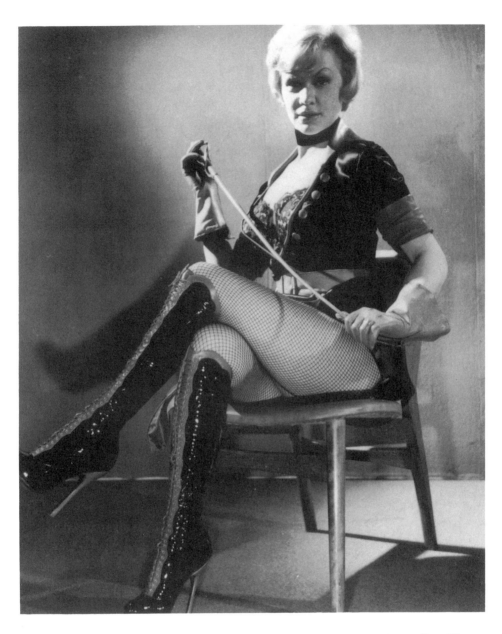

German actress Ingrid van Bergen plays a counter-spy disguised as a "whip girl" in Hamburg's red-light district during World War II, in The Counterfeit Traitor, *1962.* (Penguin Photo/Bettmann Archive)

the common fantasy of corporal punishment, which is not only about beating because the action is also a metaphor for sex. ("Beat your meat.") For psychoanalysts, the whip is a "punishing penis."[18] To whip is also to caress. At the very least, it involves paying attention to the person being beaten. In the polarity of passive and active, the conspicuously active person (we can see her arm move) is the one giving the beating. The passive figure is the one acted on. It is said to be "hard work" to be a master or top, and much easier to be a slave or bottom.

If the dominatrix wears boots, is the slave to be trod on? Certainly this is what the pornographic stories tell us: He licks the boot, and she kicks him. He sucks on the stiletto heel, and she inserts it in his anus. The tap-tap of her heels promises that someone is coming; the shiny patent leather already looks wet. The high heels affect her gait, making her hips and buttocks sway. Since high heels are a sign of femininity, he knows it is a woman coming—unless it is a transvestite. The heels are hard and stiff and long; they will walk all over the slave, who loves this evidence of his submission.

Fetishists like Pat Califa reject most aspects of the psychoanalytic interpretation. She does, however, agree that "the key word to understand S/M is fantasy. The roles, dialogue, fetish costumes, and sexual activity are part of a drama or ritual. . . . The S/M subculture is a theatre in which sexual dramas can be acted out."[19] Pychoanalytic studies of fantasy indicate, moreover, that the subject may play different roles—indeed, may play all the roles in any given story. The male viewer of a pornographic video does not necessarily identify with only the male character, but also simultaneously with the female character, with both characters, with the entire mise-en-scène, and with the role of the voyeur—he who watches. Even, perhaps, with the boot that is licked.

The overwhelming majority of fetishists are men. Most women who wear fetish costumes seem to do so either for direct economic reasons (i.e., they are professional sex workers) or to please their husbands or boyfriends. This is not to "erase" the existence of those women who identify themselves as fetishists. In perversion (probably in all forms of sex), we are dealing with deep fantasies that should not be glibly conflated with consciously articulated gender politics.

Clothing itself is generally associated with power, and nakedness with its lack. Just as the dominatrix is usually fully clothed, so is the male master. By contrast, the slave, bottom, masochist, or submissive is often (although not inevitably) stripped naked or reduced to wearing clothing that exposes breasts, buttocks, and/or genitals. One master–slave heterosexual couple reports spending entire weekends with the slave remaining totally naked.[20] Nudity also carries submissive

connotations in the titles of pornographic paperbacks like *Naked Teen on a Leash* and *Naked Wet Wife*. The meaning of fetish clothes, however, depends on the context and wearer.

If the master's mask hides the executioner, the slave's leather hood implies the victim. The master's boots are made for stomping, while the slave is "hobbled" by shoes that may have more than 6-inch heels and/or very high platforms, to say nothing of multiple straps and buckles. The corseted dominatrix is powerfully armored; the corseted cross-dressing slave is in bondage. And yet accounts by SM adherents uniformly stress that the slave figure is very often the one "really" in command—indeed, often quite bossy: "Do it harder! Don't stop! Not like that, like this!" The real question may not be Who wields the whip? but rather Who pays? Or: Whose fantasy is this?

Of Maids and Men

The maid is an obviously submissive role, which indicates the power differential implicit in traditional gender stereotypes. In the nineteenth century, prostitutes in brothels sometimes dressed up as maids, in dark uniforms punctuated by white aprons and caps. They also dressed up as brides, nuns, and schoolgirls, all conspicuously virginal figures. The maid, however, was not virgin but victim, sexually servicing her master. The theme remains popular today, when fantasy costume shops report steady sales of so-called French maid costumes. There are also pornographic films with titles like *Little French Maid* and *Maid to Be Spanked*.

Transvestites seem particularly fond of dressing up as "sissy maids," perhaps because this is such a quintessentially feminine, slavish role. The transvestite magazine *Repartee* published a letter from an expatriate cross-dresser living in Japan who reported on several television programs:

> [M]y favorite has been a cartoon series in which the hero, in order to be with the girl he loves, since her parents disapprove of his impoverished background, becomes one of her maids. The cartoon series then revolves around the maid and her mistress keeping the secret. Interestingly, the maid begins to find herself attractive in black dress, white apron and cap, and after the girl gets married, decides to stay as her maid forever. Now that's a nice fantasy.[21]

The pornography associated with transvestite SM often features the man being humiliated—by being put in women's clothing or underwear. Yet he ultimately

triumphs, since underneath his frilly skirt (or apron), there is the unmistakable sign of manhood.

The maid's uniform seems to fit perfectly into this scenario of eroticized humiliation. "Servant's Clothes Turn on Transvestites,"[22] proclaims one article, while books carry titles like *Housemaid Husband* and *She-Male Slave*. Many London prostitute cards feature images such as a kneeling figure dressed entirely in black rubber (including a gas mask), except for a white apron. The slogan reads: "Maid to Dress Correctly." Another shows a transvestite in a maid's cap: "Gentleman Maid to Serve." A third card depicts a man in a rubber maid's uniform (that covers his mouth) with the words: "Rubber Domination and Uniform Training."

Although aprons occasionally appear in contemporary women's fashion, they

Fetish maid, 1994. (Centurian/Spartacus)

have tended to be hard and masculine: black leather butchers' aprons, for example, not frilly little white aprons. Nor have little white caps been fashionable for a century. In their sartorial self-presentation, modern women do not seem to want to play the submissive role. The apron as feminine *cache-sexe* remains hidden from public view. (But a few designers, such as Vivienne Westwood and Betsey Johnson, have incorporated maid's caps into their runway shows.)

The costume of the harem girl also evokes a master–slave typology, together with long-standing and fairly transparent fantasies about group sex. Nineteenth-century soft-core erotica often focused on the idea of white sex slaves in the hands of lascivious Turks. The same theme, minus its racist subtext, was also played out in movies and television shows like *I Dream of Jeannie*. Pin-up star Betty Page posed as a harem girl with a bare midriff, a jeweled brassiere, and diaphanous trousers. There are also contemporary porn films like *Harem Girls in Bondage*. Harem fantasies also, of course, carry quasi-lesbian overtones, with the master as voyeur.

While the leather and rubber favored by the dominatrix evoke power and cover most of the body, the maid and harem girl wear soft, feminine, semisheer fabrics that lightly veil their anatomy. Thus, if the dominatrix is the quintessential armored Phallic Woman, the maid's apron and the sheer harem trousers evoke an alternative model of the Veiled Woman. Although popular as fantasy costumes, neither the maid nor the harem girl has had much impact on fashion, even though stylists and photographers sometimes play with the exotic eroticism of the harem girl or the lesbian overtones of the mistress–maid pair.

We began with the dominatrix as Phallic Woman; when fetishizing males disguise themselves *as men*, they also frequently choose phallic costumes associated with ultra-masculine roles, such as the cowboy, the motorcyclist, and the soldier or policeman. The clothing associated with these roles functions as a kind of armor against the world that protects the wearer's inner self, while projecting an image of aggressive masculinity.

Larry Townsend's *The Leatherman's Handbook* insists on the iconic significance of motorcycle clothing:

> Intrinsic to the leather scene is the motorcycle and the guy who rides it. The clothing we all find so appealing is primarily designed for the cyclist's use . . . sexual appeal of a leather-clad rider on his great rumbling machine. As a symbol of phallic might the motorcyclist is the epitome, the living embodiment of our fetish.[23]

The motorcycle itself is a powerful machine with thrusting pistons and an engine that throbs and roars before the thrill of taking off, which functions as a

Harem girl, ca. 1955. (Paula Klaw/Movie Star News)

metaphor for the "pounding rhythm" of sexual excitement. The Kinsey Institute contains numerous examples of sexual imagery featuring men and motorcycles. In a file on "Fetish-Costume-Leather," a leatherite is described as "pulling on his footgear in preparation for some heavy stomping." A photograph is captioned: "A leather riding suit can get pretty warm at times, and a fella might need to unzip and cool down a bit." The anonymous copywriter then drew attention to the "contrast between cool flesh tones and the richer qualities of the leather gear."[24] The pornography associated with this constantly reiterates the idea of man as Sex Machine. Titles include *Bang the Bikers*, *Biker Buddies*, *Motorcycle Cops*, *Nazi Bikers*, *Rough Rider*, and *S&M Bike Cop*.

Townsend's poll indicated that the leather motorcycle jacket was interpreted as powerful and desirable: 90 percent of the Sadists wanted a motorcycle jacket for themselves, although 70 percent of the Masochists did, too. Leather motorcycle hats and motorcycle boots were more associated with the Sadists, as were leather belts, wristbands, gloves, and chaps. (All wanted Levis for themselves.[25])

Leather fetishism does not exist in a vacuum. Leather is clearly associated with certain male types (not just the motorcyclist, but also the cowboy, soldier, and policeman). Townsend's research also associates these roles with "psychodramas I enjoy: obey rules or else, bootcamp, barracks, classroom, jail, etc."[26] A 1974 advertisement for G.B.M. Leathers demanded: "Are you proud to be gay, butch, and a man!" A personals service was then offered "to only the MEN of S&M, 'Leather,' Levis, Denim and Cowboys, Rubber, Boots and Uniforms."[27]

According to *The Leatherman's Handbook*, cowboy clothes are "compatible with leather and jackboots." The cyclist and cowboy are brothers. Groups of men "ride horseback and camp out," wrote Townsend, wearing "leather chaps over Levis . . . or maybe over naked hips and thighs. Even if the group is dressed, at least half will have stripped to the waist." Later on, "the group is mostly in the nude, except for boots," "tooled boots with pointed toes and elevated heels," and cowboy hats.[28]

Although historically cowboys wore a motley assortment of cheap clothes, the cowboy as icon is conceived of as wearing Levis or other tight pants, special boots (often polished, colored, and decorated high-heeled boots), wide heavy leather belts (sometimes including gun holsters), leather chaps, fancy shirts and/or fringed suede jackets, neckerchiefs, and large distinctive hats. Fetishistic pornography in this category includes titles such as *Boots and Saddles*, *Cock Crazy Cowboy*, *Cock-Hungry Cowboy*, *The Cocky Cowboy*, *Cowpoke*, and *Hard Horny Cowpokes*. Erotic images often show a man who is naked except for his boots, his hat, and his gun.

Drawing by Tom of Finland, 1977. (Image used by written permission of the Tom of Finland Foundation, P.O. Box 26658, Los Angeles, Calif. 90026)

Fetish cowboy in leather chaps, ca. 1960. (Kinsey Institute)

English fashion designer Vivienne Westwood was prosecuted in the 1970s for selling "pornographic" T-shirts. (Vivienne Westwood)

Both the motorcyclist and the cowboy are important gay male icons. Women's fashion designers (many of whom are gay men) have also frequently been inspired by clothing of the cowboy and the biker. The fashionable cowgirl copies every element in the macho wardrobe of the cowboy, from his big hat to his polished boots, and all his leather gear. She is almost a caricature of the Phallic Woman, and erotic images emphasize her gun and the fact that she has something big between her legs. The fashionable female biker has also acquired a permanent place in the pantheon of high fashion. If Claude Montana dresses women in leather biker jackets, and Calvin Klein's advertisements pose them with big, powerful motorcycles, Thierry Mugler went a step further and created (for his runway show) a metal bustier that turned the woman herself into the representation of a motorcycle. Meanwhile, within the sexual subculture, "the biker look, which was popular among S&M people for a long time, has kind of gone away. Now they go for a more high-fashion look."[29]

179

The Cult of the Uniform

Uniforms are perfect for the kind of role-playing characteristic of fetishistic sex, because when wearing a uniform, the individual is subsumed by his (or her) role. As they say in the army, one "salutes the uniform and not the man." Because the uniform is a symbol of membership in a group, it suppresses individuality, sometimes leading "to total depersonalization." Uniforms also frequently symbolize authority, evoking fantasies of dominance and submission.[30] Military and police uniforms, in particular, signify that the wearers are legally endowed with state-sanctioned power. By contrast, maid's uniforms imply servility and a lack of power.

Military uniforms are probably the most popular prototype for the fetishist uniform because they signify hierarchy (some command, others obey), as well as membership in what was traditionally an all-male group whose function involves the legitimate use of physical violence. Soldiers can shoot and stab without constraint. The erotic connotations of military uniforms derive, in part, from the sexual excitement that many people associate with violence and with the relationship between dominance and submission. Military uniforms also enhance the perceived sexual attractiveness of the wearer through the use of phallic signifiers, such as boots and weapons, and through the design of the clothing, which frequently emphasizes the physical body to a degree uncommon in ordinary menswear.

Magnus Hirshfeld, the pioneering gay sexologist, found that among "soldier lovers," there was great variation. Some like only infantrymen; others, only cavalry officers. A military tailor in Berlin "whose establishment was a frequented resort of homosexuals, kept a collection of all kinds of uniforms in his closets with which he was able to transform any kind of Uhlan or infantryman into a sailor or marine."[31] The sailor, especially, has become a recognized gay icon, immortalized in paintings, ballets, and operas.

Uniformed authority figures, such as military and police officers, are still the focus of considerable sexual interest among both gay and straight men. (There is some evidence that they may also appeal sexually to gay and straight women.) Gay pornographic titles include *The Cop on 69th Street, Dominant Drill Sargeant, Leather Boot Camp, Marine Master,* and *Soldiers of Sodom.* Heterosexual pornography also often features uniformed female figures. "Kinky Fun and Uniforms with Sexy Model" promises one prostitute's card. "Bobbie—An Arresting Experience," announces another with a picture of a woman in police uniform.

The uniform in fashion, Prada, 1994. (M. Chandoha Valentino)

Some sadomasochists argue that SM makes explicit the power relationships that exist throughout society. Pornographic fiction often utilizes political themes and costumes to express sadomasochistic fantasies. Paperback titles include *Nazi Sex Slave*, *Slave to the SS*, *Soviet Sex Slaves*, *Teen Sex Slaves of Saigon*, and *Student Victims of Red Torture*. In these, the uniforms of the "enemy" function less as symbols of evil than of erotic power. Townsend's survey found that only 10 percent of the Masochists wanted a Nazi uniform for themselves, but 60 percent of the Masochists wanted a Nazi uniform to be worn by the Sadists.

The uniform itself can also be a fetish, even apart from an erotic psychodrama. The famous gay illustrator Tom of Finland said that "sometimes the attraction to the uniform is so powerful in me that I feel as if I am making love to the clothes, and the man inside them is just a . . . sort of animated display-rack."[32] Hermann Broch described the psychological appeal of the uniform in *The Sleepwalkers*, a novel about a Prussian military officer:

> A uniform provides its wearer with a definitive line of demarcation between his person and the world. . . . [I]t is the uniform's true function to manifest and ordain order in the world, to arrest the confusion and flux of life, just as it conceals whatever in the human body is soft and flowing, covering up the soldier's underclothes and skin. . . . Closed up in his hard casing, braced in with straps and belts, he begins to forget his own undergarments, and the uncertainty of life.[33]

The appeal of this obviously extends beyond a minority of fetishists. Every person in a business suit is wearing a uniform of power.

But not all uniforms are equal, and not all play an equally important role in fashion. The study "The Nurse as a Sex Object in Motion Pictures, 1930–1980" found that "seventy-three percent of the nurse roles characterize nurses as sex objects." In line with the increasingly overt eroticism of recent decades, "the frequency and intensity of this stereotype rose significantly during the 1960s and 1970s." Moreover, the image of the nurse was divided into the "sadistic nurse" stereotype and the "sexy playmate" stereotype.[34] Pornographic paperbacks carry titles like *Nurses' Bedside Skills*, *Sex with a Nurse*, *Virgin Student Nurse*, and *Wild and Kinky RN*. Then there are films like *Nasty Nurses* and *Naughty Nurses*.

An analysis of the nurse's uniform provides clues about these pervasive stereotypes. The history of nursing makes it clear that the nurse's uniform derives from that of the housemaid (cap and apron), not the labcoat of the scientist or doctor. For many years, nursing was a very low-paid, low-status female job. Whereas the

"HE'S TAKEN A TURN
FOR THE NURSE"

A MUTOSCOPE CARD PRINTED IN U. S. A.

The nurse as sex object, ca. 1940.

doctor is clearly an authority figure, the same cannot be said of the nurse. The nurse costumes worn by fetishists are often made of rubber, a material associated with degrading objects such as rubber sheets and panties.

And yet the nurse has a certain power that gives her an erotic charisma. She is officially supposed to help the patient "get better," and in much ordinary pornography this translates directly into therapeutic intercourse. Sadomasochistic and fetishist pornography, however, emphasizes how she also inflicts pain on the patient. Moreover, the patient is in a dependent and passive position vis-à-vis the nurse—on his back in bed—while she is erect and standing, hypodermic needle or enema in hand. Fetish paperbacks have titles like *Nurse in Rubber*. Nurse costumes have a strong appeal for many fetishists (and many men in general), but their appeal for women seems to be limited, and they have seldom appeared as fashion inspiration. The masculine associations of other uniforms have made them more attractive as fashion.

Where Cock Is King, Go for the Codpiece

In her 1985 essay "Sorrow and Silk Stockings," lesbian Marcia Pally interpreted both tough street styles and "androgynous" business suits as imitation male: "Popular styles don't lie midway between masculinity and femininity, they fall—rush—toward butch. Where cock is king, go for the codpiece. It's not surprising that gay lib produced a butch uniform, feminism a tailored one."[35]

"Self-presentation is about power," agrees fashion scholar Elizabeth Wilson, and this has often meant that women's fashions have drawn on male prototypes. Contrary to popular belief, men's clothes (like trousers) are not necessarily *functionally* superior to women's clothes, but they are symbolically powerful. An advertisement for business suits shows a woman standing at a conference table with the caption: "How to Be Taken Seriously." The caption of another advertisement quotes Walt Whitman: "Resist Much, OBEY LITTLE." It shows a woman sitting on the back of a car, wearing a black leather jacket and cowboy boots. Historically, men have had both more physical power (as implied by the black leather jacket) and greater socioeconomic power (as reflected in an expensive suit).

Thus, business suits and cowboy boots alike are assertions of masculine power—even, perhaps especially, when women wear them. Whether a woman dresses young and tough like a biker, rich and important like a capitalist, or in the high heels of a dominatrix—in a sense, she masquerades as the Phallic Woman. It is not that women want a penis, but that, like men, they want the power that patriarchal society has attributed to the phallus and that is symbolized by phallic clothing. But high heels and negligees may also serve as the insignia of power.

"Women rule, OK?" says the young American designer Marc Jacobs. "Women in control, in high heels!" Versace describes modern women as "ruling . . . men with an iron hand." This is not literally true, of course, but it might have a certain psychic reality for both men and women. The artist Allen Jones (creator of controversial fetish images) insists that although feminists have criticized eroticized pictures of phallic women in rubber and leather, "these images come from the same system as power dressing."[36] This idea provides an important clue regarding the popularity of fetish fashions: They make women look powerful, very powerful.

"Who'd want to be seen as a gorgeous, sexy, long-legged killer in costumes cut up to here and down to there? Who'd collude in such a disgraceful display of male chauvinism? Then again, who'd be so lucky?" According to fashion journal-

ist Sarah Mower, fashion in the 1990s is "fearlessly expressing the politically in-correct" idea that women should use their "sexuality as an instrument of com-bat."[37] During the 1970s and 1980s, fashionable women tried to avoid looking too feminine, because they associated femininity with powerlessness and not be-ing taken seriously. Even now, many women argue about the "morality" of items like corsets and high heels, on the grounds that they pander to (sexist) male fantasies. But Mower insists:

> I think we're pandering to our *own* fantasies. . . . We don't want to be men. We don't want to wear those suits . . . We are women, therefore we want to wear wom-anly clothes. . . . It doesn't set women back, because we're not saying that we want to be like our mothers and grandmothers were in the Fifties. . . . And it definitely *is* having a laugh at men, because they get helplessly turned on by it![38]

It is not necessary to agree with Mower to recognize that her viewpoint is widely shared. To the extent that fetish fashion is popular with women, in large part this is because it adds the idea of *power* to femininity.

Another word for *power* is *freedom*, since although power is oppressive when wielded by others, it is something that most people desire for themselves. The various sartorial strategies for conveying power change constantly, however; after Versace presented the Phallic Woman armored in black leather, he shifted gears and presented the Veiled Woman in diaphanous chiffon. The combat boots of the early 1990s gave way by the middle of the decade to stiletto heels.

What *Vogue* calls the "strong and sexy" look has become the paradigm of con-temporary fashion. This is a direct result of women's liberation. For although feminists such as Susan Faludi and Naomi Wolf rage against fashion for holding women in a "beauty trap," in fact the history of fashion reveals a more complex picture. In the past (and today in countries like Saudi Arabia and Iran), socially conservative males have made a point of controlling and concealing women's bodies. As women became more independent, they adopted both men's clothes and body-revealing clothes.

The issue of *sexual power* is problematic, however. "I don't feel that I have to be a man, look like a man to succeed," argues English fashion designer Katherine Hamnett. "I really hated that old-fashioned idea that looking sexy was bad."[39] Do "sexy" clothes increase or undercut women's power? If power is defined as the ability to do what you want (including the ability to command another per-son), then the evidence cuts both ways. Some women obviously have achieved what they wanted by sexually manipulating other people, although other women

have found that their sexuality made them more vulnerable to the often greater physical power of men. The notorious "mini-skirt rape case" in Fort Lauderdale, Florida, involved a woman whose alleged assailant was acquitted by a jury that interpreted the victim's "provocative clothes" as saying that she was "asking for it."

Fashion obviously exists within a gendered world where men call most of the shots. Yet the feminist critique of fashion has rested on problematic assumptions about "natural" appearance, which is contrasted with fashionable artifice. The distinction between the "natural" and the "artificial" cannot be maintained, since all clothes (and other aspects of appearance, such as hairstyles) are culturally constructed. Blue jeans are not any more "natural" than high heels. Moreover, it could be argued that there is no "real self" underneath the artifice of culture because human identity itself is culturally constructed. In an influential theoretical essay on fashion, Kaja Silverman writes:

> The male subject, like the female subject, has no visual status apart from dress and/ or adornment. . . . Clothing and other kinds of ornamentation make the human body culturally visible . . . clothing draws the body so that it can be culturally seen, and articulates it as a meaningful form. . . .
>
> Even if my sympathies were not fully on the side of extravagant sartorial display, I would feel impelled to stress as strongly as possible that clothing is a necessary condition of subjectivity—that in articulating the body, it simultaneously articulates the psyche.[40]

The scholarly discourse on fashion has, in fact, increasingly suggested that adornment is intrinsically human, frequently pleasurable, and potentially subversive. The issue of "lesbian chic," for example, has pitted the orthodox feminist belief that fashion sexually objectifies women and contributes to their subordination against the modernist idea that dress provides an opportunity to "play" with gender roles and conventions.

Pornography also has been reassessed by some feminists, who observe that the alliance between antiporn feminists and the fundamentalist right is based on the fantasy that there exists (or should exist) only one kind of "natural" sexuality. Anticensorship feminists have spoken out against this "policing of desire," which would forcibly suppress all "deviant" or "politically incorrect" sexuality. Irving Klaw's notorious bondage pornography of the 1950s, for example, was directed toward a male audience and exploited many of the fetishistic icons that have been recently incorporated into fashion. Yet fashion photographs in the *Advocate* (shot

by a woman for other women-identified women) include many of the same garments and sex toys that Klaw used. Naomi Wolf, author of *The Beauty Trap*, has admitted that a "butch" lesbian in leather regalia does not seem "passive or victimized."[41] Yet Wolf remains more or less hostile to the fashion industry, as such. I would argue that her implicit distinction between "good" street fashion and "bad" commercial fashion is as invalid as the distinction between "good" erotica and "bad" pornography.

Many people believe that pornography causes perversion and sexual violence. But this is like saying that country-and-western music *causes* adultery and alchoholism.[42] According to sex researcher John Money, paraphilias like fetishism are disorders not only of sex, but of love. Paraphiles have what Money calls a "vandalized love map." Although some were the victims of child abuse, many others were victimized by well-meaning parents whose militantly *antisexual* attitudes "warped" their sexual psychology: "with monotonous regularity, paraphiles have a religious history of relentlessly orthodox upbringings." To salvage any sexual arousal, they must enforce a radical split between lust and love. By lusting after a shoe, for example, the fetishist "saves" the "pure" love object from defilement. Ironically, notes Money, the current war on pornography will probably lead to an even more "sex-negative climate," which will produce more hypophiliac (frigid) females and paraphiliac males. To prevent paraphila, Money argues, society must ensure "healthy love-map development in childhood."[43]

Anorexia, bulimia, and obesity are also serious problems in contemporary America, but they are not *caused* by fashion. Although the neo-hippy fashions of the early 1990s briefly spawned the so-called waif look among high-fashion models, the dominant trend for the past twenty years has emphasized a mesomorphic body type for both men and women. Hence the phrase "hard bodies." It is simplistic to characterize contemporary fashion as a "backlash" against independent women.

Freud once suggested that "half of humanity must be classed among the clothes fetishists. All women, that is, are clothes fetishists." He announced triumphantly, "Only now we understand why even the most intelligent women behave defenselessly against the demands of fashion." But this is naive. Until the eighteenth century, men wore clothing that was at least as modish and sexually provocative as women's clothing; and even today, men's clothing follows fashion, albeit more slowly and discreetly than is the case with women's dress. If male fetishists repress the desire to look, worshipping instead the clothes that prevent them from seeing, women, Freud argued, repress the passive desire to be looked at: "For [women],

clothes take the place of parts of the body, and to wear the same clothes [i.e., the latest fashions] means only to be able to show what others can show."[44]

But this hypothesis is not supported by the evidence. Fashion has never been simply about body parts, but about identity. (As our sense of ourselves changes, so also do our clothes.) We have seen how fetishism involves a symbolic system, and one, moreover, that changes only very slowly. But in the world of fashion, cultural signs have no fixed meaning; they change continually. Indeed, one could say that fashion is "the celebration of a perverse, fetishized passion for the abstract code."[45] Perhaps, in that restricted sense, many women might be clothing fetishists.

It is also possible that women's "excessive" concern with beauty and fashion could be "partly theorized in terms of the investment in the fantasy of a common skin: the archaic sensory interface between infant and mother." Although this fantasy (emerging in infancy through contact with the skin of the mother) would be common to both males and females, it would necessarily find different symbolic expressions: "For the man, the fascination with female dress is always tinged with envy," whereas the woman (being the same sex as the m/other) can "act out the fantasy of the primordially glorious skin."[46]

Raising Fetishism to New Heights of Fashion

In the recent collection *Leatherfolk*, Scott Tucker writes: "Words like leatherfolk, fetishists, and sadomasochists don't fully describe the full spectrum of persons and eroticism I have in mind, but they serve approximately." He goes on to note with pleasure the way radical sex groups were "raising fetishism to new heights of fashion."[47]

Pride in fetish fashion is obviously predicated on an acceptance of one's personal involvement with fetishistic and sadomasochistic sexuality. This position, in turn, reflects the cultural importance of gay liberation, which, along with the women's movement, is one of the most culturally significant phenomena of the twentieth century. Over the past decade, other sexual minorities (especially sadomasochists and transvestites, but also fetishists and even pedophiles) began to organize their own attempts to legitimate their sexual practices, based on the prototype of the gay liberation movement.

In works such as Marjorie Garber's *Vested Interests*, transvestism is interpreted as a force that disrupts or subverts conventional ideas about sex and gender. But

Annie Woodhouse's *Fantastic Women* questions just how transgressive cross-dressing really is, since it traffics so heavily in stereotypes. "Transvestites see gender as something which is rigidly demarcated," Woodhouse writes. "Through cross-dressing the transvestite creates a synthetic woman," his "feminine self," which "responds to the wishes and desires of his masculine self." The liberal belief that transvestism "might chip away at patriarchal institutions and behavior" is "unrealistic."[48]

The popular discourse on fashion, however, suggests that any style that helps one escape from "the prison of gender" is implicitly "liberating."[49] Although cross-dressing has "always been a part of the fetish scene" (embracing a wide range of sissy maids, drag queens, and men trying to "pass" as women), the rise of "Fetish Drag" is a new phenomenon. "Fetish drag does not require the look to be 'complete,'" notes Tony Mitchell. Instead, it mixes "male" elements like a black leather jacket and boots with "female" elements like stockings and corsets. "And there is also the ambiguity of SM orientation which the style allows."[50]

The politicization of sexuality has led to disagreements between sex radicals and feminists. As Ken Plummer points out,

> the main debate is currently set up between the politics of desire (the sexual libera-
> tionists) and the politics of sexism (the gender liberationists). Both attack the tradi-
> tional views of sexuality. . . . But the former seek a proliferation of new forms of
> sexualities, while the latter seek a reduction of gender inequalities. . . . Both these
> positions claim to be "progressive." . . . But they are diametrically opposed—since
> the former seeks to liberate a male model of desire while the latter sees this as the
> very source of oppression . . . perversions become a battle-ground for redefinition:
> as positive sexuality or oppressive to women.[51]

There are also disagreements within the camp of the sex radicals. Some approve of the convergence of fashion and fetishism, while others have criticized what they regard as the "co-opting" of fetish themes by fashion designers. You will recall, for example, how the leather designer Randall complained that Versace had "wrecked" the look.

Yet it is a false binary to suggest that fetish costumes are ipso facto rebellious, "authentic," and good, while fashions derived from fetish costumes are conform-ist, consumerist, and bad. The relationship between fashion and fetishism is not so simple. Fetishism can be obsessive and repetitive, while fashion can offer the possibilities of choice and change. In an essay in *Skin Two*, designer Krystina Kitsis suggests that

the "real" fetishist is interested in . . . TRANSFORMATION: flesh becomes cool fluid black rubber—simulated skin. . . . The fashionable are seduced by the external gloss of fetishism which is assimilated into the personal wardrobe of the wearer. The fashionable are distinguished by the inscription of glamour and style which converts the stereotype of fetishism into personal identity.

For fetishists it is the STEREOTYPE itself which is the object of fascination.[52]

As Kitsis says, "The fashionable are now dedicated to the notion of difference and choice. . . . Fetishism has both opened up this realm of choice and is also benefitting [from it]."

The assimilation of fetishistic motifs into fashion obviously entails the commercialization of fetishism, but does it also imply the domestication (or de-radicalization) of fetishism? Jean-Paul Gaultier has been quite candid about his lifelong interest in fetishistic clothing. From the age of sixteen, he was constantly sketching feet that curved so dramatically that they looked "almost broken."[53] But he insists, "When I do things it's not just my fantasy, it's done to reflect what I think people want." Almost every style that he has created for women, he also did for men, on the theory that clothes expressed the fact that "there is a lot of sex in our lives," and if women can be seductive, so can men.[54]

Fetishists are also inspired by popular culture phenomena that draw on fetish sources, making for a circular pattern of influence. The editors of the European sex magazine *O: Fashion, Fetish, Fantasies* enthusiastically described Catwoman's costume in the film *Batman Returns*, drawing connections with contemporary fashion: "High Heels. Rubber Catsuit. Breast Harness. Face Mask . . . [Catwoman's] shiny black outfit . . . makes fetish fashion internationally known. Thus speeding up its triumphal march and gaining general approval."[55] General approval may not be immediately forthcoming, but fetish clubs witnessed a flurry of Catwoman costumes inspired by the film. Yet fascinating as fetish *costumes* are, in and of themselves, I would argue that it is even more interesting to explore why fetishism has recently had such an influence on *fashion* and popular culture in general. It is time to look closely again at fetish fashions to identify the sources of their charisma.

The color symbolism associated with fetish fashion is particularly significant. Black is overwhelmingly the most popular color, rivaled only by red. Black is a uniquely powerful color—abstract, pure, and mysterious. In African symbolism, black is associated with night and nothingness. According to anthropologists, black and red are rare in being natural symbols: Night, after all, is black, and

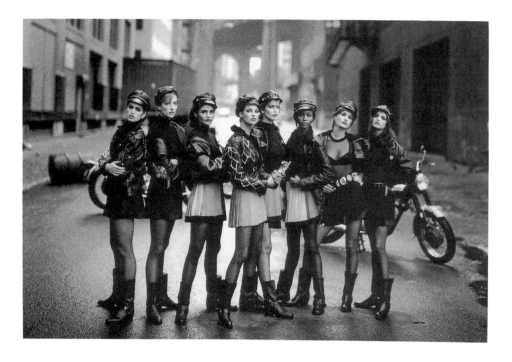

Biker chic, as modeled in Vogue, *September 1991.* (Copyright © Peter Lindbergh)

blood is red. By contrast, the symbolism associated with other colors tends to be primarily conventional: There is nothing in nature that makes green the color of jealousy or white the color of virginity.[56]

Yet black also has a cultural history that influences our responses to it. Since the Middle Ages, black has been associated with evil:

> Black robes befit our age. Once they were white;
> Next many-hued; now dark as Afric's Moor,
> Night-black, infernal, traitorous, obscure,
> Horrid with ignorance and sick with fright.
> For very shame we shun all colors bright,
> . . . our souls sunk in the night.

The concept of infernal, satanic black would prove perversely erotic. Yet black carried other, antisexual meanings, connected with the ascetic garb of the Catholic clergy and the sober conformity of the Puritans.

Black became the color of mourning, associated with widows as well as nuns. Some people, therefore, found it depressing when black began to dominate the clothing of the capitalist bourgeoisie. "This black clothing that the men of our time wear is a terrible symbol . . . of mourning," wrote the nineteenth-century Romantic poet Alfred de Musset. But a far greater poet, Charles Baudelaire, author of *The Flowers of Evil*, found the black clothing of modern life not only serious and severe, "a uniform livery of affliction," but also perversely beautiful.

"Scheherazade is easy, a little black dress is difficult," argued Coco Chanel, the first true female dandy. And although the little black dress soon became a bourgeois fashion cliché, it coexisted with the image of the rebel's black leather jacket and the bohemian black of leotards, turtleneck sweaters, and dark glasses. Black was cool, dangerous, and sexy. In the racially charged atmosphere of American society, Norman Mailer even claimed that he wanted to be black. The 1960s saw the rise of Black Power, pushing white boy wannabees aside. Then in the 1970s, both gays and punks revived the mystique of black leather, associated with SM and Hells Angels. But it was in the 1980s that black had the greatest impact on avant-garde fashion. All-black clothing was introduced by Japanese designers like Rei Kawakubo, becoming the dominant antifashion for artists and intellectuals. Although many fashion journalists found the new Japanese styles sad and funereal, Suzy Menkes recognized that there might be something "feminist" about "clothing that owes nothing to outworn concepts of femininity." Kawakubo's models looked like "a race of warrior women" in their sombre black dresses.

By the 1990s, black had become the quintessential color in modern fashion. I think that black has come to dominate contemporary fashion for some of the same reasons that it dominates fetish fashion: Black is associated with night, death, danger, nothingness, evil, perversion, rebellion, and sin. This is not a matter of racism. The magazine *Black Leather . . . In Color* was started by African-American leather enthusiasts.

For symbolic and visual power, black is rivaled only by red, the color of blood, fire, wine, and rubies. Indeed, Kawakubo once cryptically remarked that "red is black." Red is associated with the Scarlet Woman and the flames of hell. In "Panty Raid," the victim is forced to wear an imported French gown: "The color was Vampire Red!" Tightly belted, its buckle bore "a huge replica of Satan." Red is the color of passion, anger, danger, and revolution. But black is also the color of revolution. The black flag of anarchy, like the black of fascism, evokes the image of total destruction. The devil is the prince of darkness, the dandy is the black prince of elegance.

The growing popularity of fetish fashions within the wider culture is directly related to the charisma of deviance. Evil, rebellion, danger, and pleasure exert a powerful emotional appeal. In his disturbing and original book *Seductions of Crime*, the sociologist Jack Katz argues that "all the provocatively sensual evils of 'the night' " are powerfully charismatic. Sneaky thrills are exciting. Looking tough, evil, alien, and "bad" has a broad appeal, especially to young people. As a result, images of deviance, "whorish styles . . . torn shirts and motorcycles," permeate popular culture because advertisers recognize that an "association with deviance" helps sell products.[57] If the fashion industry has increasingly drawn on fetishist themes, this is one important reason why.

"I do not see perversions only as disorders of a sexual nature affecting a relatively small number of people," writes the French psychoanalyst Janine Chasseguet-Smirgel, "though their role and importance in the socio-cultural field can never be over-estimated. I see perversions more broadly, as a dimension of the human psyche in general, a temptation in the mind common to us all."[58] Approaching the subject from a very different perspective, literary theorist Kaja Silverman agrees that "perversion poses [a challenge] to the symbolic order" because it is not only a matter of sexuality, but also a turning away "from hierarchy and genital sexuality" and even "from the paternal signifier, the ultimate 'truth' or 'right.' " Perversion is, therefore, "a radical challenge to sexual difference."[59]

The "second-skin" materials of which fetish fashion is made are also significant. The human skin is one of the most important erogenous zones; it may also be conceptualized as a protective envelope, marking the body boundaries: "Reliable data exist indicating that stimulation of the skin can be reinforcing of the body boundaries."[60] If fetishists like shiny, tight garments that tie or lace closed, this may indicate a heightened concern about body penetrability. Certainly, fetish materials dramatize the exterior (boundary) aspects of the body. Fetish fashion draws attention to the sexual aspects of the body, while simultaneously restricting access to it.

The hardening and moistening of sexual arousal seem to be implied by shiny rubberized surfaces. Whether or not the person fashionably dressed in latex is actually anxious about sexuality or bodily integrity (and in an age of AIDS, who is not anxious about body invaders?), the very *look* of hard, wet impenetrability implicitly signifies safe sex. Latex bodysuits and thigh-high boots have become "the fashion insignia of cybersex," says Mike Saenz, the designer of a computer-generated comic book character, Donna Matrix. Saenz ascribes the "groundswell

of interest in fetishized fashions" to the way they "function as a kind of pseudo-armor and, in this age of AIDS, represent an attempt to romanticize and eroticize the use of latex barriers."[61]

An erotic fashion is not simply one that exposes the body or exaggerates the secondary sexual characteristics. To be interpreted as erotic, a fashion must be associated in some way with the sexual marketplace—the arena in which sexual encounters take place. Fashion trendsetters, I suspect, are drawn to the *theatricality* of fetishistic eroticism, the implication that merely by wearing a particular style one becomes the kind of person to whom sexual adventures happen. We may be justified in describing the ubiquity of fetish-inspired fashion in terms of "parasexuality" or the "eroticism of demeanour."[62] Fetish fashion seems to talk about sexuality in ways that pose important and potentially subversive questions.

But why should fetishists be privileged as especially sexual people? Freud's idea that perversion is the opposite of neurosis now seems mistaken; it might be more useful to characterize the perversions as "erotic neuroses." Although fetishists repress some of their fears and conflicts, they clearly eroticize others. But the appeal of fetishism, and of "perverse" sexuality in general, rests on more than a "mistake."

Long pathologized and demonized, the "pervert" came in time to be regarded as a "victim of circumstances" and then as someone in rebellion against the social order. From being "culturally marginal," the "deviant" has been repositioned as an exemplar of "radical, transgressive sexuality." Today the status of the "sexual outlaw" is widely admired. Among intellectuals, this paradigmn shift reflects in part the influence of Michel Foucault, but within the wider society it is a direct result of the recent "explosion of unorthodox sexualities."[63]

We may be fascinated with fetishism, though, for reasons that have little to do with the actuality of sexual "perversion" (which most people know little about, anyway). Some psychiatrists have expressed dismay about the popularity of fetishistic fashions. They may be overreacting. Most people who wear black leather and fetish gear are not "into" SM or fetishism. As one sadomasochist complained,

> There's a club in Chicago . . . I've seen women there—generally young, in their early 20s—who will wear a chain or a very hot, kinky outfit. I'll [ask], "Is this an expression of one of your fantasies or desires?" And they'll say, "What?" I'll say, "What you're wearing is a personification of something that's special to a lot of people, and I was wondering if you are interested in that?" And [they'll say], "What?" All they're doing is making fashion statements.[64]

Why is "sexual chic" so popular now? In her analysis of "perversion as fashion," the poet Diane Ackerman presents two of the most commonly accepted reasons. First, because of "our meandering return to Victorian morals": "When societies try to stifle sexuality, they often produce a yen for acting out." Second, because of AIDS: "In these plague years, when we cannot be promiscuous without worry, voyeurism has hit an all-time high." There is also a third explanation, popular with conservatives, which argues that perversion flourishes because society has become increasingly sexually permissive. Indeed, Ackerman admits, à la Allan Bloom, that popular culture is saturated with sexual imagery: "Rock stars perform fellatio on the microphone."[65] I do not think that these explanations suffice. Our society is both sexually repressed *and* hedonistic. People are still having sex, not just dressing up. I think the answer is more . . . perverse.

Whatever is forbidden is eroticized. Back in the 1960s, the philosopher Herbert Marcuse suggested that "the perversions seem to give a *promesse de bonheur*

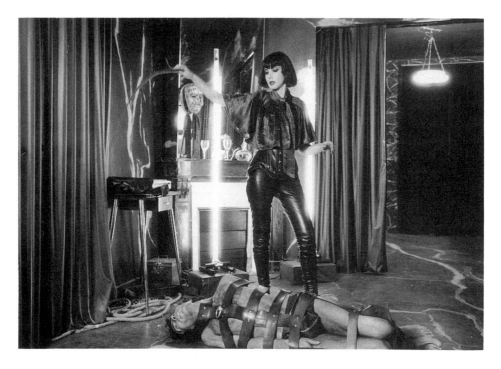

Bulle Ogier plays a dominatrix in Barbet Schroeder's film Maîtresse. *Costumes by Karl Lagerfeld.* (Films du Losange)

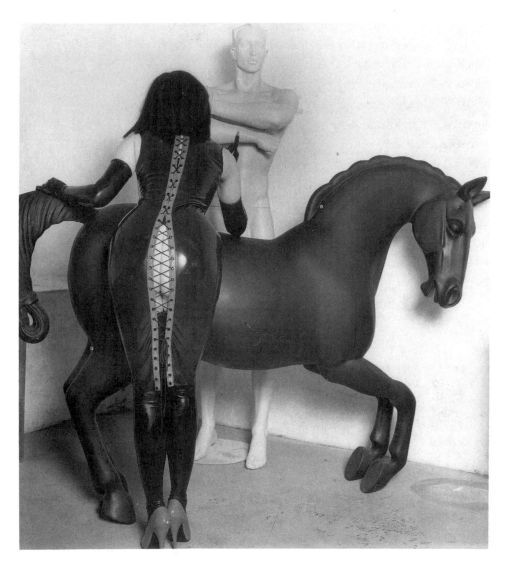

Fetish dress, London. (Copyright © Grace Lau)

greater than that of normal sexuality" because they express "rebellion against the subjugation of sexuality under the order of procreation and against the institutions which guarantee this order." And Freud himself observed that "it is as if they exerted a seductive influence; as if at bottom a secret envy of those who enjoy them had to be strangled."[66] It is not only that the perversions stand for pleasure, as opposed to procreation, but that they are also an implicit cri-

196

tique of the sexuality of the parents: "a temptation in the mind common to us all."[67]

We may protest that "the pervert is always someone else!" but our fantasies betray our hypocrisy. "What is a 'normal' erotic fantasy?" Fantasy, or imagination, is inevitably about the forbidden and the impossible.[68] The late Fred Davis wrote eloquently about how cultural ambivalence profoundly affects fashion, which ambiguously expresses a tension between oppositions, such as "youth versus age, masculinity versus femininity . . . and conformity versus rebellion."[69] Perhaps we are now seeing played out in fashion our ambivalence about what seems to be a disappearing boundary between the "normal" and the "perverse."

Notes

Introduction

1. Cynthia Rose, "Skin Deep," *Guardian Weekend*, March 5, 1994, p. 29.

2. Ibid.

3. Jean Baudrillard, *For a Critique of the Political Economy of the Sign* (St. Louis: Telos Press, 1981), p. 91.

4. Reverend P. Baudin, *Fetichism and Fetich Worshippers* (New York: Benziger Brothers, 1885), pp. 5, 109.

5. Karl Marx, *Capital: A Critique of Political Economy*, trans. Samuel Moore and Edward Aveling, ed. Friedrich Engels (New York: Modern Library, 1906), p. 85.

6. Linda Williams, *Hard Core: Power, Pleasure, and the "Frenzy of the Visible"* (Berkeley: University of California Press, 1989), p. 6.

7. Anne McClintock, quoted in *Feminists for Free Expression Newsletter* 2 (1994): 2.

8. See Emily Apter and William Pietz, eds., *Fetishism as Cultural Discourse* (Ithaca, N.Y.: Cornell University Press, 1993), cover.

9. Andrea Raab, "Fetishes," *Self*, April 1992, p. 94.

10. Susan Crain Bakos, "Sexual Obsessions," *Ladies' Home Journal*, April 1993, p. 113.

11. Louis Nizer, *My Life in Court* (Garden City, N.Y.: Doubleday, 1961), pp. 199–200, 203–204.

12. Karen Freifeld, "What a Heel! Sole Suspect Nabbed in Marla Shoe Thefts," *New York Newsday*, July 17, 1992, p. 3.

13. David Kocieniewski, "That's Shoe Biz. Sole Searching," *New York Newsday*, July 27, 1993, p. 5.

14. Edward Klein, "Trump Family Values," *Vanity Fair*, March 1994, p. 158.

15. "Jury Convicts Publicist of Footwear Theft," *New York Times*, February 17, 1994, p. B2.

16. "Diary of a High Heel Model," *High Heels*, January 1962, p. 17.

Chapter 1

1. Richard von Krafft-Ebing, *Psychopathia Sexualis with Especial Reference to the Antipathic Sexual Instinct: A Medico-Forensic Study*, trans. F. J. Rebman (1886; New York: Physicians and Surgeons Book Company, 1906, 1934), p. 218. This edition uses the obsolete spelling *fetichism*, which I have altered to *fetishism*.

2. Emile Laurent, *Les Perversions sexuelles: Fétichistes et érotomanes* (Paris: Vigot, 1905), quoted in Yves Edel, preface to Gaëtan Gatian de Clérambault, *Passion érotique des étoffes chez la femme* (1908; Paris: Empêcheurs de Penser en Rond, 1991), p. 11.

3. Alfred Binet, "Le Fétichisme dans l'amour: Etude de psychologie morbide," *Revue philosophique* 24 (1887), quoted in Edel, preface to Clérambault, *Passion érotique*, p. 11.

4. Krafft-Ebing, *Psychopathia Sexualism*, p. 224.

5. Georges Canguilhem, *The Normal and the Pathological* (New York: Zone Books, 1991), p. 37.

6. Paul H. Gebhardt, "Fetishism and Sadomasochism," as described by Lorraine Gamman and Merja Makinen, *Female Fetishism: A New Look* (London: Lawrence & Wishart, 1994), p. 38.

7. Robert Stoller, *Observing the Erotic Imagination* (New Haven, Conn.: Yale University Press, 1985), p. 35.

8. Chris Gosselin and Glenn Wilson, *Sexual Variations: Fetishism, Sadomasochism, and Transvestism* (London: Faber and Faber, 1980), p. 43.

9. Attorney General of the United States, *Final Report of the Attorney General's Commission on Pornography* (Nashville: Rutledge Hill Press, 1986), pp. 343–344.

10. Mark Elliott Dietz and Barbara Evans, "Pornographic Imagery and Prevalence of Paraphilia," *American Journal of Psychiatry* 139 (1982): 1495. Dietz and Evans find that less than 2 percent of the pornography they surveyed dealt with leather garments, rubber garments, and exaggerated shoes and boots. Other sources indicate somewhat higher figures of between 3 and 5 percent.

11. Attorney General, *Final Report of the Attorney General's Commission on Pornography*, p. 427. Titles of magazines, books, and films are listed on pp. 387–424.

12. Stoller, *Observing the Erotic Imagination*, pp. 11–12.

13. Robert Stoller, *Presentations of Gender* (New Haven, Conn.: Yale University Press, 1985), p. 135.

14. Louise Kaplan, "Women Masquerading as Women," in *Perversions and Near Perversions in Clinical Practice: New Psycholanalytic Perspectives*, ed. Gerald I. Fogel and Wayne A. Myers (New Haven, Conn.: Yale University Press, 1991), p. 129.

15. Ibid., p. 130.

16. Sigmund Freud, "Fetishism," in *The Standard Edition of the Complete Psychological Works* (London: Hogarth Press and The Institute for Psychoanalysis, 1953–1975), vol. 21, p. 129.

17. Ted Polhemus, *Body Styles* (Luton: Leonard Books, 1988), p. 100.

18. Louise Kaplan, *Female Perversions: The Temptations of Emma Bovary* (New York: Doubleday, 1991), p. 54.

19. Ibid., p. 154.

20. Freud, "Fetishism," p. 154.

21. Kaplan, *Female Perversions*, p. 54.

22. Ibid., pp. 21–22.

23. Quoted, pace Freud, in "Bits and Bobbitts," *Economist*, January 15–21, 1994, p. 28.

24. Eugénie Lemoine-Luccioni, *La Robe: Essai psychoanalytique sur le vêtement* (Paris: Éditions du Seuil, 1983), p. 34.

25. Robert Bak, "The Phallic Woman: The Ubiquitous Fantasy in Perversions," *Psychoanalytic Study of the Child* 23 (1968): 16.

26. Janine Chasseguet-Smirgel, *Creativity and Perversion* (New York: Norton, 1985), p. 80.

27. Ibid., pp. 85–86.

28. Assuming that castration anxiety is a factor in the genesis of fetishism, we still do not know why some males react to castration anxiety by becoming fetishists, and others do not. But *pre-Oedipal* causes for fetishism involving infantile anxiety about separation and even bodily integrity are implicated.

29. Phyllis Greenacre, "Certain Relationships Between Fetishism and Faulty Development of the Body Image," *Psychoanalytic Study of the Child* 8 (1953): 93, quoted in Ernest Becker, *The Denial of Death* (New York: Free Press, 1973), p. 228. See also Greenacre's "Perversions: General Considerations Regarding Their Genetic and Dynamic Background," *Psychoanalytic Study of the Child* 23 (1968): 47–62.

30. Stoller, *Presentations of Gender*, pp. 93–136.

31. Ibid., pp. 130–131.

32. Chasseguet-Smirgel, *Creativity and Perversion*, p. 81.

33. Ibid.

34. Ibid., p. 87.

35. Michel Foucault, *The History of Sexuality*, vol. 1, *An Introduction*, trans. Robert Hurley (New York: Random House, 1978), pp. 78, 111, 153–154.

36. Domna Stanton, "Introduction: The Subject of Sexuality," in *Discourses of Sexuality: From Aristotle to AIDS*, ed. Domna Stanton (Ann Arbor: University of Michigan Press, 1992), p. 40. See also Robert A. Padgug, "Sexual Matters: On Conceptualizing Sexuality in History," *Radical History Review* 20 (1979): 3–24.

37. Lynn Hunt, ed., *The Invention of Pornography: Obscenity and the Origins of Modernity, 1500–1800* (New York: Zone Books, 1993) pp. 10, 16.

38. Alex Comfort, "Deviation and Variation," in *Variant Sexuality: Research and Theory*, ed. Glenn Wilson (Baltimore: Johns Hopkins University Press, 1987), p. 2.

39. Gilbert Herdt and Robert J. Stoller, *Intimate Communications: Erotics and the Study of Culture* (New York: Columbia University Press, 1990), pp. 126–127.

40. Colin Wilson, *The Misfits: A Study of Sexual Outsiders* (New York: Carroll & Graf, 1988), pp. 8, 75.

41. Matt Ridley, *The Red Queen: Sex and the Evolution of Human Nature* (New York: Macmillan, 1993); David M. Buss, *The Evolution of Desire: Strategies of Human Mating* (New York: Basic Books, 1994).

42. Glenn Wilson, *The Great Sex Divide: A Study of Male–Female Differences* (London: Peter Owen, 1989), p. 86.

43. Ibid., pp. 8–11.

44. Ronald A. La Torre, "Devaluation of the Human Love Object: Heterosexual Rejection as a Possible Antecedent to Fetishism," *Journal of Abnormal Psychology* 89 (1980): 1295–1298.

45. Arthur Epstein, "The Relationship of Altered Brain States to Sexual Psychopathology," in *Contemporary Sexual Behavior: Critical Issues in the 1970s*, ed. Joseph Zubin and John Money (Baltimore: Johns Hopkins University Press, 1973), pp. 300–301. See also W. Mitchell, M. A. Falconer, and D. Hill, "Epilepsy with Fetishism Relieved by Temporal Lobectomy," *Lancet* 2 (1954): 626–630.

46. Epstein, "Relationship of Altered Brain States to Sexual Psychopathology," p. 302.

47. Robert Stoller, "Psychoanalysis and Physical Intervention in the Brain: The Mind–Body Problem Again," in *Contemporary Sexual Behavior*, ed. Zubin and Money, p. 341.

48. See Wilson, ed., *Variant Sexuality*.

49. Chris Gosselin, "Why Me?" (1984), in *Skin Two Retro 1* (London: Tim Woodward, 1991), p. 24.

50. Gosselin and Wilson, *Sexual Variations*, pp. 153–154.

51. American Psychiatric Association, *Diagnostic and Statistical Manual of Mental Disorders*, 4th ed. rev. (Washington, D.C.: American Psychiatric Association, 1994), p. 526 [hereafter cited as *DSM*].

52. Paul H. Gebhard, "Fetishism and Sadomasochism," in *Sex Research: Studies from The Kinsey Institute*, ed. Martin Weinberg (New York: Oxford University Press, 1976), p. 159.

53. A clinical study of fetish preferences of forty-eight fetishists who had been in psychiatric hospitals indicated that clothes were most popular (58%), followed by rubber (23%), parts of the body (15%), footwear (also 15%), leather (10%), soft materials like silk (6%), and clothes of soft material (8%). See A. J. Chalkley and E. E. Powell, "The Clinical Description of Forty-eight Cases of Sexual Fetishism," *British Journal of Psychiatry* 142 (1983): 292–295, quoted in William B. Arndt, *Gender Disorders and the Paraphilias* (Madison, Conn.: International Universities Press, 1991), p. 183.

54. David Kunzle, *Fashion and Fetishism* (Totowa, N.J.: Rowman and Littlefield, 1982), p. 14.

55. *DSM*-3 (1987), p. 283; *DSM*-4 (1994), p. 26.

56. Kunzle, *Fashion and Fetishism*, p. xx.

57. Joyce McDougall, *Plea for a Measure of Abnormality* (New York: Brunner/Mazel, 1992), p. 59.

58. Pat Califa, "Beyond Leather: Expanding the Realm of the Senses to Rubber," from "Dominas: Women with Attitude," *Skin Two*, no. 11 (n.d. [1993]): 28.

59. Ibid.

60. Freud, "Fetishism," p. 152.

61. According to Samuel S. Janus and Cynthia L. Janus, "Twenty-two percent of the men surveyed and 18% of the women were generally approving . . . of fetishes." That is, they thought that fetishes were either "very normal" (5%) or "all right." "Eleven percent of the men and 6% of the women reported having had experience with fetishes" (*The Janus Report on Sexual Behavior* [New York: Wiley, 1993], p. 122).

62. Comfort, "Deviation and Variation," p. 1.

63. Glenn Wilson, *The Secrets of Sexual Fantasy* (London: Dent, 1978), pp. 100–101.

64. Robert H. Morneau and Robert R. Rockwell, *Sex, Motivation, and the Criminal Offender* (Springfield, Ill.: Thomas, 1980), p. 317.

65. Arndt, *Gender Disorders and the Paraphilias*, pp. 201–202.

66. Glenn Wilson, Preface to *Variant Sexuality*, ed. Wilson.

67. Sigmund Freud, *Three Essays on the Theory of Sexuality*, in *Standard Edition*, vol. 7, p. 153.

68. Ibid., p. 147

69. Joyce McDougall, *Theatres of the Mind: Illusion and Truth on the Psychoanalytic Stage* (New York: Basic Books, 1985), p. 252.

70. Joyce McDougall, "Perversions and Deviations in the Psychoanalytic Attitude: Their Effects on Theory and Practice," in *Perversions and Near-Perversions in Clinical Practice*, ed. Vogel and Myers, pp. 178–179, 183–184, 188.

71. George Stade, "The Hard-Boiled Dick: Perverse Reflections in a Private Eye," in *Perversions and Near-Perversions in Clinical Practice*, ed. Vogel and Myers, pp. 232–233.

Chapter 2

1. Xavier Moreau, quoted in Georgina Howell, "Chain Reactions," *Vogue*, September 1992, p. 532.

2. Shari Benstock and Suzanne Ferris, eds., *On Fashion* (New Brunswick, N.J.: Rutgers University Press, 1994), p. 5.

3. David O. Friedrichs, "The Body Taboo," *Sexual Behavior* 2 (1972): 64.

4. *High Heels* 2 (1965): 27.

5. "Letters from Our Readers," *Bizarre Life* (n.d. [ca. 1966]), Vertical File, Kinsey Institute.

6. *Erolastica* 1 (1975): 6.

7. *Throttle: The Book for Leather Lovers* (n.p., n.d.), Human Sexuality Collection, Cornell University Library.

8. Krystina Kitsis, "Bound by Our Image," *O: Fashion, Fetish, Fantasies*, no. 23 (1994): 33.

9. Dick Hebdidge, *Subculture: The Meaning of Style* (1979; London: Routledge, 1993), pp. 107–108. [Emphasis added]

10. Caroline Evans and Minna Thornton, *Women and Fashion: A New Look* (London: Quartet Books, 1989), p. 21.

11. John Savage, *England's Dreaming* (New York: St. Martin's Press, 1992), pp. 64, 68.

12. Quoted in Evans and Thornton, *Women and Fashion*, p. 23.

13. Vivienne Westwood to author, September 19, 1994.

14. "Malcolm McClaren," *O: Fashion, Fetish, Fantasies*, no. 23 (1994): 36–38.

15. Michael Selzer, *Terrorist Chic: An Exploration of Violence in the Seventies* (New York: Hawthorn Books, 1979).

16. Edmund White, "Fantasia on the Seventies," in Edmund White, *The Burning Library*, ed. David Bergman (New York: Knopf, 1994), p. 39.

17. Barbara Rose, "The Beautiful and the Damned," *Vogue*, November 1978, p. 326.

18. Howell, "Chain Reactions," p. 532.

19. Valerie Steele, "Erotic Allure," in *The Idealizing Vision: The Art of Fashion Photography*, ed. Andrew Wilkes (New York: Aperture, 1991), pp. 81–97.

20. Roger Madison, "Dig Black Stockings and Boots?" *Sexology* 41 (1975): 25–26.

21. Hugh Jones, *The Sexual Fetish in Today's Society* (North Hollywood, Calif.: Brandon House, 1965), pp. 17–18.

22. John Gagnon, *Human Sexualities* (Glenview, Ill.: Scott, Foresman, 1977), pp. 332–333.

23. *Medical Aspects of Human Sexuality*, June 1974, pp. 201–202.

24. Albert Ellis, *Sex and the Liberated Man* (Secaucus, N.J.: Lyle Stewart, 1976), pp. 77–78, 143.

25. Ibid., p. 144.

26. Kathy Myers, "Fashion 'n' Passion: A Working Paper," in *Zoot Suits and Second-Hand Dresses: An Anthology of Fashion and Music*, ed. Angela McRobbie (Boston: Unwin Hyman, 1988), pp. 189–198.

27. Rosetta Brooks, "Fashion: Double Page Spread," *Camerawork*, January–February 1980, p. 2.

28. Colin McDowell, *Dressed to Kill: Sex, Power & Clothes* (London: Hutchinson, 1992), p. 168.

29. Quoted in ibid., p. 178.

30. Sarah Mower, "Fashion Intelligence: Of Human Bondage," [British] *Vogue*, February 1991, p. 15.

31. Tony Mitchell, "Scene & Heard: Cheek to Chic," *Skin Two*, no. 9 (1989): 18.

32. Quoted in Shane Watson, "The New Glamour," [British] *Elle*, August 1994, p. 94.

33. Naomi Schor, "Female Fetishism: The Case of George Sand," in *The Female Body in Western Culture: Contemporary Perspectives*, ed. Susan Rubin Suleiman (Cambridge, Mass.: Harvard University Press, 1986), p. 371.

34. But see Janine Chasseguet-Smirgel, "Freud and Female Sexuality: The Consideration of Some Blind Spots in the Exploration of the 'Dark Continent,' " in *Sexuality and Mind: The Role of the Father and the Mother in the Psyche* (New York: New York University Press, 1986), pp. 89–90.

35. Tina Papoulias, "Fetishism," in *The Sexual Imagination from Acker to Zola: A Feminist Companion*, ed. Harriet Gilbert (London: Cape, 1993), pp. 89–90.

36. Juliet Hopkins, "The Probable Role of Trauma in a Case of Foot and Shoe Fetishism: Aspects of Psychotherapy of a Six-year-old Girl," *International Review of Psychoanalysis* 11 (1984): 79–91, cited in Gregorio Kohon, "Fetishism Revisited," *International Journal of Psycho-Analysis* 68 (1987): 219.

37. Lorraine Gamman and Merja Makinen, *Female Fetishism: A New Look* (London: Lawrence & Wishart, 1994), pp. 96–102.

38. Robert Stoller, *Observing the Erotic Imagination* (New Haven, Conn.: Yale University Press, 1985), p. 137.

39. Ibid., p. 142.

40. Michael Mason, *The Making of Victorian Sexuality: Sexual Behavior and Its Understanding* (Oxford: Clarendon Press, 1994), pp. 43, 44.

41. Michel Foucault, *The History of Sexuality*, vol. 1, *An Introduction*, trans. Robert Hurley (New York: Random House, 1978), pp. 12–13.

42. Alain Corbin, *Women for Hire: Prostitution and Sexuality in France After 1850*, trans. Alan Sheridan (Cambridge, Mass.: Harvard University Press, 1990), pp. 125–126

43. Ibid., pp. 124–127.

44. Richard von Krafft-Ebing, *Psychopathia Sexualis with Especial Reference to the Antipathic Sexual Instinct: A Medico-Forensic Study*, trans. F. J. Rebman (1886; New York: Physicians and Surgeons Book Company, 1906, 1934), p. 249.

45. Corbin, *Women for Hire*, pp. 201, 212.

46. Ken Plummer, "Sexual Diversity: A Sociological Perspective," in *The Psychology of Sexual Diversity*, ed. Kevin Howells (Oxford: Blackwell, 1984), p. 227.

47. Havelock Ellis, *Studies in the Psychology of Sex* (New York: Random House, 1936), vol. 2, pp. 1, 3.

48. Quoted in "The Forbidden Books of Youth," *New York Times Book Review*, June 6, 1993, p. 28. In the 1950s, fetishist members of the Biz-zare Club also said that they enjoyed reading Krafft-Ebing's case histories.

49. Walter Benjamin, *Charles Baudelaire: A Lyric Poet in the Era of High Capitalism*, trans. Harry Zohn (London: New Left Books, 1973), p. 166.

50. As the German economist Werner Sombart wrote many years ago. See Valerie

Steele, *Fashion and Eroticism: Ideals of Feminine Beauty from the Victorian Era to the Jazz Age* (New York: Oxford University Press, 1985), p. 18.

51. Gamman and Makinen, *Female Fetishism*, pp. 28–37, 182–183.

52. Ibid., pp. 37, 205.

53. *London Life* [special correspondence supplement], July 29, 1933, p. 68.

54. Madame Kayne, *The Corset in the Eighteenth and Nineteenth Centuries* (Brighton: Greenfields, n.d. [ca. 1932]). The book contains advertisements in the back.

55. Cosmopolite, "The Fascination of the Fetish," *Photo Bits*, May 13, 1911, pp. 8–9.

56. Biz-zarre Club, n. p.

57. Ted Polhemus and Lynn Proctor, "Fetish Fashion," in *Fashion 1985*, ed. Emily White (New York: St. Martin's Press, 1984), pp. 115–126.

58. Ted Polhemus, *Street Style: From Sidewalk to Catwalk* (London: Thames and Hudson, 1994), pp. 103–105.

59. James Laver, *Modesty in Dress* (Boston: Houghton Mifflin, 1969), p. 119.

Chapter 3

1. Michel Foucault, *Discipline and Punish: The Birth of the Prison*, trans. Alan Sheridan (New York: Vintage Books, 1979), pp. 138, 25.

2. Valerie Steele, *Fashion and Eroticism: Ideals of Feminine Beauty from the Victorian Era to the Jazz Age* (New York: Oxford University Press, 1985), chap. 9.

3. "Surfacing," *New York Times*, August 21, 1994, p. 53.

4. "Waist Case," *Vogue*, September 1994, p. 244.

5. *London Life League Newsletter*, no. 3 (1984): 1.

6. Rigid corsets with whalebone stays first appeared in sixteenth-century Europe. The iron "corsets" of the same period were *not* the fashion, but were crude orthopedic instruments intended to correct spinal deformations. Erotic enthusiasm began to focus on the corset in the eighteenth century, and spread rapidly in the later nineteenth century—the same pattern we see with shoe fetishism.

7. Susan Faludi, *Backlash: The Undeclared War Against American Women* (New York: Crown, 1991), p. 189.

8. Ibid., p. 173.

9. Ibid., pp. 496, 499.

10. MORALIST, in *Englishwoman's Domestic Magazine*, February 1871, p. 127 [hereafter cited as *EDM*].

11. Fakir Musafar, quoted in *Modern Primitives*, ed. V. Vale and Andrea Juno (San Francisco: Re/Search 1989), pp. 29–30.

12. Hyygeia, "Does Tight-Lacing Really Exist?" *Family Doctor*, September 3, 1887, p. 7.

13. "Tight-Lacing," *Family Doctor*, March 3, 1888, p. 1.

14. Measurements of corsets in other museum collections indicate that the majority were 20 to 26 inches when laced completely closed—and many women left their corsets open in back two or three inches. For a further analysis of corset and dress measurements, see Steele, *Fashion and Eroticism*, chap. 9.

15. Mistress Angel Stern, "A 'Corset Moment' with Pearl," *Verbal Abuse*, no. 3 (1994): 7.

16. Musafar, quoted in *Modern Primitives*, ed. Vale and Juno, pp. 15, 8.

17. Fakir Musafar, quoted in Gloria Brame, William Brame, and Jon Jacobs, *Different Loving: An Exploration of the World of Sexual Dominance and Submission* (New York: Villard Books, 1994), p. 311.

18. Stephanie Jones, "Strictly Fashionable: A Straight-Laced Look at Corsetry," *Skin Two*, no. 9 (1989): 45–47.

19. Ibid.

20. Quoted in Brame et al., *Different Loving*, p. 319.

21. Fakir Musafar, "The Corset and Sadomasochism," *Sandmutopia Guardian: A Dungeon Journal*, no. 11 (n.d.): 14–16.

22. See, for example, LA GENIE, in *EDM*, September 1868, p. 166. There is further discussion of this issue in Steele, *Fashion and Eroticism*.

23. ALFRED, in *EDM*, January 1871, p. 62.

24. *Modern Society*, December 25, 1909, p. 22.

25. Richard von Krafft-Ebing, *Psychopathia Sexualis with Especial Reference to the Antipathic Sexual Instinct: A Medico-Forensic Study*, trans. F. J. Rebman (1886; New York: Physicians and Surgeons Book Company, 1906, 1934), p. 253.

26. William Stekel, *Sexual Aberrations: The Phenomenon of Fetishism in Relation to Sex* (New York: Liveright, 1930), vol. 1, pp. 222–224.

27. Ibid., pp. 218–220.

28. NORA, in *EDM*, May 1867, p. 279.

29. FANNY, in *Queen*, July 25, 1863, reprinted in W. B. L. [William Barry Lord], *The Corset and the Crinoline* (London: Ward, Lock and Tyler, n.d. [ca. 1868]), pp. 157–158.

30. A LADY FROM EDINBURGH, in *EDM*, March 1867, reprinted in W. B. L., *Corset and the Crinoline*, p. 172; STAYLACE, in *EDM*, June 1867, p. 224, reprinted in W. B. L., *Corset and the Crinoline*, pp. 173–174.

31. WASP WAIST, in *Society*, 23 September 1899, p. 1871.

32. AN ENGLISH SCHOOLGIRL, in *Family Doctor*, September 27, 1890, p. 73.

33. See, for example, SATIN SKIN, in *Society*, March 24, 1900, p. 183; and MARTYR, in *Society*, April 21, 1900, p. 263.

34. A TRAVELLER, in *Family Doctor*, December 10, 1887, p. 235.

35. L. Mears, "The Vogue of the Wasp-Waist," *London Life*, April 26, 1930, p. 29.

36. Brigitte Hamann, *The Reluctant Empress: A Biography of Empress Elizabeth of Austria* (New York: Knopf, 1986), p. 127.

37. F. B., in *Society*, April 21, 1900, p. 263.

38. *Society*, December 16, 1899, p. 2109.

39. *Photo Bits*, February 5, 1910, p. 2.

40. Private collection.

41. Rick Cohen, "Female Like Me," *New York Observer*, July 19–July 26, 1993, p. 13.

42. A WOMAN OF FIFTY, "The Cult of Beauty in a Girl's School Forty Years Ago," *Society*, October 7, 1899, p. 1911.

43. WALTER, in *EDM*, November 1867, p. 613.

44. Alison Carter, *Underwear: The Fashion History* (New York: Drama Books, 1992), p. 36.

45. WALTER, in *Modern Society*, December 4, 1909, p. 23.

46. LA GENIE, in *EDM*, September 1868, pp. 166–167.

47. A DUBLIN BOY, in *EDM*, July 1868, p. 33.

48. ANTI-CORPULENCE, in *EDM*, March 1870, p. 192.

49. A STAIDMAN, in *EDM*, January 1871, p. 63.

50. MARY BROWN, in *Family Doctor*, June 5, 1886, p. 211.

51. *Family Doctor*, October 20, 1888, p. 121.

52. BROUGHT UP AS A GIRL, in *Family Doctor*, June 23, 1888, p. 265; A WOULD BE LADY, in *Family Doctor*, December 8, 1888, p. 230. According to psychiatrist Robert Stoller, there *are* authenticated modern cases of transvestites who, as boys, were put into girls' clothes by female relatives who hated males. This is also, however, a popular fantasy among transvestites.

53. SATIN STAYS, in *Society*, August 18, 1894, pp. 663–664.

54. RETIRED COLONEL, in *Modern Society*, November 20, 1909, p. 11.

55. REFORMER, in *Family Doctor*, December 21, 1889, p. 267.

56. BROUGHT UP AS A GIRL, in *Family Doctor*, June 23, 1888, p. 265.

57. A KENSINGTON BELLE, in *Modern Society*, July 27, 1889, p. 920.

58. DORA WELBY, "Slaves of the Stay-Lace," *Modern Society*, November 20, 1909, p. 22.

59. SMALL WAIST, in *Modern Society*, December 4, 1909, p. 24.

60. "Recollections of a Corsetière," *London Life*, December 27, 1930, pt. 2, p. 24.

61. Olden Outlake, *The Gentle Art of Nerve Wrecking: Discipline in an Austrian Gymnasium of 1930, Autobiographically Assessed from an American Vantage Point* (New York: Olden Outlake, 1961), pp. 50–51.

62. London Life League, "Corsetry Education Notes," no. 4 (n.d.).

63. THE VANISHING WAIST? in *Photo Bits*, October 29, 1910.

64. *Photo Bits*, January 22, 1910; May 14, 1910.

65. "The Vogue of the Wasp-Waist," *London Life*, April 26, 1930, p. 29.

66. *Society*, May 26, 1900, p. 362.

67. A WORSHIPPER OF WASP-WAISTS, in *London Life*, February 25, 1933, p. 58.

68. "Polaire and Others," *London Life*, June 26, 1937, p. 67.

69. William A. Granger, *An Exclusive Production: A Guinness Record World Smallest Waist. The Biography of Mrs. Ethel Granger. By Her Husband* (n. p., n. d.).

70. Alex Comfort, "Deviation and Variation," in *Variant Sexuality: Research and Theory*, ed. Glenn Wilson (Baltimore: Johns Hopkins University Press, 1987), p. 4.

71. David Kunzle, *Fashion and Fetishism* (Totowa, N.J.: Rowman and Littlefield, 1982), p. 338.

72. Musafar, quoted in *Modern Primitives*, ed. Vale and Juno, pp. 30–31.

73. Ibid., pp. 30–32.

74. Pearl, interview with author, August 1993.

75. Cathie J., interviews with author, June and September 1994. Unless otherwise noted, all quotations from Cathie come from these interviews.

76. Brame et al., *Different Loving*, pp. 311, 319.

77. Lauren, interview with author, December 1994.

78. Marion Hume, "Portrait of a Former Punk," *Vogue*, September 1994, p. 190.

79. Vivienne Westwood to author, September 19, 1994.

80. Michelle Olley, "Jean-Paul Gaultier: Rascal of Radical Chic," in *The Best of Skin Two*, ed. Tim Woodward (London: Kasak Books, 1993), p. 70.

81. Quoted in "Waist Case," *Vogue*, September 1994, p. 244.

82. *New York Times*, August 28, 1994, p. 31.

Chapter 4

1. John K. Fairbank, *The Great Chinese Revolution, 1800–1985* (New York: Harper & Row, Perennial, 1987), pp. 68–73.

2. Quoted in Samuel S. Janus and Cynthia L. Janus, *The Janus Report on Sexual Behavior* (New York: Wiley, 1993), pp. 123–124.

3. Dorothy Ko, "Talking About Footbinding: Discourses of Manhood and Nationhood in Late Imperial China" (Paper delivered at panel "The Mindful-Body: Footbinding," at the Forty-sixth Annual Meeting of the Association for Asian Studies, March 26, 1994).

4. Feng Jicai, *The Three-Inch Golden Lotus: A Novel on Foot Binding*, trans. David Wakefield (Honolulu: University of Hawaii Press, 1994), p. 236.

5. William A. Rossi, *The Sex Life of the Foot and Shoe* (Ware: Wordsworth, 1977), p. 33.

6. Stephen Kern, *Anatomy and Destiny: A Cultural History of the Human Body* (Indianapolis: Bobbs-Merrill, 1975), p. 2.

7. Philippe Perrot, *Fashioning the Bourgeoisie: A History of Clothing in the Nineteenth Century*, trans. Richard Bienvenu (Princeton, N.J.: Princeton University Press, 1994), p. 11.

8. Robert Buchanan, *The Fleshly School of Poetry* (1872), quoted in Kern, *Anatomy and Destiny*, p. 82.

9. David Coward, "The Sublimations of a Fetishist: Restif de La Bretonne (1734–1806)," *Eighteenth-Century Life*, May 1985, p. 100.

10. Ann Magnuson, "Hell on Heels," *Allure*, September 1994, pp. 128, 131.

11. Rossi, *Sex Life of the Foot and Shoe*, p. 149.

12. Ann Hollander, quoted in William Grimes, "The Chanel Platform," *New York Times*, May 17, 1992, p. 8.

13. Ken Baynes and Kate Baynes, eds., *The Shoe Show: British Shoes Since 1790* (London: Crafts Council, 1979), p. 46.

14. HARMONIE, in *EDM*, June 1, 1869, p. 327.

15. ROBIN ADAIR, in *EDM*, September 1, 1870, p. 190.

16. HIGH HEELS and FRED, in *EDM*, September 1, 1869, p. 167.

17. ROBIN ADAIR, in *EDM*, December 1, 1870, p. 377.

18. WALTER, in *EDM*, January 1871, p. 62.

19. Mary Trasko, *Heavenly Soles: Extraordinary Twentieth-Century Shoes* (New York: Abbeville Press, 1989), p. 74.

20. *London Life*, June 10, 1933, p. 22.

21. HAPPY HEELS, in *London Life*, May 31, 1930.

22. Mr. X, "The Cult of the High Heel," *Photo Bits*, March 25, 1910.

23. SIX-INCH HEELS, in *London Life*, April 15, 1933, pp. 44–45.

24. *Photo Bits*, June 2, 1910.

25. "Peggy Paget's Patent Paralyzing Pedal Props," *Photo Bits*, May 14, 1910.

26. *High Heels*, January 1962, pp. 7–11.

27. Ibid.

28. *High Heels*, February 1962, p. 37.

29. HIGH-HEELED, in *London Life*, May 31, 1930.

30. *High Heels*, January 1962, pp. 9–10.

31. Ibid., pp. 8–9.

32. *Leg Show*, September 1994, pp. 16, 78–81.

33. Richard von Krafft-Ebing, *Psychopathia Sexualis with Especial Reference to the Antipathic Sexual Instinct: A Medico-Forensic Study*, trans. F. J. Rebman (1886; New York: Physicians and Surgeons Book Company, 1906, 1934), pp. 172–175.

34. Quoted in Havelock Ellis, *Studies in the Psychology of Sex* (New York: Random House, 1936), vol. 2, pt. 1, pp. 33–34.

35. Ibid., pp. 34–35.

36. Ibid., pp. 34–38.

37. Photocopy in Fetish File, Kinsey Institute.

38. *London Life*, May 13, 1933, p. 22.

39. *Helmut Newton*, intro. Karl Lagerfeld, with comments by Helmut Newton (New York: Pantheon Books, 1987), image 36.

40. "Panty Raid," in Carlson Wade, *Panty Raid and Other Stories of Transvestism and Female Impersonation* (New York: Selbee, 1963).

41. *Booted Master* (New York: Star, n.d. [ca. 1980]), pp. 8, 5.

42. Ibid., pp. 15–17, 19, 41.

43. Ibid., pp. 3, 42, 46, 75–77, 163.

44. George Wilson, *Boot-Licking Slave* (n.p., n.d.), p. 149.

45. Richard G. Parker, *Bodies, Pleasures and Passions: Sexual Culture in Contemporary Brazil* (Boston: Beacon Press, 1991), pp. 52–53.

46. A SUSCEPTIBLE BACHELOR, in *EDM*, October 1, 1870, p. 253.

47. NIMROD, in *EDM*, October 1, 1870, p. 254.

48. Robert Stoller, *Sex and Gender: On the Development of Masculinity and Femininity* (New York: Science House, 1968), p. 219.

49. Case history recorded by Mrs. H. Hug-Hellmuth, quoted in Wilhelm Stekel, *Sexual Aberrations: The Phenomenon of Fetishism in Relation to Sex*, trans. Samuel Parker (New York: Liveright, 1971), vol. 1, p. 295.

50. *Leg Show*, September 1994, p. 105.

51. Ernest Becker, *The Denial of Death* (New York: Free Press, 1973), p. 237.

52. Quoted in ibid., p. 236.

53. Ibid., pp. 235–236.

54. Stekel, *Sexual Aberrations*, vol. 1, p. 227.

55. Ibid., p. 31.

56. Internet, 1994.

57. Jeffrey Meyers, *Scott Fitzgerald* (New York: HarperCollins, 1994), pp. 12–14.

58. Becker, *Denial of Death*, p. 235.

59. Ibid., p. 236.

60. E. Glover, "Sublimation, Substitution and Social Anxiety" (1931), in *On the Early Development of Mind* (London: Imago, 1956), pp. 146–147.

61. E. Glover, "A Note on Idealization" (1938), in ibid., pp. 293–294.

62. Krafft-Ebing, *Psychopathia Sexualis*, pp. 261–262.

63. Ibid., pp. 262–264.

64. For example, that of Louis Nizer, *My Life in Court* (Garden City, N.Y.: Doubleday, 1961), pp. 199–204.

65. See, for example, Paul H. Gebhard, "Fetishism and Sadomasochism," in *Sex Research: Studies from The Kinsey Institute*, ed. Martin Weinberg (New York: Oxford University Press, 1976), p. 159.

66. Quoted in Rossi, *Sex Life of the Foot and Shoe*, p. 183.

67. Mark Elliott Dietz and Barbara Evans, "Pornographic Imagery and Prevalence of

Paraphilia," *American Journal of Psychiatry* 139 (1982), cited in William B. Arndt, *Gender Disorders and the Paraphilias* (Madison, Conn.: International Universities Press, 1991), p. 176.

68. Dian Hanson, "Just My Opinion: Perfect Strangers," *Leg Show*, September 1994, pp. 4–5.

69. Gebhard, "Fetishism and Sadomasochism," p. 160.

70. Magnuson, "Hell on Heels," pp. 128, 130, 131.

71. Faith Bearden, "Cruel Shoes," *Bizarre*, no. 4 (1994): 46–49.

72. "Boots Are Made for Walking," *Bizarre*, no. 4 (1994): 54.

73. Robert Stoller, *Pain and Passion: A Psychoanalyst Explores the World of S&M* (New York: Plenum, 1991), pp. 84–85.

74. "Vive la Difference," *Wall Street Journal*, October 15, 1984, p. 35.

75. Magnuson, "Hell on Heels," p. 130.

76. Salvatore Ferragamo, *Shoemaker of Dreams* (London: Harrap, 1957), pp. 208, 69.

77. A selection of catalogues from Frederick's of Hollywood and Victoria's Secret were examined, especially at the Kinsey Institute.

78. *High Heels*, February 1962, p. 2.

79. Magnuson, "Hell on Heels," pp. 130–131.

80. Holly Brubach, "Shoe Crazy," *Atlantic*, May 1986, p. 87.

81. Frances Rogers Little, "Sitting Pretty," *Allure*, June 1994, pp. 34, 149.

Chapter 5

1. Flyer distributed by the Lingerie Lounge, 216 West Fiftieth Street, New York, N.Y.

2. Alison Carter, *Underwear: The Fashion History* (New York: Drama Books, 1992), p. 15.

3. Anne Buck, "Foundations of the Active Woman," in *La Belle Epoch: Costume, 1890–1914*, ed. Ann Saunders (London: Costume Society, 1968), p. 43.

4. Emile Zola, *Au bonheur des dames* (1883; Paris: Livre de Poche, n.d.), p. 478.

5. Quoted in Gertrude Aretz, *The Elegant Woman from the Rococo Period to Modern Times*, trans. James Laver (London: Harrap, 1932), p. 273.

6. *Lady's Realm*, April 1903; Mrs. Eric Pritchard, *The Cult of Chiffon* (London: Grant Richards, 1902), quoted in Valerie Steele, *Fashion and Eroticism: Ideals of Feminine Beauty from the Victorian Era to the Jazz Age* (New York: Oxford University Press, 1985), p. 195.

7. Comtesse de Tramar, *Le Bréviare de la femme* (Paris: Havard, 1903), quoted in Steele, *Fashion and Eroticism*, p. 207.

8. Baroness d'Orchamps, *Tous les secrets de la femme* (Paris, 1907), pp. 78–79.

9. SATIN WAIST, in *Society*, September 23, 1899, p. 1871.

10. *Modern Society*, October 13, 1900, p. 1555.

11. *Modern Society*, October 31, 1903, p. 1648.

12. "The Strange History of a Lace Petticoat," *Modern Society*, April 23, 1892, p. 713.

13. Wilhelm Stekel, *Sexual Aberrations: The Phenomenon of Fetishism in Relation to Sex* (New York: Liveright, 1930), vol. 1, pp. 126–127.

14. Clipping in Vertical File, "Underwear," Kinsey Institute.

15. Magnus Hirshfeld, *Sexual Anomalies and Perversions: Physical and Psychological Development, Diagnosis and Treatment*, comp. and ed. Norman Haire (1938; London: Encyclopaedic Press, 1962), p. 578.

16. Robert Stoller, *Pain and Passion: A Psychoanalyst Explores the World of S&M* (New York: Plenum, 1991), pp. 83–84.

17. Vertical File, Kinsey Institute.

18. Magnus Hirshfeld, *Transvestites: The Erotic Drive to Cross Dress*, trans. Michael Lombardi-Nash (Buffalo: Prometheus Books, 1991), p. 63.

19. *Le Sport* (1873), quoted in Romi, *Histoire pittoresque du pantalon féminin* (Paris: Jacques Grancher, 1979), p. 68.

20. René Maizeroy, *L'Adorée* (1887), quoted in Romi, *Histoire pittoresque du pantalon féminin*, p. 74.

21. Dianne Kendall, "Pampered in Panties," *Repartee* 12 (1993): 43.

22. Dianne Kendall, private communication April 29, 1993.

23. Quoted in William B. Arndt, *Gender Disorders and the Paraphilias* (Madison, Conn.: International Universities Press, 1991), pp. 86–87.

24. LOVER OF LINGERIE, in *London Life*, March 6, 1933, p. 23.

25. "Undercover News," in Carlson Wade, *Panty Raid and Other Stories of Transvestism and Female Impersonation* (New York: Selbee, 1963).

26. *Erolastica* [catalogue], December 1974, p. 16; "Candy Pants," *Playgirl*, June 1976, p. 113.

27. William H. Masters, Virginia E. Johnson, and Robert C. Kolodny, *Heterosexuality* (New York: HarperCollins, 1994), pp. 216–217.

28. Richard von Krafft-Ebing, *Psychopathia Sexualis with Especial Reference to the Antipathic Sexual Instinct: A Medico-Forensic Study*, trans. F. J. Rebman (1886; New York: Physicians and Surgeons Book Company, 1906, 1934), p. 250–251.

29. Stekel, *Sexual Aberrations*, vol. 1, p. 100.

30. "Unacceptable Lace of Capitalism," *Economist*, October 9, 1993, p. 76.

31. Nicholas Bornoff, *Pink Samurai: Love, Marriage & Sex in Contemporary Japan* (New York: Pocket Books, 1991), pp. 295–296, 71.

32. Hirshfeld, *Sexual Anomalies and Perversions*, pp. 583–587.

33. Brenda Love, *Encyclopedia of Unusual Sex Practices* (Fort Lee, N.J.: Barricade Books, 1992), p. 111.

34. "Panty Raid," in Wade, *Panty Raid*.

35. Robert Stoller, *Perversion: The Erotic Form of Hatred* (New York: Pantheon Books, 1975), p. 81.

36. "Panty Raid," in Wade, *Panty Raid*.

37. Richard Martin, "Ideology and Identity: The Homoerotic and Homospectatorial Look in Menswear Imagery and George Platt Lynes' Photyograph of Carl Carlson" (Paper delivered at the annual meeting of The Costume Society of America, Montreal, May 1994).

38. Rodney Bennett-England, *Dress Optional: The Revolution in Menswear* (London: Peter Owen, 1967), p. 42.

39. Ibid., pp. 44–45.

40. Miscellaneous catalogues and advertisements, Kinsey Institute.

41. Valerie Steele, "Clothing and Sexuality," in *Men and Women: Dressing the Part*, ed. Claudia Kidwell and Valerie Steele (Washington, D.C.: Smithsonian Institution Press, 1989), pp. 56–57.

42. Valerie Steele, "Calvinism Unclothed," *Design Quarterly*, Fall 1992, p. 32.

43. Dan Shaw, "Unmentionables? No More," *New York Times*, August 14, 1994, pp. 49, 52.

44. Advertisement for *Spurt*, "the contact fanzine for underwear fetish fans," in *Gay Times*, January 1994, p. 35.

45. Paul Walters, "The Nyloned Mystique: The Garter Belt," *Nylon Jungle* 4 (1967): 25, 49.

46. "Her Lingerie Limbo," *Nylon Jungle* 4 (1967): 4, 18, 21.

47. Ira Levine, "Fashion & Fetish," *Details*, March 1994, p. 158.

48. Poster, Kinsey Institute.

49. Stekel, *Sexual Aberrations*, vol. 1, pp. 86–87.

50. *La Vie parisienne* (1888), quoted in David Kunzle, *Fashion and Fetishism* (Totowa, N.J.: Rowman and Littlefield, 1982), p. 60.

51. Quoted in Stephanie Jones, "Sheer Pleasure," in *Skin Two Retro 1* (London: Tim Woodward, 1991), p. 71.

52. Quoted in Ray Durgnat, "Rubber with Violence," *International Times*, November 14–27 [n.y.], p. 9, in Vertical File, "Inanimate Fetishism," Kinsey Institute.

53. Paul H. Gebhard, "Fetishism and Sadomasochism," in *Sex Research: Studies from The Kinsey Institute*, ed. Martin Weinberg (New York: Oxford University Press, 1976), p. 160.

54. *Modern Society*, December 18, 1909, p. 23.

55. *Society*, August 8, 1895, p. 642; June 30, 1900, p. 463.

56. Journal entry, April 12, 1890, in *Pages from The Goncourt Journal*, ed. and trans. Robert Baldick (Oxford: Oxford University Press, 1978), pp. 356–357.

57. Philippe Perot, *Fashioning the Bourgeoisie: A History of Clothing in the Nineteenth*

Century, trans. Richard Bienvenu (Princeton, N.J.: Princeton University Press, 1994), p. 106.

58. C. Cody Collins, *The Love of a Glove* (New York: Fairchild, 1947), pp. 3–15.

59. Gerard Lenine, *Sex on the Screen: Eroticism in Film*, trans. D. Jacobs (New York: St. Martin's Press, 1985), p. 72.

60. Edward Podolsky and Carlson Wade, *Erotic Symbolism: A Study of Fetishism in Relation to Sex* (New York: Epic, 1960), p. 117.

61. Quoted in Collins, *Love of a Glove*, pp. 67–68.

62. "Undercover News," in Wade, *Panty Raid*.

63. Frederick's of Hollywood catalogue, Kinsey Institute.

64. Gilbert Herdt and Robert Stoller, *Intimate Communications: Erotics and the Study of Culture* (New York: Columbia University Press, 1990), pp. 59–69.

65. John Godwin, "Nudity—The Year's Most Popular Fashion," *Penthouse Forum*, May 1974, pp. 22–27.

66. Eric John Dingwall, *The American Woman: An Historical Study* (New York: Rinehart, 1956), pp. 183–185; Prudence Glynn, *Skin to Skin: Eroticism in Dress* (New York: Oxford University Press, 1982), pp. 31–57.

67. Gebhard, "Fetishism and Sadomasochism," p. 160.

68. Clyde Farnsworth, "Shirts On, Shirts Off: Canadian Feminists Protest an Indecency Law," *New York Times*, September 6, 1992, p. 3.

69. Paul Veyne, ed., *A History of Private Life*, vol. 1, *From Pagan Rome to Byzantium* (Cambridge, Mass.: Harvard University Press, 1987), p. 203.

70. Jean-Paul Gaultier, interview with Richard Smith, *Gay Times*, January 1994, p. 58.

71. Ibid.

72. "Panty Raid," in Wade, *Panty Raid*.

73. Robert Stoller, *Sex and Gender: On the Development of Masculinity and Femininity* (New York: Science House, 1968), p. 220.

74. Quoted in Frank DeCaro, "Out from Under," *New York Newsday*, April 7, 1994, p. B43.

75. Charlotte DuCann, "Love and Death on the London Catwalk," *Guardian*, October 15, 1990, p. 36.

76. Nightgowns are also specifically designed to be worn in the sexual arena of the bedroom. Several studies of transvestites indicate that more than one-quarter wear a nightgown during sex. According to a 1972 survey, 504 transvestites reported that the garments they liked to wear during coitus were: nightgowns (27%), panties (20%), padded bra (18%), hose (17%), high heels (11%), and full costume (20%). See Chris Gosselin and Glen Wilson, "Fetishism, Sadomasochism, and Related Behaviours," in *The Psychology of Sexual Diversity*, ed. Kevin Howells (Oxford: Blackwell, 1984), p. 98.

77. Dr. Daumas, "Hygiène et médecine" (1861), quoted in Philippe Perrot, *Les Dessus*

et les dessous de la bourgeoisie: Une histoire du vêtement au XIX^e siècle (Paris: Fayard, 1981), p. 267.

78. Vertical File, "Cat Girl," Kinsey Institute.

79. Paul Cavaco and Josie Natori, quoted in DeCaro, "Out from Under."

80. Quoted in Robin Micheli, "Dreaming of a White Christmas," *Money*, December 1986, p. 117.

81. Woody Hochswender, "Pins & Needles," *Harper's Bazaar*, June 1994, p. 164.

82. Clavel Brand, *Fetish* (London: Luxor Press, 1970), p. 24.

83. Jennifer Jackson, "Summer in Brief," *Harper's Bazaar*, July 1994, p. 20.

Chapter 6

1. Candice Bushnell, "Rubber Wear," *Vogue*, September 1994, p. 254.

2. Tony Mitchell, "Scene & Heard: Cheek to Chick," *Skin Two*, no. 9 (1989): 18–21.

3. Quoted in Frances Rogers Little, "Sitting Pretty," *Allure*, June 1994, pp. 154, 149.

4. Gilles Deleuze, *Masochism: An Interpretation of Coldness and Cruelty* (New York: Braziller, 1971), appendix 2, p. 234.

5. Leopold von Sacher-Masoch, *Venus in Furs*, trans. Jean McNeil, quoted in ibid., p. 201.

6. Gaylyn Studlar, "Masochism, Masquerade, and the Erotic Metamorphoses of Marlene Dietrich," in *Fabrications: Costume and the Female Body*, ed. Jane Gaines and Charlotte Herzog (New York: Routledge, 1990), pp. 234–237.

7. Sacher-Masoch, *Venus in Furs*, quoted in Deleuze, *Masochism*, pp. 201–202.

8. Iwan Bloch, *The Sexual Life of Our Time*, trans. M. Eden Paul (1908; New York: Allied, 1928), p. 150.

9. Richard von Krafft-Ebing, *Psychopathia Sexualis with Especial Reference to the Antipathic Sexual Instinct: A Medico-Forensic Study*, trans. F. J. Rebman (1886; New York: Physicians and Surgeons Book Company, 1906, 1934), pp. 271–272.

10. Ibid., p. 272.

11. Ibid., pp. 270–271.

12. Magnus Hirshfeld, *Sexual Anomalies and Perversions: Physical and Psychological Development, Diagnosis and Treatment*, comp. and ed. Norman Haire (1938; London: Encyclopaedic Press, 1962), p. 575.

13. Robert Wood, "Fur Fetishism," *Sexology*, February 1956, pp. 427–431.

14. Krafft-Ebing, *Psychopathia Sexualis*, p. 274.

15. *London Life*, May 27, 1933, p. 43.

16. BLACK VELVET, in *London Life*, May 13, 1933, p. 22.

17. Cosmopolite, "The Fascination of the Fetish," *Photo Bits*, May 13, 1911, pp. 8–9.

18. Krafft-Ebing, *Psychopathia Sexualis*, pp. 276–277.

19. Ibid., pp. 274–275.

20. Gaëtan Gatian de Clérambault, *Passion érotique des étoffes chez la femme* (1908; Paris: Empêcheurs de Penser en Rond, 1991), p. 19.

21. Jann Matlock, "Masquerading Women, Pathologized Men: Cross-Dressing, Fetishism, and the Theory of Perversion, 1882–1935," in *Fetishism as Cultural Discourse*, ed. Emily Apter and William Pietz (Ithaca, N.Y.: Cornell University Press, 1993), pp. 31–61.

22. Biz-zarre Club mimeographed correspondence, collected in 1954, Kinsey Institute.

23. Both *Punished in Silk* (New York: Exotique, [early 1960s]) and *Mistress in Satin* (New York: Exotique, [early 1960s]) are photo-fiction paperbacks.

24. "Undercover News," in Carlson Wade, *Panty Raid and Other Stories of Transvestism and Female Impersonation* (New York: Selbee, 1963).

25. Natural Rubber Company, brochure (London, n. d.).

26. SILK MAC, in *London Life*, February 25, 1933, p. 44.

27. RUBBER LOVER, in *London Life*, May 13, 1933, p. 23.

28. CHROMIUM KID, in *London Life*, March 25, 1933, pp. 44–45.

29. MACAMOUR, in *London Life*, April 15, 1933, p. 55.

30. *London Life*, May 20, 1933, p. 20.

31. *London Life*, September 30, 1933, p. 31.

32. OILSILK, in *London Life*, May 25, 1940, p. 67.

33. Biz-zarre Club correspondence, 1954, Kinsey Institute.

34. William B. Arndt, *Gender Disorders and the Paraphilias* (Madison, Conn.: International Universities Press, 1991), p. 207.

35. Clavel Brand, *The Kinky Crowd*, vol. 1, *The Rubber Devotee and The Leather Lover* (London: Luxor Press, 1970), pp. 14–15.

36. Quoted in Gillian Freeman, *The Undergrowth of Literature* (London: Nelson, 1967), p. 157.

37. Ibid., pp. 146–148.

38. Natural Rubber Company, "Just to Show You What We Can Do" [pamphlet] (London, n.d. [ca. 1965]).

39. Robert Bledsoe, *Male Sexual Deviations and Bizarre Practices* (Los Angeles: Sherborne, 1964), pp. 135–138.

40. Marie Constance of Dressing for Pleasure, interview with author, Spring 1994.

41. Quoted in Robert Stoller, *Pain and Passion: A Psychoanalyst Explores the World of S&M* (New York: Plenum, 1991), pp. 278–279.

42. Ibid., pp. 279–282.

43. Wilhelm Stekel, *Sexual Aberrations: The Phenomenon of Fetishism in Relation to Sex*, trans. Samuel Parker (New York: Liveright, 1971), vol. 1, pp. 103–107.

44. Mick Farren, *The Black Leather Jacket* (New York: Abbeville Press, 1985), p. 22.

45. Larry Townsend, *The Leatherman's Handbook* (Beverly Hills, Calif.: Le Salon, 1970, 1974, 1977), p. 282.

46. Roger F. Mays, *Leather and Things* [catalogue] (1977), Cornell Human Sexuality Collection.

47. *Hard Leather* (New York: Star, 1980), pp. 22–28.

48. Townsend, *Leatherman's Handbook*, p. 221.

49. Michael Grumley and Ed Gallucci, *Hard Corps: Studies in Leather and Sadomasochism* (New York: Dutton, 1977), n.p.

50. Vito Russo, "Why Is Leather Like Ethel Merman?" *Village Voice*, April 15–21, 1981, p. 37.

51. John Preston, "What Happened?" in *Leatherfolk: Radical Sex, People, Politics, and Practice*, ed. Mark Thompson (Boston: Alyson, 1991), p. 212.

52. Grumley and Gallucci, *Hard Corps*.

53. Quoted in Gloria G. Brame, William D. Brame, and Jon Jacobs, *Different Loving: An Exploration of the World of Sexual Dominance and Submission* (New York: Villard Books, 1994), p. 396.

54. Quoted in Lynn Longway, "Going Hell-for-Leather," *Newsweek*, October 19, 1981, p. 90.

55. Colin McDowell, *Dressed to Kill: Sex, Power & Clothes* (London: Hutchinson, 1992), pp. 12, 31, 48.

56. Pat Califa, "Beyond Leather: Expanding the Realm of the Senses to Rubber," from "Dominas: Women with Attitude," *Skin Two*, no. 11 (n.d. [1993]): 29.

57. T. S., in *Family Doctor*, February 16, 1889, p. 393.

58. See, for example, "The Latest Fashionable Craze," *Society*, March 25, 1899, p. 1341.

59. AUNTIE'S IDOL, in *London Life*, September 30, 1933, p. 62.

60. *Piercing Fans International*, October 1, 1977, p. 4.

61. Charles Gatewood, interview in Carlo McCormick, "American Primitive," *Paper*, Summer 1993, p. 26.

62. Quoted in Guy Trebay, "Primitive Culture," *Village Voice*, November 12, 1991, p. 37.

63. Quoted in Suzy Menkes, "Fetish or Fashion?" *New York Times*, November 23, 1993, sec. 9, pp. 1, 9.

64. "Alien Beauty," *Paper*, November 1993, p. 39.

65. Eric Perret, "Urban Savages," *Esquire Gentleman*, Fall 1993, p. 103.

Chapter 7

1. Sigmund Freud, "Formulations on the Two Principles of Mental Functioning," in *The Standard Edition of the Complete Psychological Works* (London: Hogarth Press and The Institute for Psychoanalysis, 1953–1975), vol. 12, p. 222.

2. Sheila Anne Feeney, "Time to Dress for Sexcess," *Daily News* "New York Life," February 12, 1989, p. 3.

3. Quoted in James Servin, "Chic or Cruel?" *New York Times*, November 1, 1992, sec. 9, p. 10.

4. *Harper's Bazaar*, September 1992, p. 319.

5. Quoted in Servin, "Chic or Cruel?" p. 10.

6. Randall, interview with the author, June 1993.

7. Quoted in Servin, "Chic or Cruel?" p. 10.

8. Elizabeth Wilson, "Making an Appearance," in *Stolen Glances: Lesbians Take Photographs*, ed. Kate Boffin (New York: Harper & Row, 1991), p. 25.

9. Quoted in Servin, "Chic or Cruel?" p. 10.

10. Jean Laplanche and Jean-Bertrand Pontalis, "Fantasy and the Origins of Sexuality," in *Formations of Fantasy*, ed. Victor Burgin et al. (London: Methuen, 1986), pp. 18–20.

11. Elizabeth Cowie, "Pornography and Fantasy: Psychoanalytic Perspectives," in *Sex Exposed: Sexuality and the Pornography Debate*, ed. Lynn Segal and Mary McIntosh (New Brunswick, N.J.: Rutgers University Press, 1993), pp. 137–139.

12. Ibid., pp. 135–136.

13. Robert Stoller, *Observing the Erotic Imagination* (New Haven, Conn.: Yale University Press, 1985), p. 155.

14. Louise Kaplan, *Female Perversions: The Temptations of Emma Bovary* (New York: Doubleday, 1991), p. 54.

15. Robert C. Bak, "The Phallic Woman: The Ubiquitous Fantasy in Perversions," *Psychoanalytic Study of the Child* 23 (1968): 35.

16. Mistress Jacqueline, as told to Catherine Tavel and Robert H. Rimmer, *Whips and Kisses: Parting the Leather Curtain* (Buffalo: Prometheus Books, 1991), pp. 228–229.

17. Madame Sadi, quoted in *Skin Two*, no. 11 (n.d. [1993]): 24.

18. Joyce McDougall, *Theatres of the Mind: Illusion and Truth on the Psychoanalytic Stage* (New York: Basic Books, 1985), p. 45.

19. Pat Califa, quoted in Cowie, "Pornography and Fantasy" p. 150.

20. Private communication.

21. Lily West, "Letter from Japan," *Repartee*, no. 14 (n.d.): 48.

22. Advertisement for *Shemale*, in *Female Impersonator News*, no. 42, (n.d.): p. 4.

23. Larry Townsend, *The Leatherman's Handbook* (Beverly Hills, Calif.: Le Salon, 1970, 1974, 1977), p. 143.

24. File, "Fetish-Costume-Leather," Kinsey Institute.

25. Townsend, *Leatherman's Handbook*, pp. 302–303.

26. Ibid., pp. 282–286.

27. G.B.M. Leathers, advertising flyer, file "Clothing Catalogs (Male) (U.S.) (20th Century), Kinsey Institute.

28. Townsend, *Leatherman's Handbook*, pp. 217–218.

29. Ron, quoted in Robert Stoller, *Pain and Passion: A Psychoanalyst Explores the World of S&M* (New York: Plenum, 1991), p. 282.

30. Nathan Joseph, *Uniforms and Nonuniforms: Communicating Through Clothing* (New York: Greenwood Press, 1986), pp. 66-68, see also pp. 106-107, 116.

31. Magnus Hirshfeld, *Die Homosexualität*, quoted in Wilhelm Stekel, *Sexual Aberrations: The Phenomenon of Fetishism in Relation to Sex*, trans. Samuel Parker (New York: Liveright, 1971), vol. 1, pp. 305-307.

32. Quoted in F. Valentine Hooven III, *Tom of Finland: His Life and Times* (New York: St. Martin's Press, 1993), p. 23.

33. Hermann Broch, *The Sleepwalkers*, trans. Willa Muir and Edwin Muir (1931; New York: Pantheon, 1964), p. 21.

34. Beatrice J. Kalisch, Philip A. Kalisch, and Mary L. McHugh, "The Nurse as a Sex Object in Motion Pictures, 1930 to 1980," *Research in Nursing and Health* 5 (1982): 147, 152.

35. Marcia Pally, "Sorrow and Silk Stockings: The Woeful State of Femme," *Advocate*, September 17, 1985 p. 35.

36. Quoted in Georgina Howell, "Chain Reactions," *Vogue*, September 1992, p. 620.

37. Sarah Mower, "Who'd Be a Bond Girl?" *Harper's Bazaar*, December 1994, p. 150.

38. Quoted in Debbi Voller, *Madonna: The Style Book* (London: Omnibus Press, 1992), pp. 40-41.

39. Quoted in Valerie Steele, *Women of Fashion: Twentieth-Century Designers* (New York: Rizzoli, 1991), p. 160.

40. Kaja Silverman, "Fragments of a Fashionable Discourse," in *Studies in Entertainment: Critical Approaches to Mass Culture*, ed. Tania Modelski (Bloomington: Indiana University Press, 1986), pp. 145, 147.

41. Quoted in Servin, "Chic or Cruel?" p. 10.

42. I borrowed this phrase from Donald Symons, *The Evolution of Human Sexuality* (New York: Oxford University Press, 1979), p. 304.

43. John Money, *Gay, Straight, and In-Between: The Sexology of Erotic Orientation* (New York: Oxford University Press, 1988), pp. 136-137, 149, 159, 169-184.

44. "Freud and Fetishism: Previously Unpublished Minutes of the Vienna Psychoanalytic Society," trans. and ed. Louis Rose, *Psychoanalytic Quarterly* 57 (1988): 156.

45. Gail Faurschou, "Fashion and the Cultural Logic of Postmodernity," in *Body Invaders: Panic Sex in America*, ed. Arthur Kroker and Marilouise Kroker (Montreal: New World Perspectives, 1987), p. 83.

46. Francette Pacteau, *The Symptom of Beauty* (London: Reaktion Books, 1994), p. 191.

47. Scott Tucker, "The Hanged Man," in *Leatherfolk: Radical Sex, People, Politics, and Practice*, ed. Mark Thompson (Boston: Alyson, 1991), p. 11.

48. Annie Woodhouse, *Fantastic Women: Sex, Gender and Transvestism* (London: Macmillan, 1989), pp. 139, 144.

49. John Duka, "Should Women Dress Like Men?" *New York Times Magazine*, March 4, 1984, p. 175.

50. Tony Mitchell, "Frock Tactics," *Skin Two*, no. 14 (1994): 58–59.

51. Ken Plummer, "Sexual Diversity: A Sociological Perspective," in *The Psychology of Sexual Diversity*, ed. Kevin Howells (Oxford: Blackwell, 1984), pp. 244–245.

52. Krystina Kitsis, "Costume Drama," in *Skin Two Retro 1* (London: Tim Woodward, 1991), p. 40.

53. Michelle Olley, "Jean-Paul Gaultier: Rascal of Radical Chic," in *The Best of Skin Two*, ed. Tim Woodward (London: Kasak Books, 1993), p. 48.

54. Quoted in Richard Smith, "Jean-Paul Gaultier: Half a Rebel," *Gay Times*, January 1994, p. 58.

55. *O: Fashion, Fetish, Fantasy*, no. 13, (n.d. [1992]): p. 4.

56. Valerie Steele, "Paint It Black," *View on Color* 1 (1992): 64–69.

57. Jack Katz, *Seductions of Crime: Moral and Sensual Attractions in Doing Evil* (New York: Basic Books, 1988), pp. 358, 72, 81.

58. Janine Chasseguet-Smirgel, *Creativity and Perversion* (New York: Norton, 1985), p. 9.

59. Kaja Silverman, *Male Subjectivity at the Margins* (New York: Routledge, 1992), p. 187.

60. Seymour Fisher, *Sexual Images of the Self: The Psychology of Erotic Sensations and Illusions* (Hillsdale, N.J.: Erlbaum, 1989), p. 216, see also pp. 214–217.

61. Quoted in Ruth La Ferla, "Terminatrix Style," *Elle*, June 1994, p. 62.

62. Michael Mason, *The Making of Victorian Sexuality: Sexual Behavior and Its Understanding* (Oxford: Clarendon Press, 1994), pp. 99–100.

63. Jonathan Dollimore, *Sexual Dissidence: Augustine to Wilde, Freud to Foucault* (Oxford: Clarendon Pres, 1991), esp. pp. 222–223.

64. Michael V., quoted in Gloria G. Brame, William D. Brame, and Jon Jacobs, *Different Loving: An Explortion of the World of Sexual Dominance and Submission* (New York: Villard Books, 1994), p. 396.

65. Diane Ackerman, *A Natural History of Love* (New York: Random House, 1994), pp. 243–244.

66. Quoted in Maurice North, *The Outer Fringe of Sex* (London: Odyssey Press, 1970), p. 40.

67. See Chapters 1 and 2.

68. Joyce McDougall, "Identifications, Neoneeds, and Neosexualities," *International Journal of Psychoanalysis* 67 (1986): 20.

69. Fred Davis, "Clothing and Fashion as Communication," in *The Psychology of Fashion*, ed. Michael Solomon (Lexington, Mass.: Lexington Books, 1985), pp. 24–25.

Selected Bibliography

Abraham, Karl. "Remarks on the Psycho-Analysis of a Case of Foot and Corset Fetishism" (1910). In *Selected Papers of Karl Abraham*. New York: Basic Books, 1960.

Ackerman, Diane. *A Natural History of Love*. New York: Random House, 1994.

Ackroyd, Peter. *Dressing Up: Transvestism and Drag: The History of an Obsession*. New York: Simon and Schuster, 1979.

Allen, Clifford. "The Erotic Meaning of Clothes." *Sexology* 41 (1974): 31–34.

American Psychiatric Association. *Diagnostic and Statistical Manual of Mental Disorders*. 3rd ed. rev. Washington, D.C.: American Psychiatric Association, 1987.

———. *Diagnostic and Statistical Manual of Mental Disorders*. 4th ed. rev. Washington D.C.: American Psychiatric Association, 1994.

Apter, Emily. *Feminizing the Fetish: Psychoanalysis and Narrative Obsession in Turn-of-the-Century France*. Ithaca, N.Y.: Cornell University Press, 1991.

———. "Specularity and Reproduction." *Fetish* 4 (1992): 20–35.

Apter, Emily, and William Pietz, eds. *Fetishism as Cultural Discourse*. Ithaca, N.Y.: Cornell University Press, 1993.

Arndt, William B. *Gender Disorders and the Paraphilias*. Madison, Conn.: International Universities Press, 1991.

Attorney General of the United States. *Final Report of the Attorney General's Commission on Pornography*. Nashville: Rutledge Hill Press, 1986.

Bak, Robert C. "Fetishism." *Journal of the American Psychoanalytic Association* 1 (1953): 285–298.

———. "The Phallic Woman: The Ubiquitous Fantasy in Perversions." *Psychoanalytic Study of the Child* 23 (1968): 15–36.

Bakos, Susan Crain. *Kink: The Hidden Sex Lives of Americans*. New York: St. Martin's Press, 1995.

———. "Sexual Obsessions." *Ladies' Home Journal*, April 1993, pp. 110–114.

Baudin, P. *Fetichism and Fetich Worshippers*. New York: Benziger Brothers, 1885.

Baudrillard, Jean. *For a Critique of the Political Economy of the Sign*. St. Louis: Telos Press, 1981.

Bearden, Faith. "Cruel Shoes." *Bizarre*. no. 4 (1994): 46–49.

Becker, Ernest. *The Denial of Death*. New York: Free Press, 1973.

Benstock, Shari, and Suzanne Ferris, eds. *On Fashion*. New Brunswick, N.J.: Rutgers University Press, 1994.

Betterton, Rosemary, ed. *Looking On: Images of Femininity in the Visual Arts*. London: Pandora, 1987.

Betts, Katherine. "Under Construction." *Vogue*, October 1994, pp. 383–384, 414.

Binet, Alfred. "Le Fétichisme dans l'amour: Etude de psychologie morbide." *Revue philosophique* 24 (1887): 143–67, 252–274.

Bloch, Iwan. *The Sexual Life of Our Time*. Trans. M. Eden Paul. 1908. New York: Allied, 1928.

"Body Heat." *Vogue*, September 1994, pp. 574–581.

Borel, France. *Le Vêtement incarné: Les métamorphoses du corps*. Paris: Calmann-Lévy, 1992.

Brame, Gloria G., William D. Brame, and Jon Jacobs. *Different Loving: An Exploration of the World of Sexual Dominance and Submission*. New York: Villard Books, 1994.

Brand, Clavel. *Fetish*. London: Luxor Press, 1970.

———. *The Kinky Crowd*. Vol. 1, *The Rubber Devotee and The Leather Lover*. London: Luxor Press, 1970.

Brubach, Holly. "Shoe Crazy." *Atlantic*, May 1986, pp. 87–88.

———. "Whose Vision Is It, Anyway?" *New York Times Magazine*, July 17, 1994, pp. 46–49.

Bullough, Vern L. *Science in the Bedroom: A History of Sex Research*. New York: Basic Books, 1994.

Bullough, Vern L., and Bonnie Bullough. *Cross Dressing, Sex, and Gender*. Philadelphia: University of Pennsylvania Press, 1993.

Bushnell, Candice. "Rubber Wear." *Vogue*, September 1994, pp. 254–256.

Buss, David M. *The Evolution of Desire: Strategies of Human Mating*. New York: Basic Books, 1994.

Califia, Pat. "The Power Exchange." In *Skin Two Retro 1*. London: Tim Woodward, 1991.

Canguilhem, Georges. *The Normal and the Pathological*. New York: Zone Books, 1991.

Carter, Angela. *The Sadeian Woman and the Ideology of Pornography*. New York: Pantheon Books, 1978.

Cauldwell, David O. "The Rubber Fetishist." *Sexology*, June 1957, pp. 716–721.

Chan, Lily M. V. "Foot Binding in Chinese Women and Its Psycho-Social Implications." *Canadian Psychiatric Association Journal* 15 (1970): 229–231.

Chasseguet-Smirgel, Janine. *Creativity and Perversion*. New York: Norton, 1985.

———. *Sexuality and Mind: The Role of the Father and the Mother in the Psyche*. New York: New York University Press, 1986.

Chicklet. "Das Boot Brigade: An International Contact Club Encourages Pride Among Men with a Passion for Boots." *Advocate*, March 10, 1992, pp. 64–65.

Clérambault, Gaëtan Gatian de. *Passion érotique des étoffes chez la femme.* Preface by Yves Edel. 1908. Paris: Empêcheurs de Penser en Rond, 1991.

Corbin, Alain. *Women for Hire: Prostitution and Sexuality in France After 1850.* Trans. Alan Sheridan. Cambridge, Mass.: Harvard University Press, 1990.

Cowie, Elizabeth. "Pornography and Fantasy: Psychoanalytic Perspectives." In *Sex Exposed: Sexuality and the Pornography Debate*, ed. Lynn Segal and Mary McIntosh. New Brunswick, N.J.: Rutgers University Press, 1993.

Craik, Jennifer. *The Face of Fashion: Cultural Studies in Fashion.* London: Routledge, 1994.

Cunningham, Bill. "What Once Was Under Is Now Over." *New York Times*, July 31, 1988, p. 44.

Davidson, J. D. *The Transvestite Handbook.* London: D & I Publications, 1988.

De Lauretis, Teresa. *The Practice of Love: Lesbian Sexuality and Perverse Desire.* Bloomington: Indiana University Press, 1994.

Dietz, Mark Elliott, and Barbara Evans. "Pornographic Imagery and Prevalence of Paraphilia." *American Journal of Psychiatry* 139 (1982): 1493–1495.

Docter, Richard F. *Transvestites and Transsexuals: Toward a Theory of Cross-Gender Behavior.* New York: Plenum, 1988.

Dollimore, Jonathan. *Sexual Dissidence: Augustine to Wilde, Freud to Foucault.* Oxford: Clarendon Press, 1991.

Dominguez, Ivo. *Beneath the Skins: The New Spirit and Politics of the Kink Community.* Los Angeles: Daedalus, 1994.

DuCann, Charlotte. "Love and Death on the London Catwalk." *Guardian*, October 15, 1990, p. 36.

Duka, John. "Should Women Dress Like Men?" *New York Times Magazine*, March 4, 1984, pp. 174–175.

Engel, Peter. "Androgynous Zones." *Harvard Magazine*, January–February 1985, pp. 24–34.

Epstein, Arthur W. "The Relationship of Altered Brain States to Sexual Psychopathology." In *Contemporary Sexual Behavior: Critical Issues in the 1970s*, ed. Joseph Zubin and John Money. Baltimore: Johns Hopkins University Press, 1973.

Eskara, Roy D. *Bizarre Sex.* London: Quartet Books, 1987.

Evans, Caroline, and Minna Thornton. *Women and Fashion: A New Look.* London: Quartet Books, 1989.

Farren, Mick. *The Black Leather Jacket.* New York: Abbeville Press, 1985.

Farrer, Peter. *Men in Petticoats.* Liverpool: Karn, 1987.

Feher, Michel, with Ramona Naddaff and Nadia Tazi, eds. *Fragments for a History of the Human Body.* 4 vols. New York: Zone Books, 1987–1994.

Fisher, Seymour. *Sexual Images of the Self: The Psychology of Erotic Sensations and Illusions.* Hillsdale, N.J.: Erlbaum, 1989.

Fogel, Gerald I., and Wayne A. Myers, eds. *Perversions and Near-Perversions in Clinical*

Practice: New Psychoanalytic Perspectives. New Haven, Conn.: Yale University Press, 1991.

Foucault, Michel. *Discipline and Punish: The Birth of the Prison*. Trans. Alan Sheridan. New York: Vintage Books, 1979.

———. *The History of Sexuality*. Vol. 1, *An Introduction*. Trans. Robert Hurley. New York: Random House, 1978.

Freeman, Gillian. *The Undergrowth of Literature*. London: Nelson, 1967.

Freifeld, Karen. "What a Heel! Sole Suspect Nabbed in Marla Shoe Thefts." *New York Newsday*, July 17, 1992, pp. 3.

Freud, Sigmund. *The Standard Edition of the Complete Psychological Works*. London: Hogarth Press and The Institute for Psychoanalysis, 1953–1975.

"Freud and Fetishism: Previously Unpublished Minutes of the Vienna Psychoanalytic Society." Ed. and trans. Louis Rose. *Psychoanalytic Quarterly* 57 (1988): 147–166.

Friedman, Norma. "Leather: A New Look, a New Appeal." *Vogue*, August 1981, p. 179.

Friedrichs, David O. "The Body Taboo." *Sexual Behavior* 2 (1972): 64–72.

Gaines, Jane, and Charlotte Herzog, eds. *Fabrications: Costume and the Female Body*. New York: Routledge, 1990.

Gamman, Lorraine, and Merja Makinen. *Female Fetishism: A New Look*. London: Lawrence & Wishart, 1994.

Garber, Marjorie. *Vested Interests: Cross-Dressing and Cultural Anxiety*. New York and London: Routledge, 1992.

Gebhard, Paul H. "Fetishism and Sadomasochism." In *Sex Research Studies from The Kinsey Institute*, ed. Martin Weinberg. New York: Oxford University Press, 1976.

Gibson, Pamela Church, and Roma Gibson, eds. *Dirty Looks: Women, Pornography, Power*. London: British Film Institute, 1993.

Gilbert, Harriet, ed. *The Sexual Imagination from Acker to Zola: A Feminist Companion*. London: Cape, 1993.

Gillespie, W. H. "A Contribution to the Study of Fetishism." *International Journal of Psychoanalysis* 21 (1940): 401–415.

———. "A General Theory of Sexual Perversion." *International Journal of Psychoanalysis* 37 (1956): 396–403.

Glover, E. "Sublimation, Substitution and Social Anxiety" (1931) and "A Note on Idealization" (1938). In E. Glover, *On the Early Development of Mind*. London: Imago, 1956.

Godwin, John. "Nudity—The Year's Most Popular Fashion." *Penthouse Forum*, May 1974, pp. 22–27.

Gosselin, Chris, and Glenn Wilson. *Sexual Variations: Fetishism, Sadomasochism, and Transvestism*. London: Faber and Faber, 1980.

Greenacre, Phyllis. "Fetishism." In *Sexual Deviation*, 2nd ed., ed. Ismond Rosen. Oxford: Oxford University Press, 1979.

Grimes, William. "The Chanel Platform." *New York Times*, May 17, 1992, p. 8.

Gross, Michael. "Lingerie Catalogues: Changing Images." *New York Times*, April 26, 1987, p. 61.

Grumley, Michael, and Ed Gallucci. *Hard Corps: Studies in Leather and Sadomasochism*. New York: Dutton, 1977.

Herdt, Gilbert, and Robert Stoller. *Intimate Communications: Erotics and the Study of Culture*. New York: Columbia University Press, 1990.

Hirshfeld, Magnus. *Sexual Anomalies and Perversions: Physical and Psychological Development, Diagnosis and Treatment*. Comp. and ed. Norman Haire. 1938. London: Encyclopedic Press, 1962.

———. *Transvestites: The Erotic Drive to Cross Dress*. Trans. Michael Lombardi-Nash. Buffalo: Prometheus Books, 1991.

Hoare, Sarajane. "Inside Out." [British] *Vogue*, February 1991, pp. 116–125.

Hochswender, Woody. "Strong Suit. But Why Does a Woman in a Necktie Look Potent, Not Perverse?" *New York Times*, May 3, 1992, sec. 9, p. 10.

Hollander, Anne. "Dressed to Thrill: The Cool and Casual Style of the New American Androgeny." *New Republic*, January 28, 1985, pp. 28–35.

Horyn, Cathy. "Of Women's Bondage." *Mirabella*, March 1993, pp. 115–118.

Howell, Georgina. "Chain Reactions." *Vogue*, September 1992, pp. 531–534, 630.

Howells, Kevin, ed. *The Psychology of Sexual Diversity*. Oxford: Blackwell, 1984.

Hunt, Lynn, ed., *The Invention of Pornography: Obscenity and the Origins of Modernity, 1500–1800*. New York: Zone Books, 1993.

Janus, Samuel S., and Cynthia L. Janus. *The Janus Report on Sexual Behavior*. New York: Wiley, 1993.

Jewell, Patrick. *Vice Art: An Anthology of London's Prostitute Cards*. Harrogate: Broadwater, 1993.

Jones, Hugh. *The Sexual Fetish in Today's Society*. North Hollywood, Calif.: Brandon House, 1965.

Jones, Stephanie. "Strictly Fashionable: A Straight-Laced Look at Corsetry." *Skin Two*, no. 9 (1989): 42–47.

"Jury Convicts Publicist of Footwear Theft." *New York Times*, February 17, 1994, p. B2.

Kaplan, Louise. *Female Perversions: The Temptations of Emma Bovary*. New York: Doubleday, 1991.

Katz, Jack. *Seductions of Crime: Moral and Sensual Attractions in Doing Evil*. New York: Basic Books, 1988.

Kern, Stephen. *Anatomy and Destiny: A Cultural History of the Human Body*. Indianapolis: Bobbs-Merrill, 1975.

Kirk, Kris, and Ed Heath. *Men in Frocks*. London: GMP Press, 1984.

Kocieniewski, David. "That's Shoe Biz. Sole Searching." *New York Newsday*, July 27, 1993, pp. 1, 5.

Kohon, Gregorio. "Fetishism Revisited." *International Journal of Psycho-Analysis* 68 (1987): 213–228.

Krafft-Ebing, Richard von. *Psychopathia Sexualis with Especial Reference to the Antipathic Sexual Instinct: A Medico-Forensic Study.* Trans. F. J. Rebman. 1886. New York: Physicians and Surgeons Book Company, 1906, 1934.

Kroker, Arthur, and Marilouise Kroker, eds. *Body Invaders: Panic Sex in America.* Montreal: New World Perspectives, 1987.

Kroll, Eric. *Eric Kroll's Fetish Girls.* Cologne: Benedikt Taschen, 1994.

Kunzle, David. *Fashion and Fetishism.* Totowa, N.J.: Rowman and Littlefield, 1982.

La Ferla, Ruth. "Terminatrix Style." *Elle*, June 1994, p. 62.

Laplanche, Jean, and Jean-Bertrand Pontalis. "Fantasy and the Origins of Sexuality." In *Formations of Fantasy*, ed. Victor Burgin, et al. London: Methuen, 1986.

La Torre, Ronald A. "Devaluation of the Human Love Object: Heterosexual Rejection as a Possible Antecedent to Fetishism." *Journal of Abnormal Psychology* 89 (1980): 1295–1298.

Lemoine-Luccioni, Eugénie. *La Robe: Essai psychanalytique sur le vêtement.* Paris: Éditions du Seuil, 1983.

Levy, Howard. *Chinese Foot Binding.* New York: Bell, 1972.

Longway, Lynn. "Going Hell-for-Leather." *Newsweek*, October 19, 1981, p. 90.

Love, Brenda. *Encyclopedia of Unusual Sex Practices.* Fort Lee, N.J.: Barricade Books, 1992.

McClintock, Anne. "Maid to Order." *Skin Two*, no. 14 (1994): 70–77.

McCully, Robert S. "A Jungian Commentary on Epstein's Case (Wet-Shoe Fetish)." *Archives of Sexual Behavior* 5 (1976): 185–187.

McDougall, Joyce. "Identifications, Neoneeds, and Neosexualities." *International Journal of Psychoanalysis* 67 (1986): 19–31.

———. "Perversions and Deviations in the Psychoanalytic Attitude: Their Effects on Theory and Practice." In *Perversions and Near-Perversions in Clinical Practice: New Psycholanalytic Perspectives*, ed. Gerald I. Fogel and Wayne A. Myers. New Haven, Conn.: Yale University Press, 1991.

———. *Plea for a Measure of Abnormality.* New York: Brunner/Mazel, 1992.

———. "Primal Scene and Sexual Perversion." *International Journal of Psychoanalysis* 53 (1972): 371–384.

———. *Theatres of the Mind: Illusion and Truth on the Psychoanalytic Stage.* New York: Basic Books, 1985.

McDowell, Colin. *Dressed to Kill: Sex, Power & Clothes.* London: Hutchinson, 1992.

Madame Kayne. *The Corset in the Eighteenth and Nineteenth Centuries.* Brighton: Greenfields, n.d. [ca. 1932].

Madison, Roger. "Dig Black Stockings and Boots?" *Sexology* 41 (1975): 25–29.

Magnuson, Ann. "Hell on Heels." *Allure*, September 1994, pp. 128–131.

Mason, Michael. *The Making of Victorian Sexuality: Sexual Behavior and Its Understanding.* Oxford: Clarendon Press, 1994.

Menkes, Suzy. "Fetish or Fashion?" *New York Times*, November 23, 1993, sec. 9, pp. 1, 9.

Metz, Christian. "Photography and Fetish." In *The Critical Image*, ed. Carol Squires. Seattle: Bay Press, 1990.

Mike. "The Belt: Perspectives on a Fetish." *Drummer*, January 1993, pp. 18–19.

Miller, Tamalyn. "This Skirt Sure Looks Snappy, But It May Be a Problem to Hem." *Wall Street Journal*, March 7, 1985, pp. 35.

Milligan, Don. *Sex-Life: A Critical Commentary on the History of Sexuality.* London: Pluto Press, 1993.

Mistress Angel Stern. "A 'Corset Moment' with Pearl." *Verbal Abuse*, no. 3 (1994): 7.

Mistress Jacqueline, as told to Catherine Tavel and Robert H. Rimmer. *Whips and Kisses: Parting the Leather Curtain.* Buffalo: Prometheus Books, 1991.

Mitchell, Tony. "Frock Tactics." *Skin Two*, no. 14 (1994): 58–59.

———. "Scene & Heard: Cheek to Chic." *Skin Two*, no. 9 (1989): 18–21.

Money, John. *Gay, Straight, and In-Between: The Sexology of Erotic Orientation.* New York: Oxford University Press, 1988.

Morneau, Robert H., and Robert R. Rockwell. *Sex, Motivation, and the Criminal Offender* Springfield, Ill.: Thomas, 1980.

Morrocchi, Riccardo, and Stefano Piselli. *Diva Fetish.* Florence: Glittering Images, 1992.

Mower, Sarah. "Fashion Intelligence: Of Human Bondage." [British] *Vogue*, February 1991, p. 15.

———. "Who'd Be a Bond Girl?" *Harper's Bazaar*, December 1994, pp. 150–153, 199.

Mulvey, Laura. *Visual and Other Pleasures.* Bloomington: Indiana University Press, 1989.

Musafar, Fakir. "The Corset and Sadomasochism." *Sandutopia Guardian: A Dungeon Journal*, no. 11 (n.d.): 13–17.

Nazarieff, Serge. *Jeux de dames cruelles, 1850–1960.* Cologne: Benedikt Taschen, 1992.

North, Maurice. *The Outer Fringe of Sex.* London: Odyssey Press, 1970.

Olley, Michelle. "Jean-Paul Gaultier: Rascal of Radical Chic." In *The Best of Skin Two*, ed. Tim Woodward. London: Kasak Books, 1993.

O'Malley, Suzanne. "How I Spiced Up My Sex Life." *Redbook*, April 25, 1985, pp. 100, 131.

O'Neill, Molly. "The Arm Fetish." *New York Times*, May 3, 1992, sec. 9, pp. 1, 13.

Pally, Marcia. "Sorrow and Silk Stockings: The Woeful State of Femme." *Advocate*, September 17, 1985, pp. 35, 46.

Peiss, Kathy, and Christina Simmons, with Robert A. Padgug, eds. *Passion and Power: Sexuality in History.* Philadelphia: Temple University Press, 1989.

Phillips, Mike, with Barry Shapiro and Mark Joseph. *Forbidden Fantasies: Men Who Dare to Dress in Drag.* New York: Collier, 1980.

Pictorial History of the Corset [three-volume compilation of clippings about corsetry with typewritten commentary]. Art Library, Brooklyn Museum.

Podolsky, Edward, and Carlson Wade. *Erotic Symbolism: A Study of Fetishism in Relation to Sex*. New York: Epic, 1960.

Polan, Brenda. "High Heel Fantasies." *Daily Mail*, August 21, 1990, pp. 13.

Polhemus, Ted. *Body Styles*. Luton: Leonard Books, 1988.

———. *Street Style: From Sidewalk to Catwalk*. London: Thames and Hudson, 1994.

Raab, Andrea. "Fetishes." *Self*, April 1992, p. 94.

"Reverse Chic Rubber Garb Springs into High Fashion." *People*, September 3, 1984, p. 89.

Ridley, Matt. *The Red Queen: Sex and the Evolution of Human Nature*. New York: Macmillan, 1993.

Robinson, Julian. *Body Packaging: A Guide to Human Sexual Display*. Los Angeles: Elysium Growth Press, 1988.

Rolley, Katrina. "Love, Desire and the Pursuit of the Whole: Dress and the Lesbian Couple." In *Chic Thrills: A Fashion Reader*, ed. Elizabeth Wilson and Juliet Ash. London: Pandora/HarperCollins, 1992.

Rose, Barbara. "The Beautiful and the Damned." *Vogue*, November 1978, pp. 324–326.

Rose, Cynthia. "Skin Deep." *Guardian Weekend*, March 5, 1994, p. 29.

Rossi, William A. *The Sex Life of the Foot and Shoe*. Ware: Wordsworth, 1977.

"Roundtable: Sex and Clothing." *Medical Aspects of Human Sexuality* 4 (1970): 114–161.

Russo, Vito. "Why Is Leather Like Ethel Merman?" *Village Voice*, April 15–21, 1981, p. 37.

Sacher-Masoch, Leopold von. *Venus in Furs*. Trans. Jean McNeil. In Giles Deleuze, *Masochism: An Interpretation of Coldness and Cruelty*. New York: Braziller, 1971.

Sanders, Clinton. *Customizing the Body: The Art and Culture of Tattooing*. Philadelphia: Temple University Press, 1989.

Schneider, Karen, and Sue Carswell. "Agony of the Feet." *People*, August 3, 1992, pp. 55–56.

Schor, Naomi. "Female Fetishism: The Case of George Sand." In *The Female Body in Western Culture: Contemporary Perspectives*, ed. Susan Rubin Suleiman. Cambridge, Mass.: Harvard University Press, 1986.

Servin, James. "Chic or Cruel?" *New York Times*, November 1, 1992, sec. 9, p. 10.

Shields, Jody. "Shoes for Scandal." *Vogue*, March 1993, pp. 378, 427.

Simpson, David. *Fetishism and Imagination: Dickens, Melville, Conrad*. Baltimore: Johns Hopkins University Press, 1982.

Smirnoff, Victor N. "The Fetishistic Transaction." In *Psychoanalysis in France*, ed. Serge Lebovici and Daniel Widlöcher. New York: International Universities Press, 1980.

Snitnow, Ann, Christine Stansell, and Sharon Thompson, eds. *Powers of Desire: The Politics of Sexuality*. New York: Monthly Review Press, 1983.

Solomon, Julie B. "Low-Cut Trend in Women's Shoes Is Exposing Toes to New Scrutiny." *Wall Street Journal*, October 15, 1984, p. 35.

Squires, Judith, ed. "Perversity" [special issue], *New Formations*, no. 19 (1993).

Stanton, Domna C., ed. *Discourses of Sexuality: From Aristotle to AIDS*. Ann Arbor: University of Michigan Press, 1992.

Steele, Valerie. "Clothing and Sexuality." In *Men and Women: Dressing the Part*, ed. Claudia Kidwell and Valerie Steele. Washington, D.C.: Smithsonian Institution Press, 1989.

———. "Erotic Allure." In *The Idealizing Vision: The Art of Fashion Photography*, ed. Andrew Wilkes. New York: Aperture, 1991.

———. *Fashion and Eroticism: Ideals of Feminine Beauty from the Victorian Era to the Jazz Age*. New York: Oxford University Press, 1985.

———. *Women of Fashion: Twentieth-Century Designers*. New York: Rizzoli, 1991.

Stekel, Wilhelm. *Sexual Aberrations: The Phenomenon of Fetishism in Relation to Sex*. 2 vols. Trans. Samuel Parker. New York: Liveright, 1971.

Stoller, Robert. "The Gender Disorders." In *Sexual Deviation*, ed. Ismond Rosen. Oxford: Oxford University Press, 1973.

———. *Observing the Erotic Imagination*. New Haven, Conn.: Yale University Press, 1985.

———. *Pain and Passion: A Psychoanalyst Explores the World of S&M*. New York: Plenum, 1991.

———. *Perversion: The Erotic Form of Hatred*. New York: Pantheon Books, 1975.

———. *Porn: Myths for the Twentieth Century*. New Haven and London: Yale University Press, 1991.

———. *Presentations of Gender*. New Haven, Conn.: Yale University Press, 1985.

———. "Psychoanalysis and Physical Intervention in the Brain: The Mind–Body Problem Again." In *Contemporary Sexual Behavior: Critical Issues in the 1970s*, ed. Joseph Zubin and John Money. Baltimore: Johns Hopkins University Press, 1973.

———. *Sex and Gender: On the Development of Masculinity and Femininity*. New York: Science House, 1968.

———. *Sexual Excitement: Dynamics of Erotic Life*. New York: Pantheon Books, 1979.

———. "Transvestism in Women." *Archives of Sexual Behavior* 11 (1982): 99–116.

Symons, Donald. *The Evolution of Human Sexuality*. New York: Oxford University Press, 1979.

Thompson, Mark, ed. *Leatherfolk: Radical Sex, People, Politics, and Practice*. Boston: Alyson, 1991.

Thorne, Melvin Q. "Marital and LSD Therapy with a Transvestite and His Wife," *Journal of Sex Research* 3 (1967): 169–177.

Townsend, Larry. *Leatherman's Handbook*. Beverly Hills, Calif.: Le Salon, 1970, 1974, 1977.

Trasko, Mary. *Heavenly Soles: Extraordinary Twentieth-Century Shoes*. New York: Abbeville Press, 1989.

Ullerstam, Lars. *The Erotic Minorities*. Trans. Anselm Hollo. New York: Grove Press, 1966.

Vale, V., and Andrea Juno, eds. *Modern Primitives*. San Francisco: Re/Search, 1989.

Vance, Carole, ed. *Pleasure and Danger: Exploring Female Sexuality*. Boston: Routledge and Kegan Paul, 1984.

Wade, Carlson. *Panty Raid and Other Stories of Transvestism and Female Impersonation*. New York: Selbee, 1963.

———. "The Pleasures of Fur." *High Heels* 3 (1962): 45–47.

Waites, Elizabeth A. "Fixing Women: Devaluation, Idealization, and the Female Fetish." *Journal of the American Psychoanalytic Association* 30 (1982): 435–439.

Weeks, Jeffrey. *Sexuality and Its Discontents: Meanings, Myths and Modern Sexualities*. London: Routledge and Kegan Paul, 1985.

Wildman, R. W., et al. "Notes on Males' and Females' Preferences for Opposite Sex Body Parts, Bust Sizes and Bust Revealing Clothing." *Psychological Reports* 13 (1976): 485–486.

Williams, Linda. *Hard Core: Power, Pleasure, and the "Frenzy of the Visible."* Berkeley: University of California Press, 1989.

Wilson, Elizabeth. *Adorned in Dreams: Fashion and Modernity*. Berkeley: University of California Press, 1985.

Wilson, Glenn. *The Great Sex Divide: A Study of Male–Female Differences*. London: Peter Owen, 1989.

———. *The Secrets of Sexual Fantasy*. London: Dent, 1978.

———, ed. *Variant Sexuality: Research and Theory*. Baltimore: Johns Hopkins University Press, 1987.

Wise, Thomas N. "Fetishism—Etiology and Treatment: A Review from Multiple Perspectives." *Comprehensive Psychiatry* 26 (1985): 249–257.

Wood, Robert. "Fur Fetishism." *Sexology*, February 1956, pp. 426–431.

Woodhouse, Annie. *Fantastic Women: Sex, Gender and Transvestism*. London: Macmillan, 1989.

Woodward, Tim, ed. *The Best of Skin Two*. London: Kasak Books, 1993.

Zavitzianos, George. "Fetishism and Exhibitionism in the Female and Their Relationship to Psychopathy and Kleptomania." *International Journal of Psychoanalysis* 52 (1971): 297–305.

———. "Homeovestism: Perverse Forms of Behavior Involving Wearing Clothes of the Same Sex." *International Journal of Psychoanalysis* 53 (1972): 471–477.

———. "The Perversion of Fetishism in Women." *Psychoanalytic Quarterly* 51 (1982): 405–425.

SELECTED BIBLIOGRAPHY

Periodicals and Catalogues

Bizarre

Bizarre Bondage

Bizarre Life

Bizarre Shoes and Boots

Black Leather . . . In Color

Black Leather Times

Blue Blood

Body Art

Body Play

Bondage Life

B. R. Corset Newsletter

Catalog of Fetish Catalogs

Custom Shoe Company

Ecstasy Lingerie

Englishwoman's Domestic Magazine

Erolastica

Erotic Bondage

Fantasy Fashion Digest

Female Foot Fetishism

Female Impersonator News

Fetish

Fig Leaf

Foot Worship

Frederick's of Hollywood

High Heel Honeys

High Heels

International Male

Latex and Leather

London Life

London Life League Newsletter [and] Corset Education Notes

Modern Society

Monique of Hollywood

SELECTED BIBLIOGRAPHY

Natural Rubber Company

Noir Leather

Nylon Jungle

O: Fetish, Fashion, Fantasies

Piercing Fans International Quarterly

Razor's Edge

Repartee

Rubber News

Rubber Rebel

Skin Two

Society

Tapestry

Transformations

Transvestite

Velvet

Vogue

Index